lucy+jorge orta

an introduction to collaborative practices

pattern
book

**black dog
publishing**

Contents

4 Introduction Paula Orrell

6 Context Sally Tallant

28 Pattern Book

30 The Gift

50 Connector

64 Dwelling

80 OrtaWater

94 Nexus

110 Vision

112 Discussion Janna Graham / Lucy + Jorge Orta

122 Do It Yourself Emma Gibson

124 www.studio-orta.com/dform_project/

136 Challenge Chris Wainwright

138 Resource Sophie Hope / B + B

154 Biographies

Introduction Paula Orrell

This publication was initiated with Lucy + Jorge Orta after I worked alongside the artists for a period of three years. I had the great fortune to be embedded in their practice, witnessing the creation of ideas, and development of their projects with the public at large and alongside an ever-expanding team of curators, fabricators, artisans, artists, designers, architects and academics to name but a few. This book investigates the collective processes the artists explore and the special relationships forged between people through the medium of art. As both participant and spectator, my fortuitous role affords me a unique and privileged perspective of the artists' work in what has become another process of collaboration: the *Lucy + Jorge Orta Pattern Book*.

Lucy Orta and Jorge Orta began their careers operating as individual artists, Jorge since the 1970s and Lucy since the 1990s. Over the last 15 years together they have formed a common partnership with an aim to challenge social and environmental agendas and issues that continue to affect sustainable development. Their work touches upon crucial issues of our society: community and social inclusion, dwelling and habitat, mobility and migration, ecology and recycling.

Committed to these agendas, they work simultaneously in a variety of group situations and locations. The demand for the Ortas' approach and distinct method of working with people has taken them to communities across the globe, everywhere from Australia to South Africa and North and South America.

The *Lucy + Jorge Orta Pattern Book* reflects and discusses how the artists operate within these contexts, creating a manual to their practice. It explores different methods of public participation and co-creation through workshops, pedagogy and collaborations, visualising their points of departure and rendering an account of how ideas are put into action. To illustrate these themes, we have chosen five distinct projects and presented both their processes and outcomes.

The text contributions have been commissioned from curators and academics, whose erudite commentary provides insight into the artists' work and offers analysis of their methods. The essay by Sally Tallant and the interview by Janna Graham explore the Ortas' relationships with people, exposing the methods and tools that Tallant concludes are "the development of a template and format for a pedagogical approach that enables this work to become more widely disseminated as a set of principles for interaction and production". The B+B Archive provides a resource framework for understanding Lucy + Jorge Ortas' work within the wider context of contemporary art practices. Sophie Hope identifies and compares their work with a selection of the most engaged artists and collectives operating today. The utilitarian format draws attention to the categorising of projects within funding and commissioning discourses. Such discourses can be seen to identify key composite elements such as 'participation', 'mediation' and 'utility' in order to value and define projects.

The *Lucy + Jorge Orta Pattern Book* is neither exhaustive as a guide to the artists' projects, nor does it represent a finite standard of the more 'successful' processes of collaboration or the 'best' outcomes. Instead we hope it will animate the discourse of public art and function as a resource for the reader be they practitioner or non-practitioner.

Context Sally Tallant

8 Section A: Chance Encounters

24 Section B: Architecture

Section A
Chance Encounters

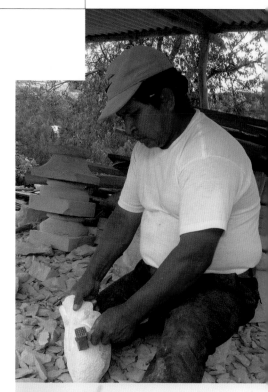

Lucy + Jorge Orta are artists, designers, architects, negotiators, teachers, collaborators, facilitators, animateurs, disruptors, interventionists, provocateurs, activists, antagonists, instigators, campaigners, cooks, hosts, conversationalists, persuaders, mediators, politicians, interlocutors, interlopers and much more. The Ortas' create convivial and collaborative situations that result in artwork based on human interaction, politics, and community. Their work is a mixture of elements; straddling several disciplines and demanding a reading in relation to ethics as much as aesthetics.

Practicing since the late 1970s (Jorge) and 1990s (Lucy), the Orta partnership, has been producing artworks that initiate complex dialogues around themes of art, social action and political provocation. The work is produced through collaboration and communication, which is transformative, relational and educational, offering prototypes for interaction and artistic production.

The context from which Lucy Orta's practice has evolved is crucial. Trained as a fashion/textile designer in Nottingham, England, her graduation coincided with a period of international political flux evidenced by the fall of the Berlin Wall, the re-mapping of Eastern Europe, protests in Tiananmen Square, the end of the Cold War and the beginning of the Gulf War, all of which was set against a background of sustained Conservative government in the United Kingdom. Her work has sought to operate in a politically complex sphere, bringing the method of artistic production to bear on the artworks themselves by employing operational tactics that irreversibly fuse process and outcome. Orta's strategies have developed through a desire to work intimately with people and to negotiate the challenges of participation. All of her works engage the difficulty and contradictions of mediating contemporary political society, and in most cases Orta chooses to work with people often marginalised by that society. Her relationship with South American artist Jorge Orta (her husband and collaborator since 1993) has been key in establishing a mode of operation that highlights these commitments. Together they have developed strategies and models of collaborative practice that reside both in political activism and creative practice. The idealism and vision that they have developed together is strategically utopian.

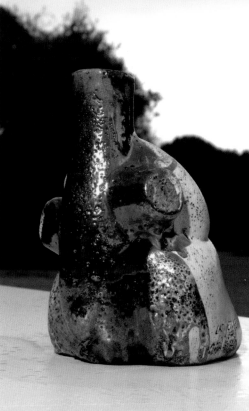

"A society cannot renew itself much less exist, without utopia. Utopia is the movement, it is the will to go further, to invent another world, so that ours may be revitalised. To build utopias is to search for the evolution of change, to imagine the change and undertake the change."[1]

Working together since the early 1990s, Lucy + Jorge Orta have advanced a number of projects in parallel. The commitment to these projects over a sustained period of time means that they have developed sophisticated strategies for collaboration and for involving other people. The ambition and scale of the projects have increased and they now have structures that enable them to engage vast numbers of people globally. For example *The Gift—*

[1] Orta, Jorge, "Return of the Utopias: The Aesthetics of Ethics, a Draft Manifesto for the Third Millennium", *Lucy Orta*, London: Phaidon, 2003, p. 102.

TOP TO BOTTOM:
The Gift—Life Nexus
2004 / Artisan stone carving in Cuenca, Ecuador.
The Gift—Life Nexus
2004 / *Raku Heart*, co-creation with La Tuilerie de Cheniers France.

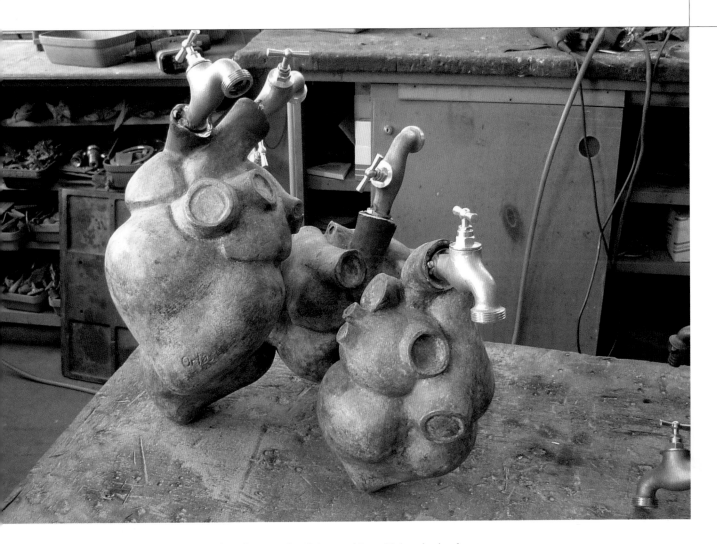

Opéra.tion Life Nexus was a project that saw the Ortas working with hundreds of local potters and brick-makers in Central and South America, and during its most intense period the work engaged over 35,000 college students from the Meurthe-et-Moselle region in France. The Ortas are also accustomed to working on a more intimate level in the form of workshops and residencies, sharing work and ideas with various people over the years. Taking this experience into account they are now developing projects that embrace the idea of a legacy for their work and consider how it can have wider impact through pedagogy.

THE GIFT

Since 1996, *The Gift–Opéra.tion Life Nexus* has been an important strand of activity and production, taking Lucy + Jorge Orta all over the world where they have fashioned artworks and situations that employ a mixture of methods and materials. The symbol of the heart is used as a starting point for the co-creation and production of objects, sound compositions, light-works and performance. Through workshops, residencies and the involvement of whole communities the artists have instigated a project that challenges notions of authorship and intention, and creates a creative space for serious humanitarian matters to take hold. The impetus for this work came from a desire to use art to both raise awareness and provoke change in terms of organ donation, following the death of a close friend who failed to receive an organ she desperately needed to

TOP:
The Gift–Life Nexus
2003 / Bronze studies for *Le Coeur du Grand Nancy*, public sculpture in Place de la République.

survive. The production of the artworks themselves is a cumulative by-product of the Ortas' engagement with communities all over Europe and North and South America. The works produced in the workshops are mostly anatomically-shaped clay hearts; created both from moulds and through individual interpretation, but despite their surface differences, they all refer to the humanitarian need for a fundamental care for one another in contemporary political community. As a development from the physical ceramic shapes, the project has developed to embrace performance as a means of communication. For *Opéra.tion Life Nexus VII* in Les Halles, Paris, 2002, Simon Stockhausen created a musical score to accompany the artworks, and Pierre Henry did the same for *Nexò Corazon* in Mexico City during 2001. These actions culminated in the 2003 *World Transplant Games* in Nancy, where 35,000 students participated in the production of artworks and performance through the collaboration of regional educational establishments. This method of engagement stands as a model for large-scale interaction and diffuse political dissemination that has come to characterise the Ortas' work over the last 20 years.

"The role of art in this approach is to generate workshops to awaken consciousness. Over the ten years and in the 40 cities in which we worked on the issue it has finally become adopted as public agenda."[2]

The methodology of developing a template of interaction is something that runs through all of the workshops and projects Lucy + Jorge Orta undertake. Individuals bring their own interpretation to elements that collectively become an ever-expandable whole. A modular approach extends the possibility of participation and, through the development of new collaborative infrastructure; it becomes possible for the reach of the work to be extended through a ripple effect, which in the longer term can operate without the artists acting as facilitators. Nicolas Bourriaud, the French theorist, has coined this "operational aesthetics".[3] The challenge of how to read work that simultaneously embraces and negates the notion of authorship in this way is crucial, and especially at the point of presentation, it becomes a political endeavour. The relationship between cultural production, and social policy is a terrain rarely explored by artists and by choosing to operate in this territory Lucy + Jorge Orta have used the principles of self-organisation to disrupt traditional artistic policy and manifest social change while producing objects in the world as (among other things) physical reminders of the situations they instigate. This approach results in what Rancière refers to as "the collapse between politics and aesthetics" and produces work that is as much about the creative and social experiences of production as it about the objects themselves. The artistic communities the Ortas create and engage act as the primary tool in the creation of the work, and in some senses, function as the work itself.

[2] Orta, Jorge, "Return of the Utopias: The Aesthetics of Ethics, a Draft Manifesto for the Third Millennium" *Lucy Orta*, London: Phaidon, 2003, p. 102.
[3] Bourriaud, Nicolas, "Interview" *Lucy Orta*, London: Phaidon, 2003, p. 6.

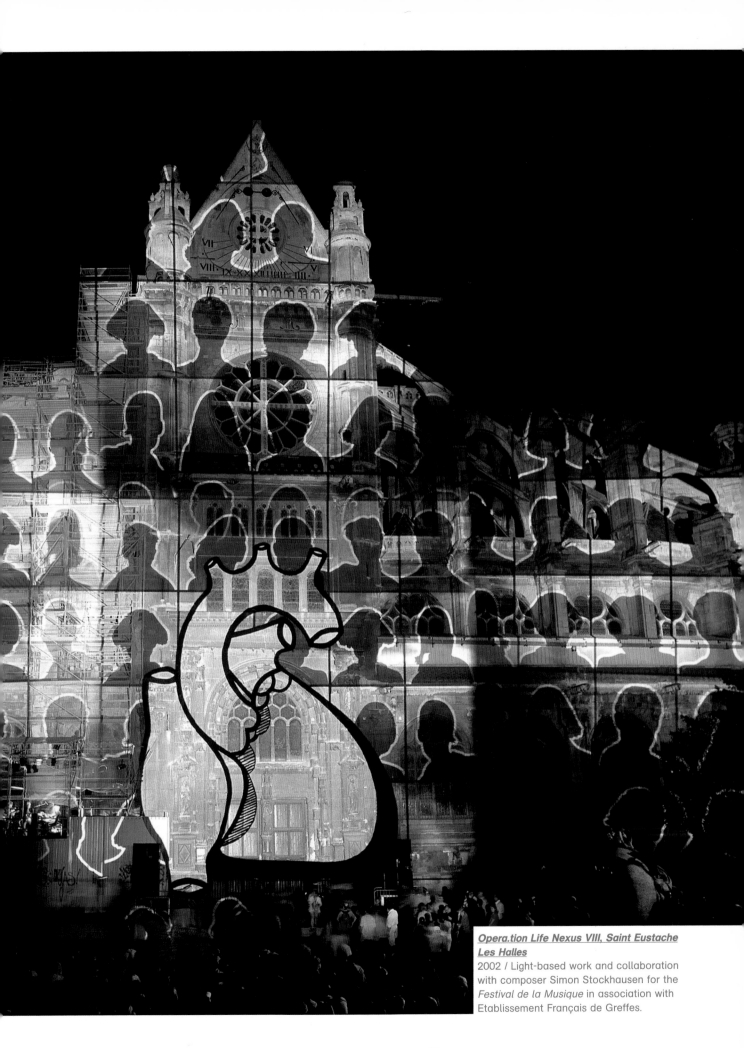

***Opera.tion Life Nexus VIII, Saint Eustache
Les Halles***
2002 / Light-based work and collaboration
with composer Simon Stockhausen for the
Festival de la Musique in association with
Etablissement Français de Greffes.

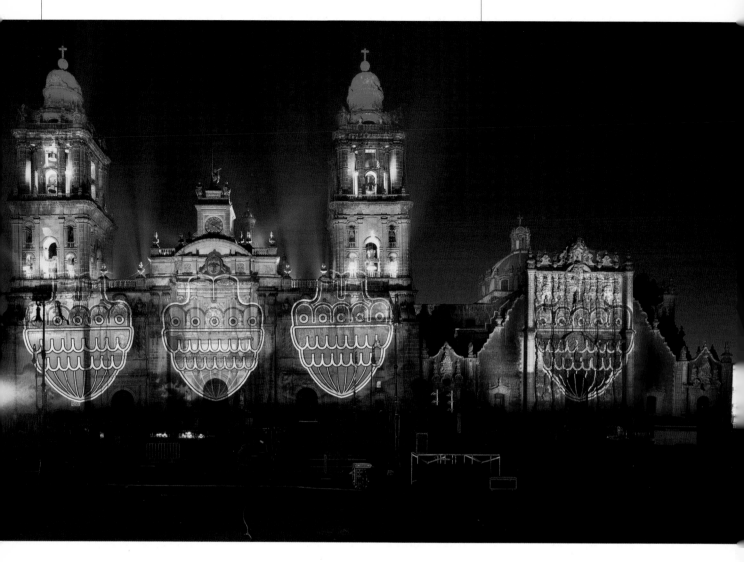

ENGAGMENTS: SITES OF LEARNING

The Ortas' strategies for making art create networks of activity between people and places and necessitate connections that become local operations in a global context. They create opportunities to reflect upon and challenge national agendas. The practices that have been developed through the workshops and projects are situational and relational within a social continuum. Engaging with people through workshops and projects remains the underlying mechanism by which the work is produced, be it sculpture, installation, intervention or event. Their studio functions collectively and as such the work that is produced is that of the collective intelligence rather than that of the autonomous artist. It is important, however, to recognise the experience that each of the two artists brings to these engagements; they provide the framework within which the work happens, and they have developed a vocabulary, a set of procedures and processes that allow individuals to gain the language and skills they need to express their individuality in creative terms. Crucially, Lucy Orta brings her skills as an artist, designer, communicator and academic to consolidate collaborative efforts and bring the individual parts of the works together as a coherent final project. The toolbox for interaction that has been developed can be thought of as a prototype for exchange and cooperation. Taking this approach further

TOP:
Opéra.tion Nexo Corazòn V, Zocàlo Mexico City
2001 / Light-based work and collaboration with composer Pierre Henry to close the Festival del Centro Histórico, Mexico.

OPPOSITE:
Opéra.tion Life Nexus IX, Place Stanislas Nancy
2003 / Light-based work and collaboration with composer Pierre Henry to inaugurate the fourteenth *World Transplant Games* in Nancy, France.

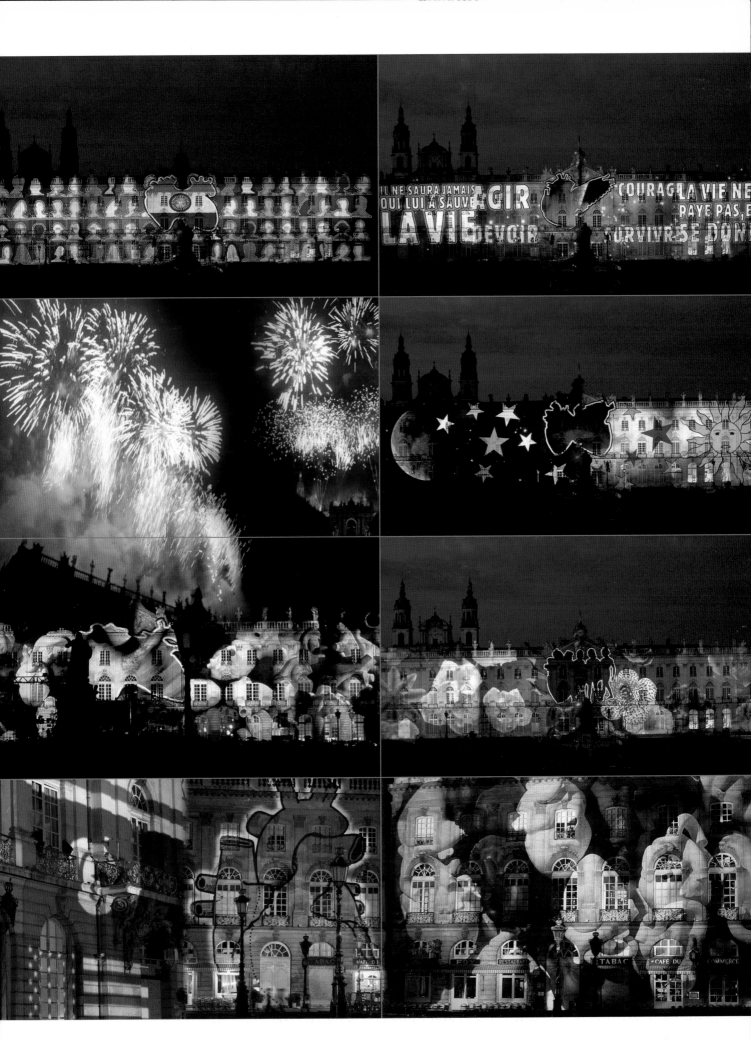

through the development of blueprints, patterns and templates that can be adopted and adapted by others remotely, the Ortas' extend the possible reach of their method, and make possible the participation of people all over the world. Jorge Orta brings his training as an artist, architect, urbanist and pedagogue to devise long-term strategies, draw up complex structural plans and put into motion a scientific analytical model of art making as an objective of research.

Lucy + Jorge Orta have their roots in the thinking and the politics of the 1970s and 80s but reinvent and build upon those practices and principles based on the changing political climate. The projects they have developed propose a model of participation that does not offer solutions, but rather provokes a discussion that holds with it the possibility of open-ended reflection. In order to further explore the influences and historical context from which the work has grown, and to understand the value of this work and its place in a wider cultural economy, it is important to be able to locate it across disciplines and histories. The 1970s were a key moment in terms of community and public art practices, set against strong social movements associated with feminism, pedagogy and social architecture. The politics of collaboration and cultural democracy that characterised this era underpinned the development of practices and strategies developed by artists to embed art at the heart of society.[4]

Social and political change, as well as the ability to reinvent and produce modes of expression and contemporary cultural forms are central to the development of educational models and philosophies. Artist studios and art schools have played a crucial role in the evolution of art, design, architecture and culture and—as sites of learning—they are the point at which change can be provoked. Independent models of schools—from the Bauhaus to Black Mountain College and the Frankfurt School— have produced some of the most exciting and radical cultural possibilities in the creative realm. Artists and pedagogues have developed these contingent sites of learning, leading to the development of hubs of creative activity with extraordinary legacies that pulse through the Ortas' work. More recently many small self-organised models or residency programmes and arts schools have been developed including Michelangelo Pistoletto's Cittadellarte, The Mountain School of the Arts and international residency programmes all over the globe. This tendency towards self-organisation emerges at a point where technology collapses geography and new modes of production and distribution are sites in which artists are developing practices that are transactional and collectively negotiated. There is a shift in how artists are defining the value of their work and the mechanisms by which it is produced. Resulting in a bigger cultural move towards participation and reciprocity as the modes of distribution are becoming more democratic. This re-orientation challenges dominant models of art making, rendering them increasingly participatory and communal.

Cittadellarte–Fondazione Pistoletto
Cittadellarte is located within a late nineteenth century disused Italian textile mill in the middle of Biella's historical textile district. Founded in 1998 by the artist Michelangelo Pistoletto, the site is now an artistic laboratory. The name incorporates two meanings: 'citadel', a protected and defended area where artistic projects can be nurtured and developed; 'city', suggesting openness and complex interrelations with the world. http://www.cittadellarte.it

[4] Owen, Kelly, *Manifesto for Community Arts* (Speech) London, 1984.

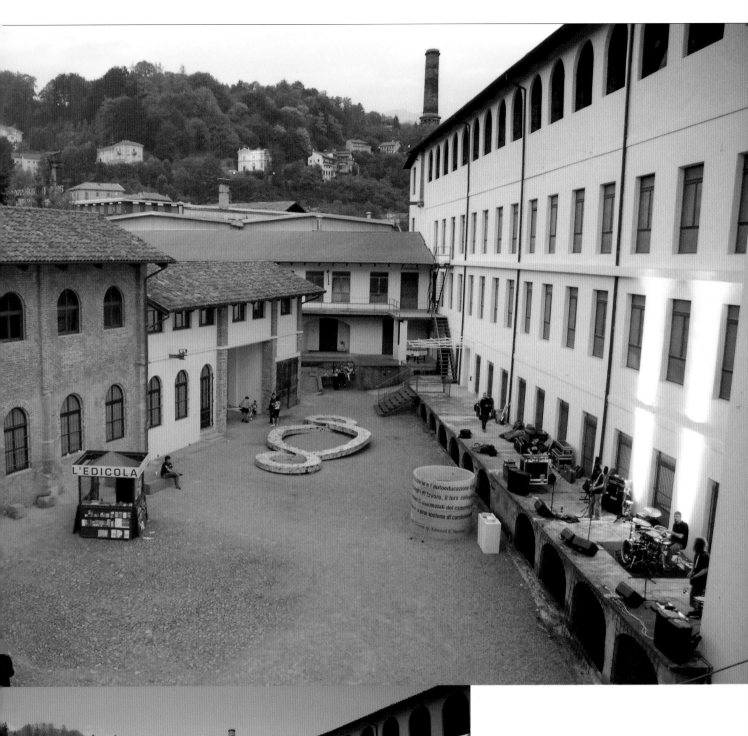

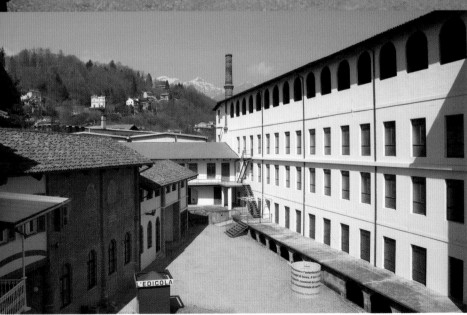

The Dairy (La Laiterie Moderne), established by Lucy + Jorge Orta in 2000, is a site where these emerging realities can be tested and produced and where Studio Orta can reflect upon and develop projects and practices that have evolved throughout their careers. It is a renovated dairy, indeed the first industrial or 'modern' dairy in the Brie region of France and has since played host to artist's residencies, exhibitions and will be a base and focal point for the Ortas' upcoming projects. Similarly, the *Fluid Architecture* website http://www.fluidarchitecture.net/ takes the idea of reach further. Developed in 2002, it functions as an online platform on which the processes of collaboration and the products of the projects are represented and discussed in a forum situation. The virtual space is both democratic and modifiable and becomes a mutable arena for the construction of ideas and networks. The space operates as a nexus in which people can collaborate and reflect upon their experiences of participation from locations all over the world. Socio-political and geographical boundaries are collapsed and direct participation is possible—virtually and remotely—thus extending the reach, temporality and the impact of the projects.

Joseph Beuys' asserted that "everyone is an artist", meaning that architects, philosophers and pedagogues were developing models of agency and social and cultural democracy in the same fashion as fine artists. Architects such as Buckminster Fuller, Cedric Price, Archigram and Yona Friedman developed architectures of negotiation and structures where interaction and social engineering were the prime objective. For example, Price's notional Fun Palace structure proposed a creative and experiential space that stretched beyond the boundaries of architecture.

> The significance of the Fun Palace was in its idea on hardware whereby architecture became something to sustain and respond to ever uncertain circumstances. Yet from the very beginning there was also a social activist edge to Price's wanting to force this hardware into the community to simulate the cycle of everyday life and spark events.[5]

Concurrently, critical pedagogy emerged from a long history of radical social thought and progressive educational movements that aspired to link schooling to democratic principles of society and transformative social action. Henry Giroux along with Paolo Freire and Ivan Illich were driving forces in the reinvention of educational principles and the progressive notion of democratic schooling. According to Freire it is the possibility of agency and dialogue that drives learning.

"Knowledge emerges only through invention and reinvention, through the restless impatient continuing, hopeful enquiry (we) pursue in the world, and with each other."[6]

Critical pedagogy is committed to the development of a culture of education that supports the empowerment of culturally and economically marginalised people. By doing so this perspective seeks to help to transform learning

[5] Arata Isozaki, *Re: CP*, by Cedric Price, Ed Hans Ulrich Obrist, Switzerland: Birkhauser, 2003, p. 53.
[6] Freire, Paulo, *Pedagogy of the Oppressed*, trans. Myra Bergman Ramos, New York: The Conntinuum International Publishing Group Inc, 1970, p. 52.

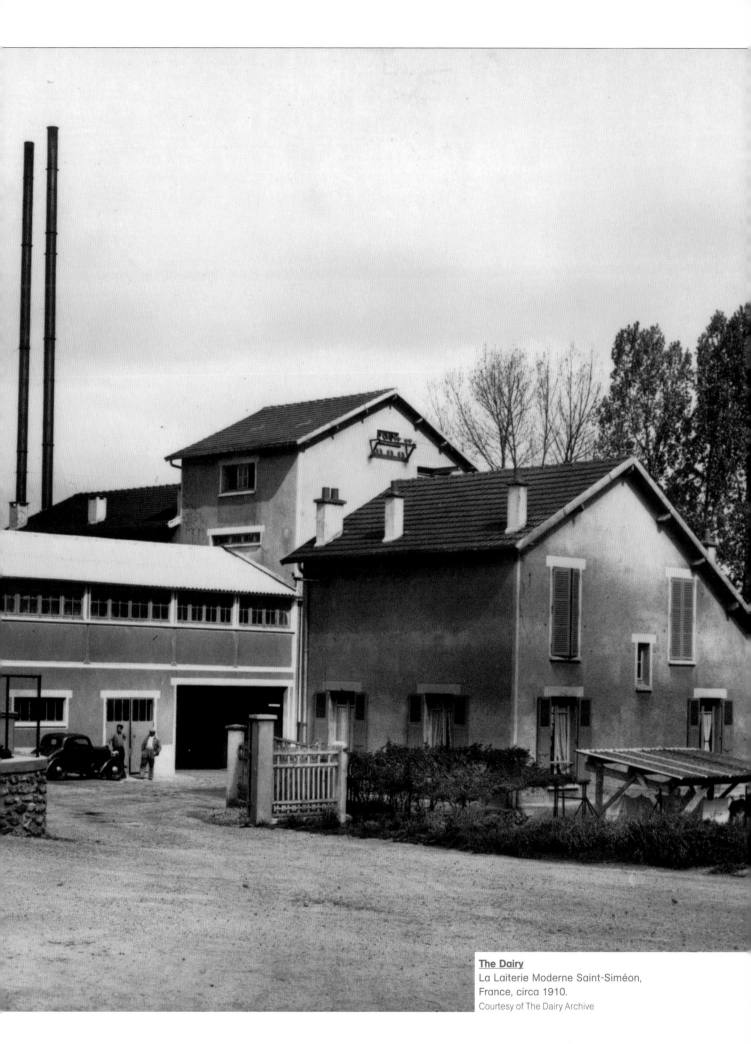

The Dairy
La Laiterie Moderne Saint-Siméon,
France, circa 1910.
Courtesy of The Dairy Archive

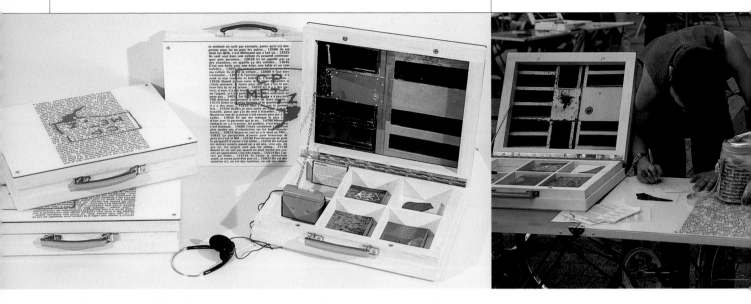

structures and practices that perpetuate undemocratic principles by supporting the development of a culture of participation and agency. Creativity and art play a crucial role in this empowerment and in shaping the histories and socio-economic realities that give meaning to how people can define and express their everyday lives.

The idea of empowerment through engagement is an inherently educational concept and along with the question of citizenship it is key to the people that Lucy + Jorge Orta choose to collaborate with. They have opted to focus on socially marginalised groups with an approach that responds to social issues. Lucy + Jorge Orta have worked with individuals who are homeless, refugees, prisoners, adolescents, craftsman, architects, fashion designers, politicians, chefs, scientists and environmentalists, collaborating with partners as wide-ranging as the Salvation Army, Emmaüs, UNESCO, the Red Cross, prisons, universities and schools. This web of dialogue and network of thinking produces challenging and discursive works that take social change as the basis for all aspects of artistic production, indeed the social architecture and relational aspects of the projects are as important as the work produced. Opening up and mediating this process to a secondary audience is a process of translation, and a challenge for the institutions that present the Ortas' work. This tension is one of the most interesting dilemmas of the artwork. It is not possible to read the Ortas' work without also understanding the means of its production and the context through which it is produced. This is a complex challenge for the art market and one which offers a critique of consumption and sites of distribution offered by museums, galleries and international exhibitions. In a climate where contemporary art has been disconnected from society, the foregrounding of processes of participation, reciprocity and negotiation poses challenges to locating the work in relation to aesthetics, and demands what Declan McGonagle cites as the fourth dimension:

> The four dimensional model of practice, which I am recommending, as a way of thinking and doing, does not replace or erase other models. It 'houses' a social continuum and also reconnects art aesthetic and ethical responsibilities. That seems to me to be the crucial task, in striking a 'new deal' between arts and society, which dynamics of negotiation and the idea of artist and negotiator serve.[7]

[7] McGonagle, Declan, *Art and the Public Realm*, (conference) Serpentine Gallery, 2003.

LEFT TO RIGHT:
Commune Communicate—19 Doors Dialogue Unit
1996 / Wood, laminated C-print, bromure, walkman, audio recording, four sets of postcards, silk screen print, leather handle / 50x40x10cm (each).
Commune Communicate—Action
1996 / Action in Metz City Centre, France.

Commune Communicate–Messages
1996 / 109 postcards with hand-written
messages for the inmates of CP (Metz
Detention Centre).

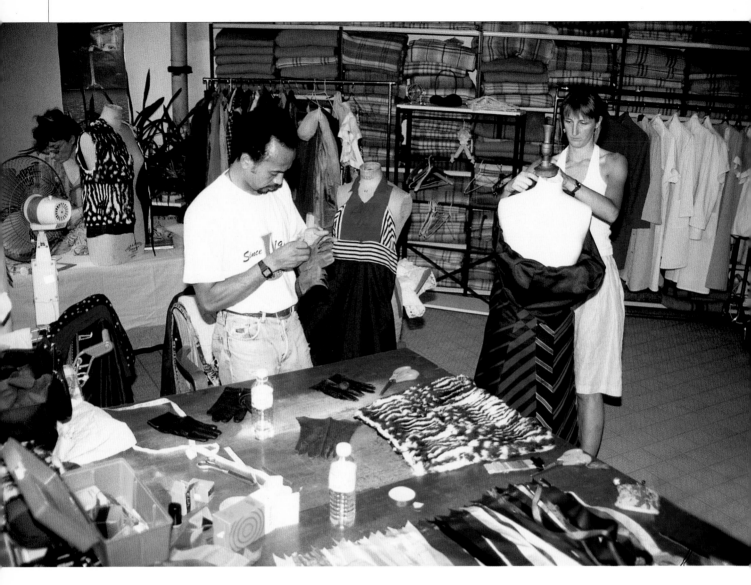

This fourth dimension is evident in projects such as the *Identity + Refuge*, 1993–1996, which consisted of workshops organised at Le Cité de Refuge, Salvation Army in Paris and then in New York at Deitch Projects for the exhibition *Shopping*, 1996. This body of work explores the relationship between clothing, architecture, function, adaptation and fashion. Orta collaborated with residents and visitors at the Salvation Army hostel to make garments out of donated and discarded clothing. Using belts, ties and zips, participants made new items, giving this 'refuse' a new function while developing the skills of the participants. The action had the additional effect of transforming the donated clothing into one-off desirable objects, imbuing them with a new value. The conceptual motive of the work was to empower marginalised people to open up their opportunities through the development of new skills, whilst engaging a hostile fashion institution in a process of entrepreneurial reinvigoration and communication, pioneering the social enterprises that later developed in Northern Europe and Australia in the late 1990s. Through making clothes which were to be seen on a fashion catwalk, and which were transformed through newly acquired skills gained from the workshops, individuals were able to gain visibility and confidence. By being defined as designers the metaphor of the recombinant clothing also extends to the recombinant identities of the participants.

TOP
Identity + Refuge I–Pilot Social Enterprise
1995 / Salvation Army, Cité de Refuge, Paris.

20

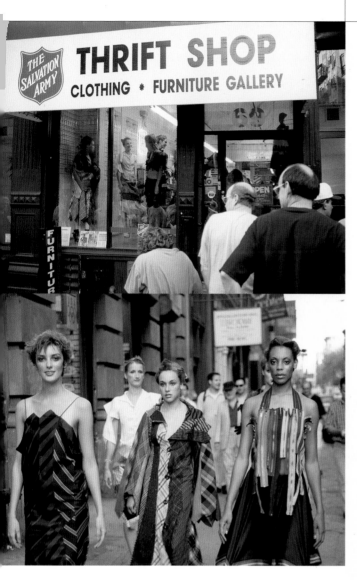

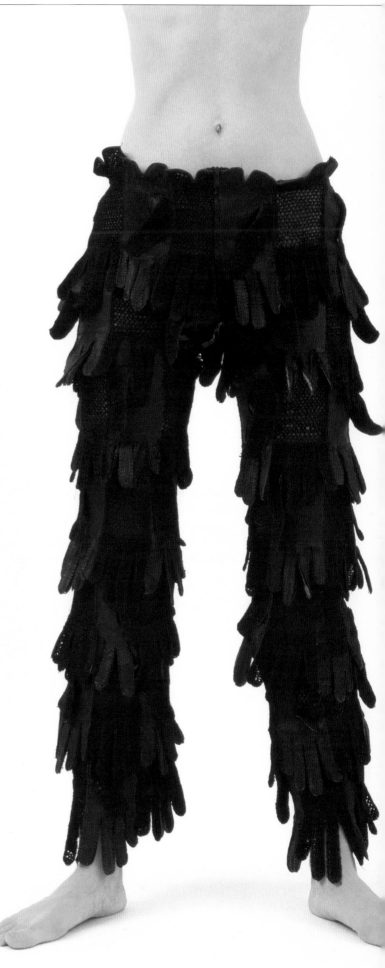

TOP AND BOTTOM:
Identity + Refuge II–Experimental Catwalk
1996 / Salvation Army, Spring Street to
Dietch Projects, New York.

RIGHT:
Identity + Refuge–Hipster pant
1995 / 36 pairs of black leather gloves
/ 95x65cm.

In these situations Lucy + Jorge Orta are both facilitators and collaborators. These works could not exist without the collaboration of the participants, but the artists create the necessary frameworks that make this co-creation possible. This interdependency is often evaluated as a benign and philanthropic relationship on the part of the artist, however in this case both parties benefit; each is able to participate in the creation of something unique and each gains something different. For the participants it is sociality and visibility, and the artists acquire the possibility of creating new cultural forms out of dialogue, and develop a practice that is constantly challenged and reinvented through the reflections and contributions of others.

The workshops are a laboratory in which strategies and vocabularies have been developed. The methodologies that have been formulated and the results have enormous pedagogic potential that can extend the projects further into the social sphere, as well as being seen both as advocacy and art. Workshops in Melbourne, London, France and the across the United States have been prompted by the various projects instigated by Lucy + Jorge Orta. Stemming from the artists ten-year research project *OrtaWater* and presented for the first time at the exhibition *Drink Water* at the Fondazione Bevilacqua La Masa in Venice, the metaphor of water was used as a starting point for a series of research forums. Firstly situated at Fabrica Centre for Research in Trevisio, then the Dairy, students from Fabrica, University of the Arts, Delft University, William de Kooning Academy and the Design Academy Eindhoven researched the purification, treatment and distribution of water, and sketched up initiatives for clean water projects in three communities within developing countries. The political and economic implications of water are pressing global and ecological issues and the question of what art and artists can do to affect change is posed by the artistic treatment of a traditionally political issue. The production of works which take the form of kits, prototypes and emergency aid resources cleaves the artworks from the traditional policies of fine art, and opens up the discussion to other branches of cultural and social production.

"(Lucy Orta's) works are poetic and aesthetic responses to the emergencies that our society is facing with diverse gradations of complicity."[8]

[8] Pinto, Roberto, "Collective Intelligence: The Work of Lucy Orta", *Lucy Orta*, London: Phaidon 2003, p. 75.

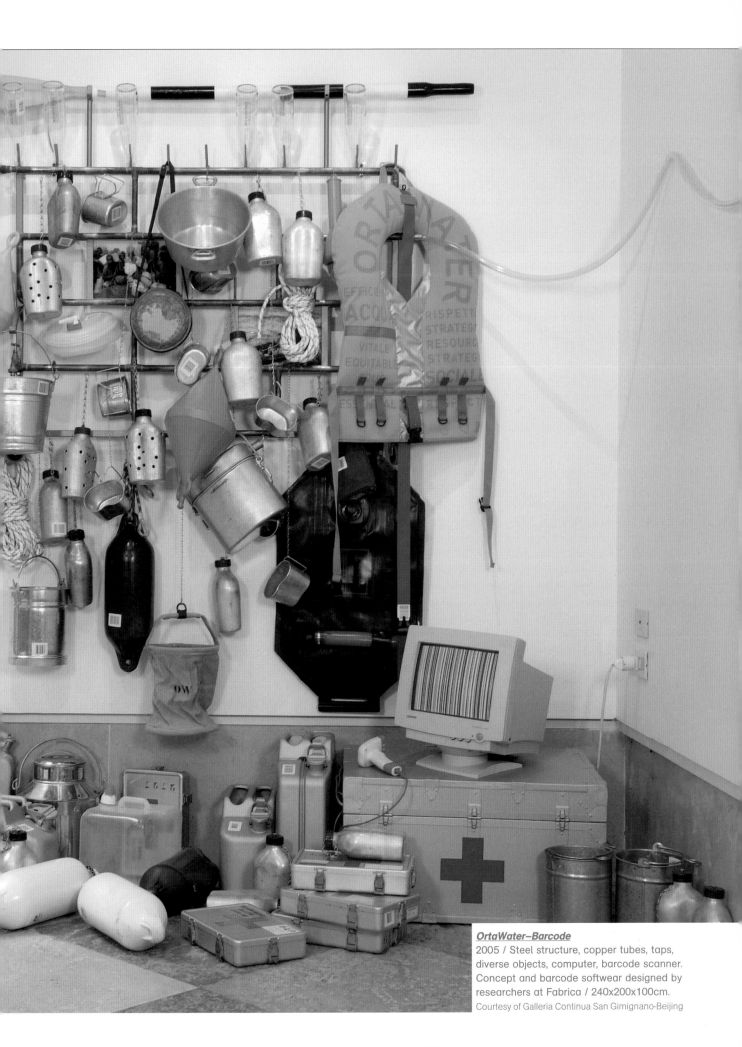

OrtaWater–Barcode
2005 / Steel structure, copper tubes, taps,
diverse objects, computer, barcode scanner.
Concept and barcode softwear designed by
researchers at Fabrica / 240x200x100cm.
Courtesy of Galleria Continua San Gimignano-Beijing

Section B
Architecture

Architecture plays an important role in the Ortas' work. The conflation of fashion and architecture and exploration of mobility and functionality in relation to clothing, dwelling and shelter reflect on social and political concerns. *Refuge Wear* is an early example of portable architectural work, employing utilitarian textiles, fabrics and fibres to construct modules that are both protective clothing and architectural constructs. The work occupies a territory somewhere between portable housing and fashion design, and gestures to issues surrounding homelessness, refugee culture and the, often ambivalent, fashion industry. Taking the body as the critical location of the work, individuals are invited to participate in the modification and adaptation of habitats and transform them into individualised units. As well as considering these as prototypes, which could be adapted for use in urban and emergency situations, they operate as reminders and poignant symbols of society and community. The emphasis of the relationship between the individual, and the social body through the construction of a mediating architectural membrane, offers the possibility of visibility to often overlooked and marginalised individuals and groups. Some versions of *Refuge Wear* have sub-titles, which suggest the situations and contexts that they respond to: *Survival Sac with Water Reserve:* in response to the crisis in Rwanda, *Mobile Cocoon:* devised after workshops with the homeless. Each unit has pockets internally and externally and often has slogans and words printed on it that speak of the experience of homelessness or refuge, functioning as a symbolic bridge between social issues and fashion.

In *Nexus Architecture,* the individual is represented within the collective. Social relations are explored and individuals are woven together within a matrix of relationships and dependencies. In *Nexus Architecture* each individual wears a unifying industrial-like uniform, which is connected to at least one other person. The physical connection of participants mirrors the social networks and communities that connect people, such as common experience, shared beliefs, discrimination or sexuality. The physical manifestations of these social architectures speak of the potential of collective social action and community. The performative aspect of the work ensures that it is continually reinvented and transformed in situ. It has been manifest many times, and chains as well as webs of people have occupied and rearticulated the nexus in contexts worldwide. The momentary occupation and procession through public space in this way is reminiscent of the language of protest. The uniformity employed also draws on the form of the parade, which is often a civic display of military presence. This formalism is appropriated by the Ortas and becomes a demonstration of the potential of a social or civilian collectivity.

Collective Dwelling and *Connector* are collaborative projects in which participants devise complex temporary architectural structures. Through workshops collaborators create designs which encorporate individual needs and desires. Prior to the workshops they are asked to think about architecture, tent structures, notions of community and mobile habitats, as well as social structures and the collective

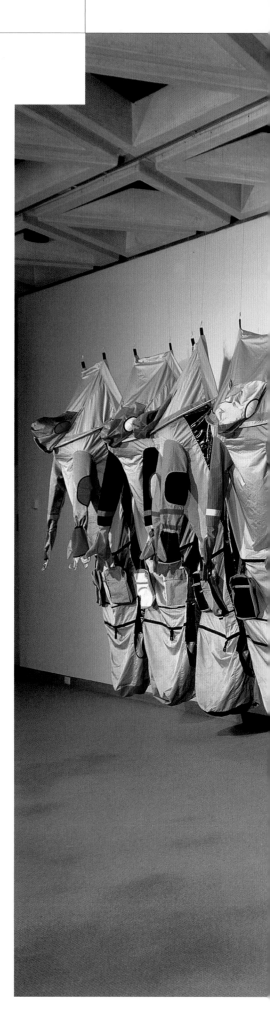

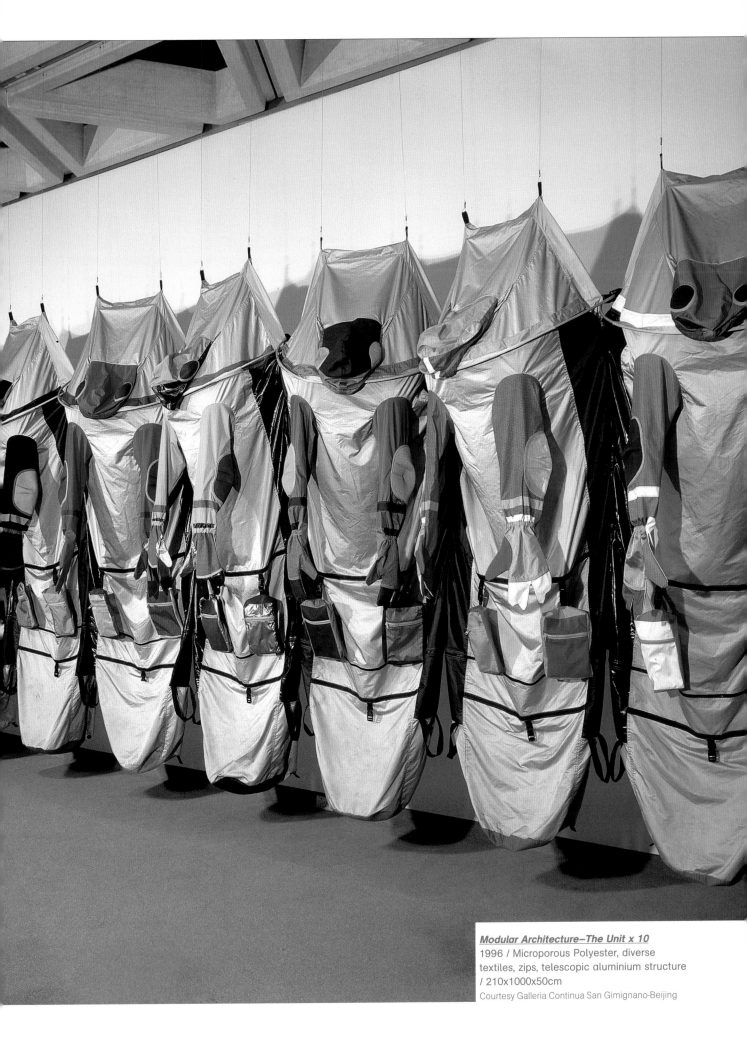

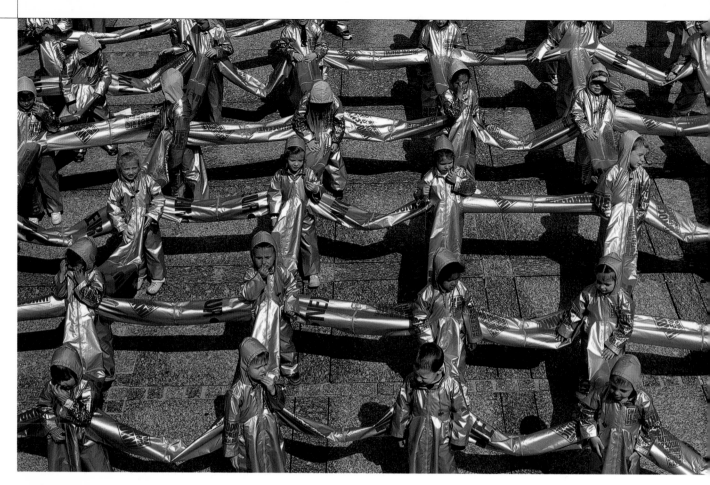

body. Once the workshops begin, participants are introduced to design methods and through the language of kits, luggage, clothing and mobile architecture, they develop designs which reflect individual identities and operate within the logic of a collective. The Studio Orta team then translate the designs into full-scale models, which become something like composite architecture. The role of the artist in this process is crucial, working both as a facilitator in the early stages and also as an artist bringing the individual elements together in the final work. This process ensures that there is coherence in the work produced, and necessitates the skilled contribution of the artist. It is important to note that this would not be possible without both the collaboration of the individual participants and the intervention of the artist. The symbiotic axis in the work is critical since it allows the work to occupy the complex territory of process- and product-oriented work simultaneously; a territory that many artists have found difficult to confront and complex to embrace.

The strategies employed by Lucy + Jorge Orta circumvent the dogmas and orthodoxies of exhibition-making and tackle the world as a social and political place in which to produce artwork. By working through collaboration and developing modes of participation that create interdependencies and possibilities for the collective to produce diffuse works, they have developed a unique vocabulary of production. Rather than directly negate the issue of authorship they act more like producers and directors with an artistic vision that requires the skilled contribution of many other people. Together they produce a coherence that can move across disciplines and audiences through events,

Nexus Architecture x 110–Cholet
2002 / Intervention with 110 children and their families in the town of Cholet, France.

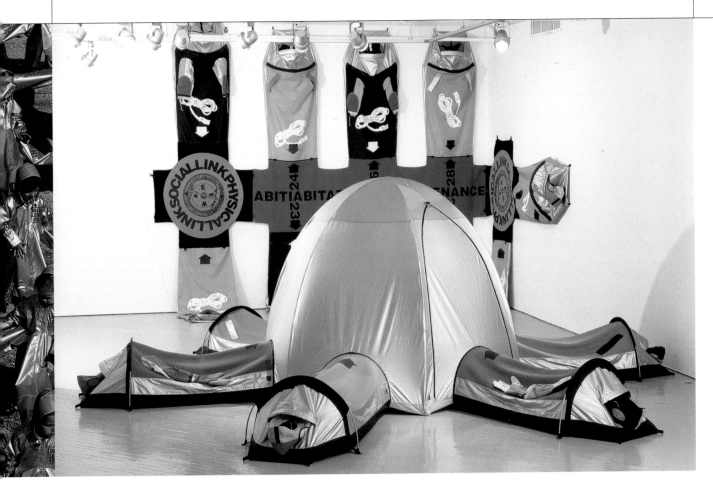

exhibitions, interventions and provocations. Establishing a template and
format for this pedagogical approach enables the work to become more
widely disseminated as a set of principles for interaction and production.
By adapting the idea of the studio and school through the Dairy, the websites
http://www.studio-orta.com/dform_project/ or http://www.fluidarchitecture.net/
and, the development of educational tools such as the pioneering industrial
design Masters in Man + Humanity at the Design Academy Eindhoven in the
Netherlands, the potential for social and artistic transformation is enormously
enhanced. The perpetual reinvention of the Ortas' work through increased
participation will ensure it can avoid the pitfalls of becoming formulaic and
stagnant and will instead be in a constant state of experiment and renewal.

Connector Mobile Village and Body
Architecture–Foyer D
2001–2002 / Installation at The Fabric
Workshop, Philadelphia, USA
/ 900x200x260cm.
Private collection Brussels

Pattern Book

30 The Gift

50 Connector

64 Dwelling

80 OrtaWater

94 Nexus

The Gift

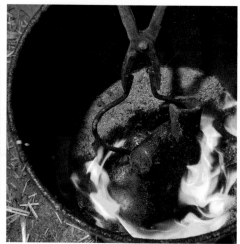

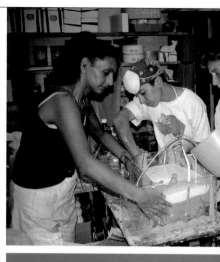

Cheniers
2004 / Co-creation workshop with
Alain Gaudebert, Raku artist and
Alicia Ascheri at La Tuilerie de
Cheniers, France.

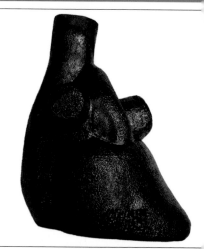

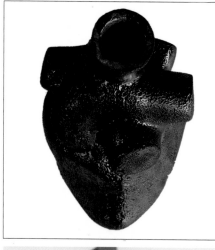

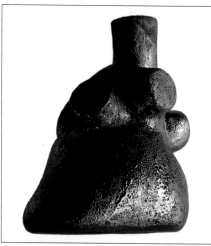

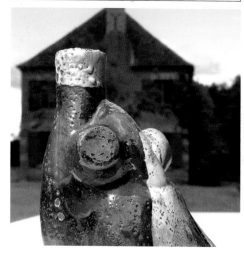

process

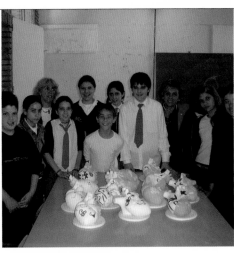

Argentina
2000–2002 / Workshops in
collaboration with Alicia Ascheri
and the Colegio Rosario, Argentina.

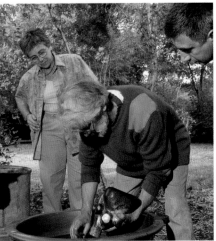

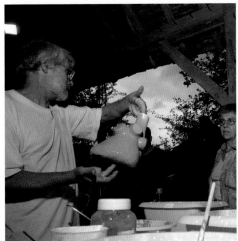

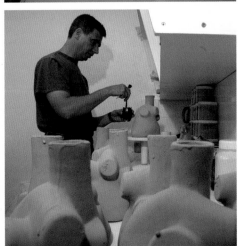

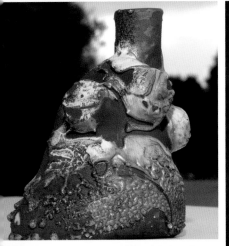

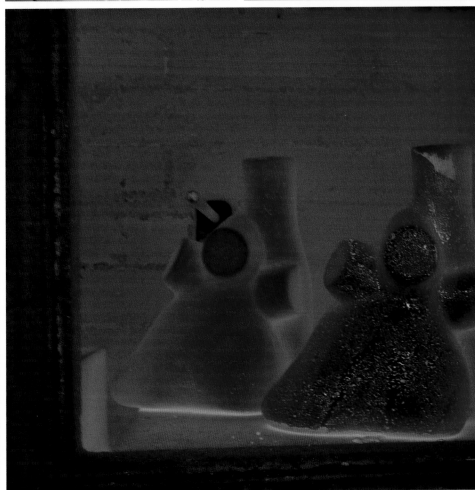

The Gift

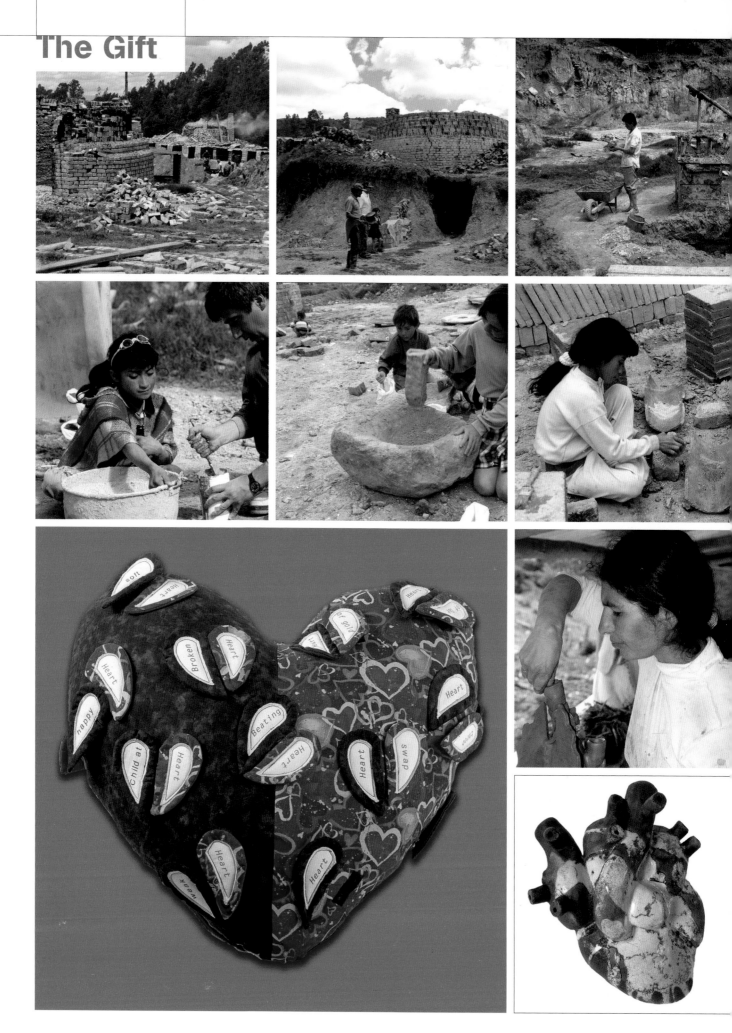

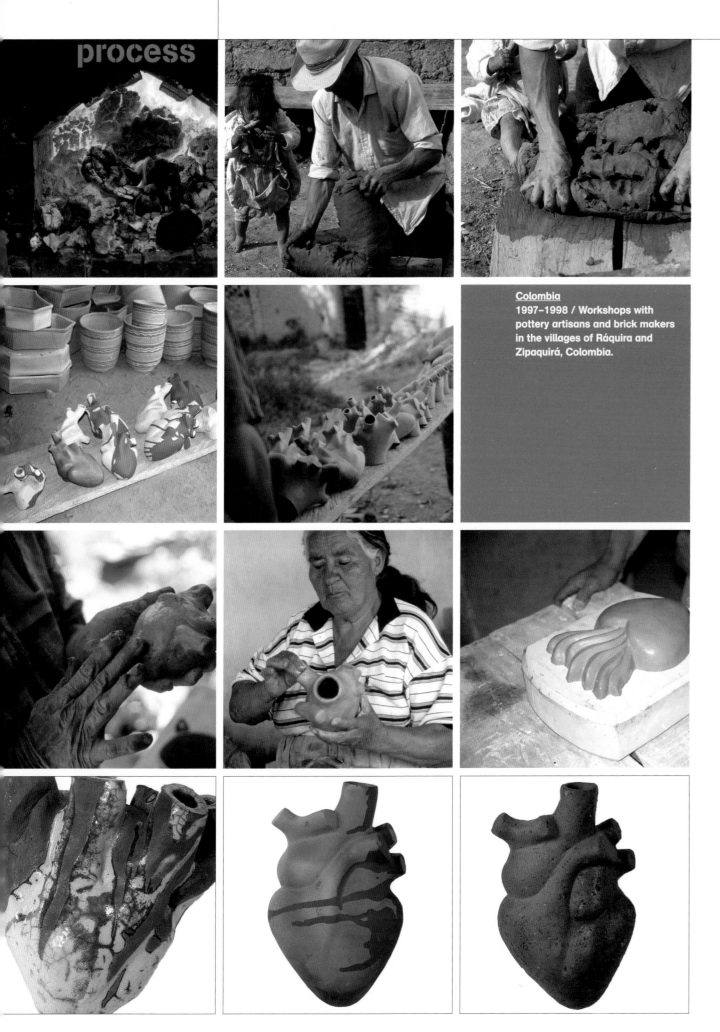

process

Colombia
1997–1998 / Workshops with pottery artisans and brick makers in the villages of Ráquira and Zipaquirá, Colombia.

The Gift

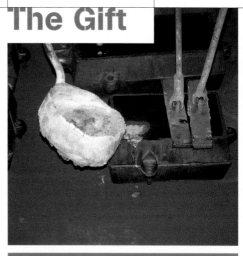

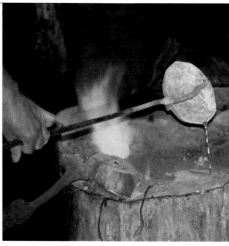

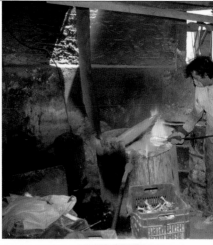

Greece
1997–1998 / Workshops with local artisans working with terracota and recycled aluminium in Athens, Greece.

ΑΝΑΣΤΑΣΙΑ

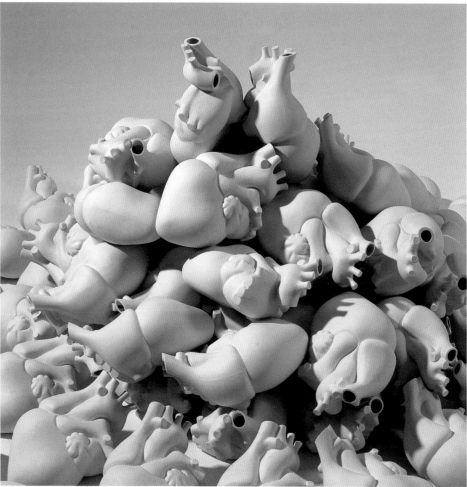

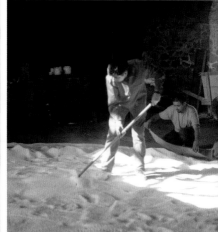

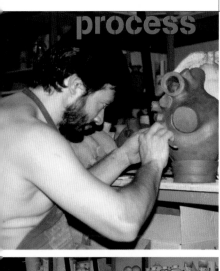

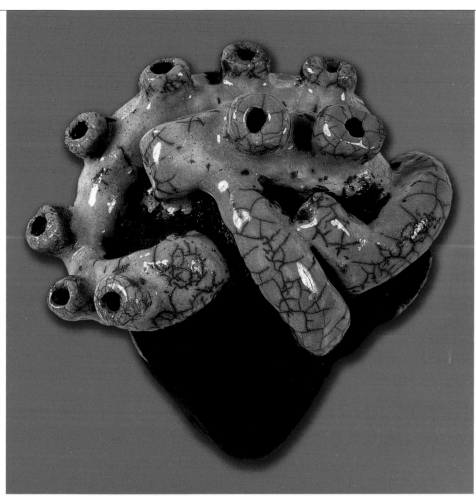

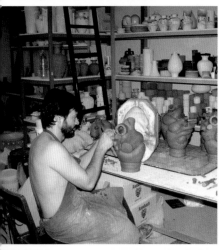

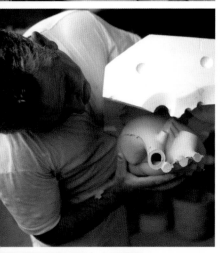

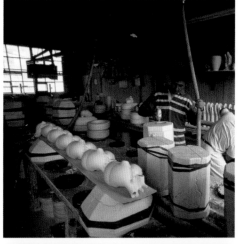

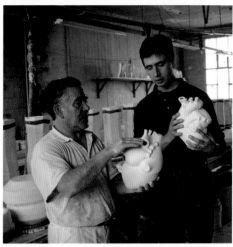

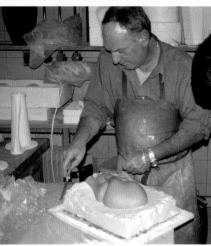

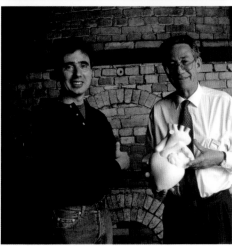

Limoges
1996–1997 / Workshop with the Royal Limoges craftsmen and edition of 100 biscuit-fired porcelain hearts.

The Gift

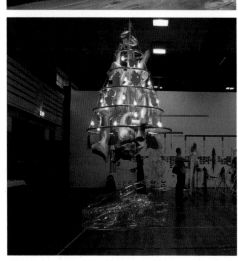

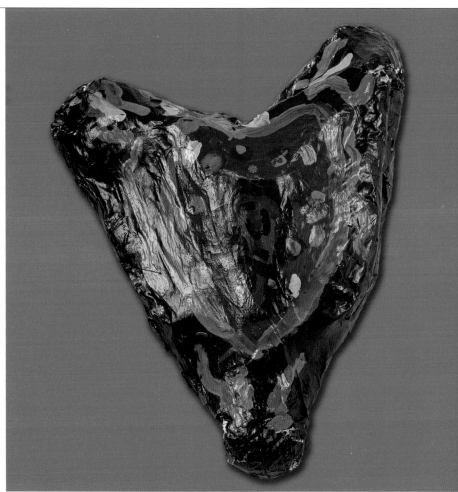

Melbourne
2002 / *Fluid Architecture*,
a four-week experimental drop-in
workshop with local residents and
RMIT art school in the City of
Melbourne. Curated by Jane
Crawley. Co-creation of papier-
maché hearts for *Arbour Vitae*;
Heart Wear and *Heart House*,
Melbourne, Australia.

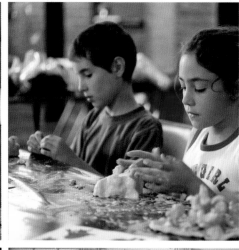

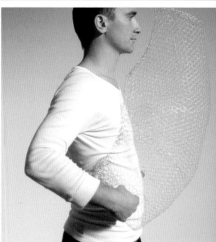

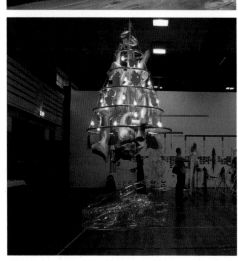

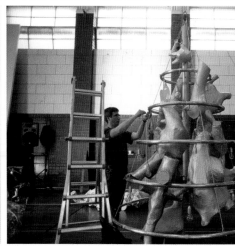

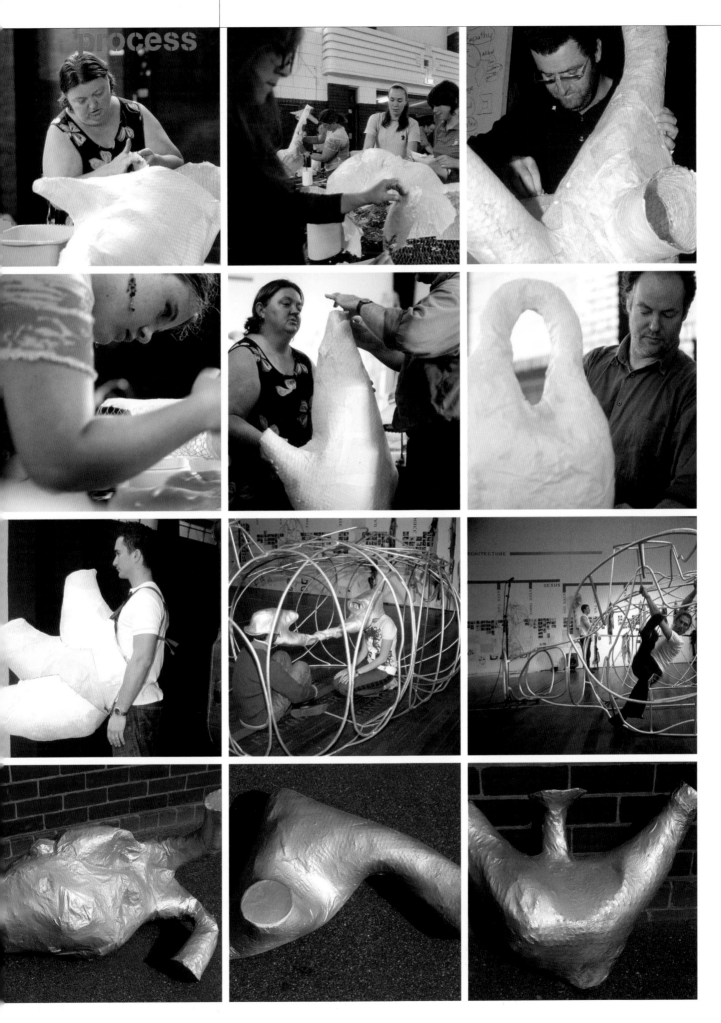

The Gift

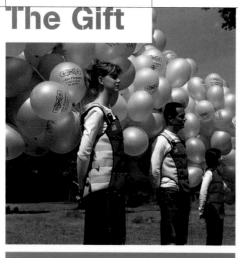
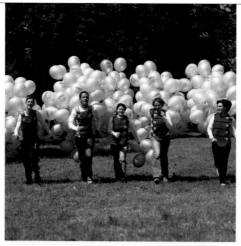
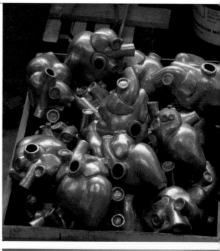

Nancy

2002–2004 / Workshops with 35,000 students from Meurthe-et-Moselle county high schools to elaborate the *Universal Declaration Gift of Heart*. Research and production of the public sculpture *Le Coeur du Grand Nancy*, France.

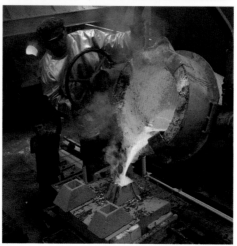

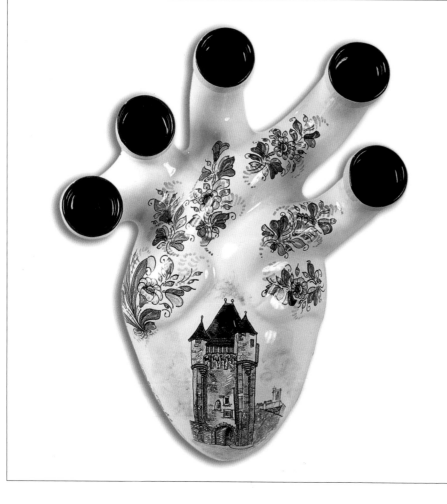

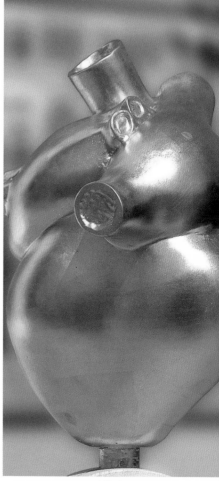

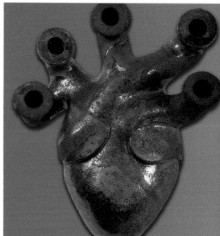

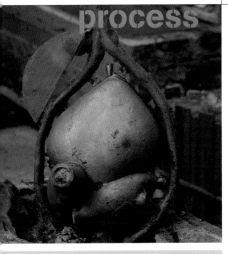

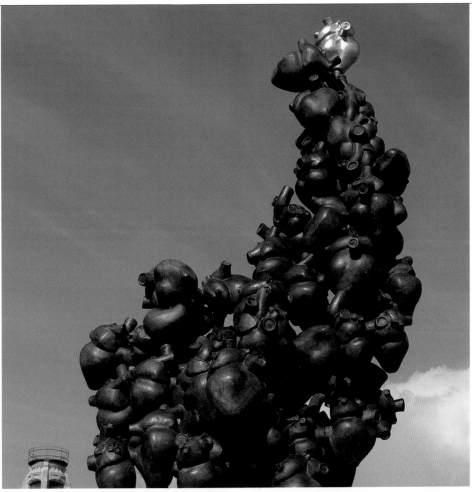

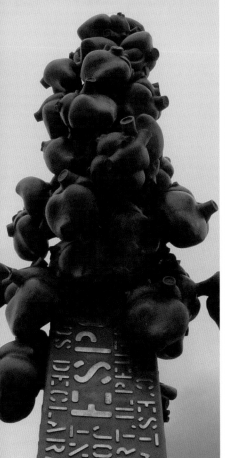

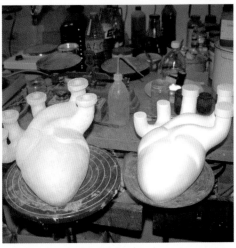

Nevers
1999–2000 / Workshop with
'faienciers d'art' from the town of
Nevers, France.

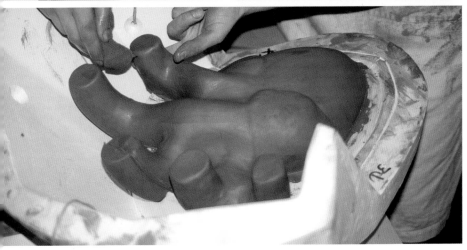

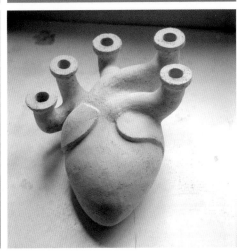

The Gift

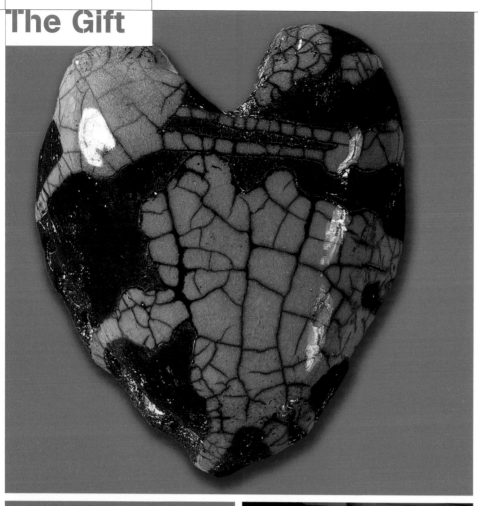

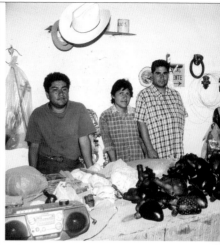

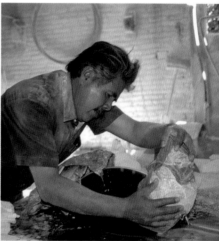

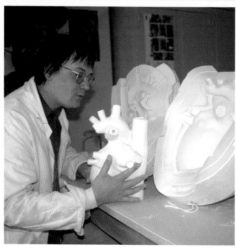

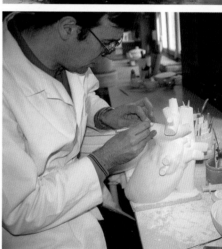

Sèvres
2000 / Workshop with the craftsmen at Manifacture Royal de Sèvres. Creation of ten Sèvres porcelain hearts using different glaze techniques, France.

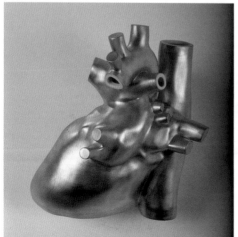

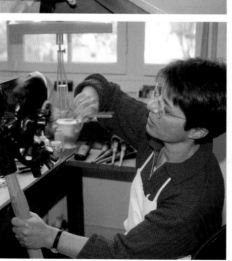

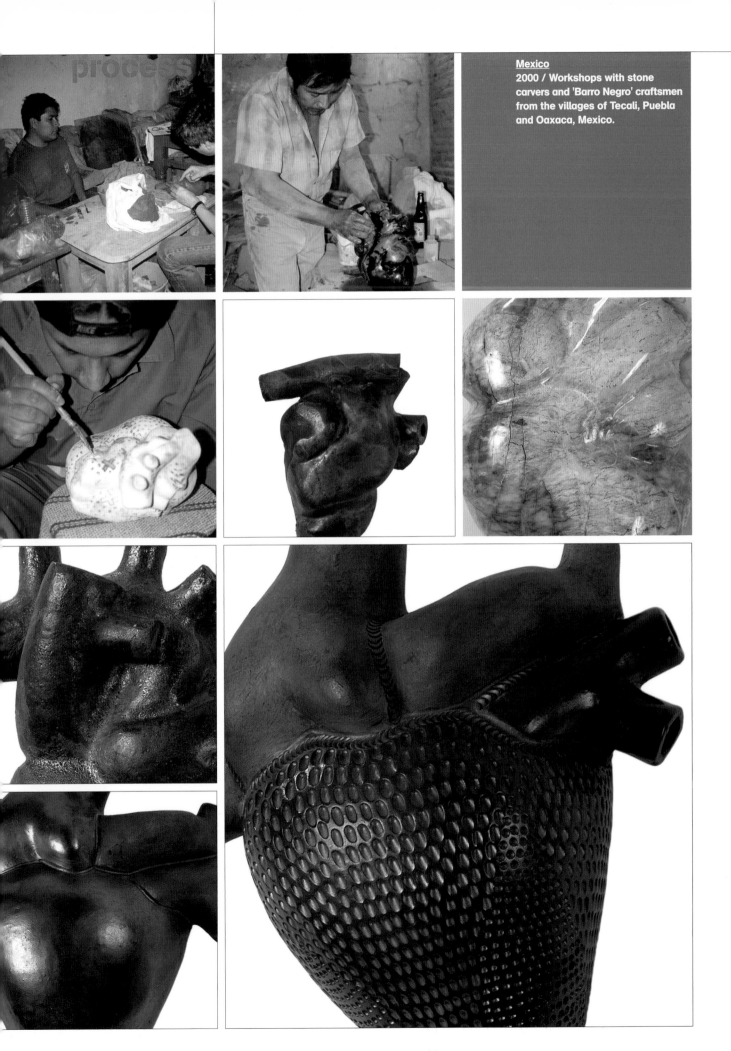

process

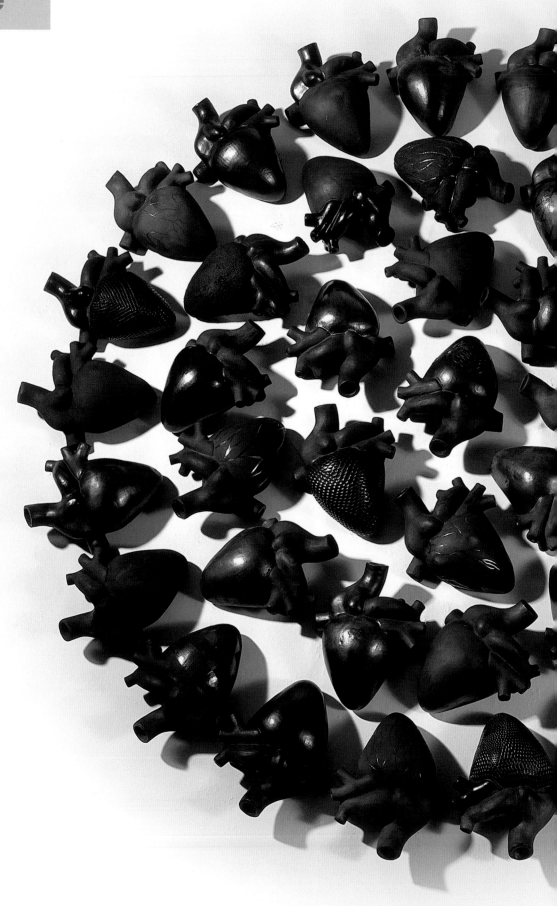

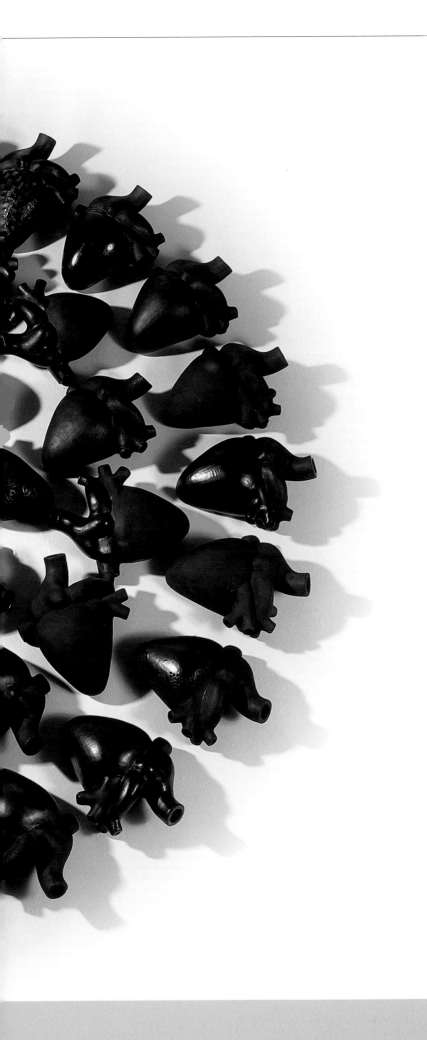

Life Nexus—The Gift
2002 / Composition, 44 Barro Negro hearts
from Oaxaca Mexico / approx. 150x150cm.

The Gift Outcome

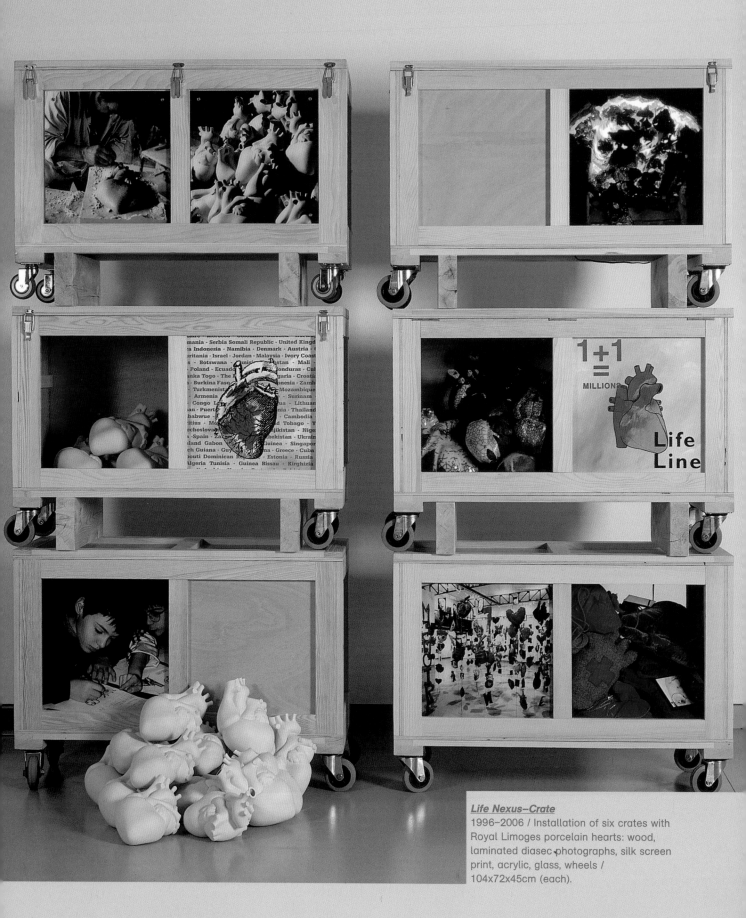

Life Nexus–Crate
1996–2006 / Installation of six crates with
Royal Limoges porcelain hearts: wood,
laminated diasec photographs, silk screen
print, acrylic, glass, wheels /
104x72x45cm (each).

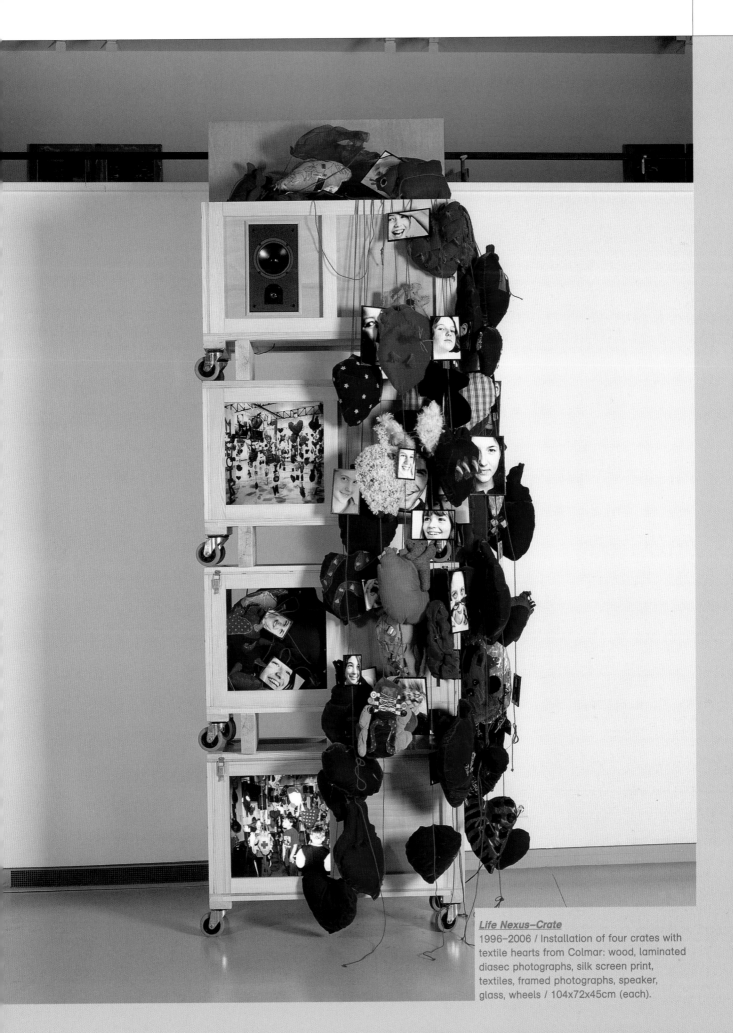

Life Nexus–Crate

1996–2006 / Installation of four crates with textile hearts from Colmar: wood, laminated diasec photographs, silk screen print, textiles, framed photographs, speaker, glass, wheels / 104x72x45cm (each).

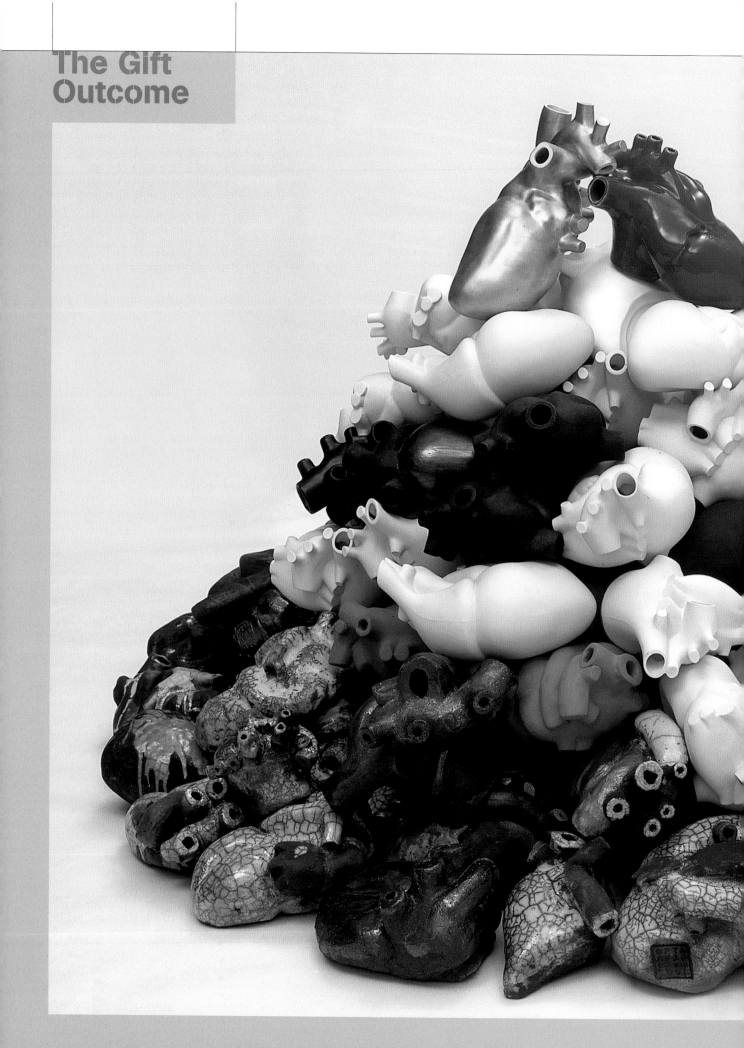

Life Nexus—The Gift
2006 / Installation with hearts from Sèvres,
Limoges, Cheniers, Athens, Mexico / approx.
150x150x90cm.

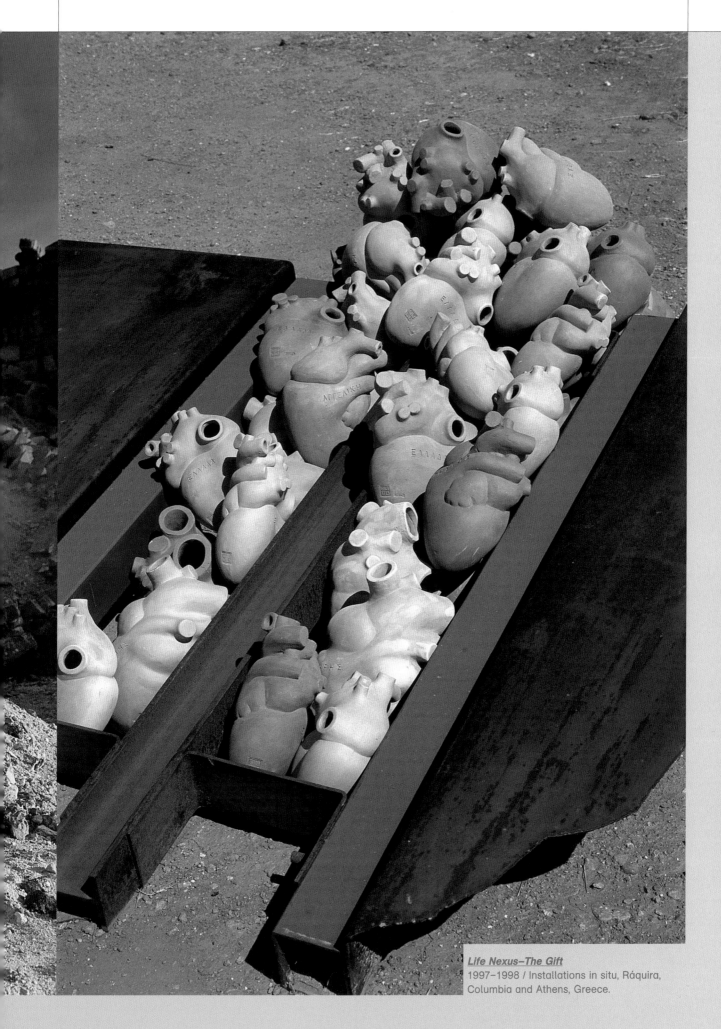

Life Nexus—The Gift
1997–1998 / Installations in situ, Ráquira,
Columbia and Athens, Greece.

Connector

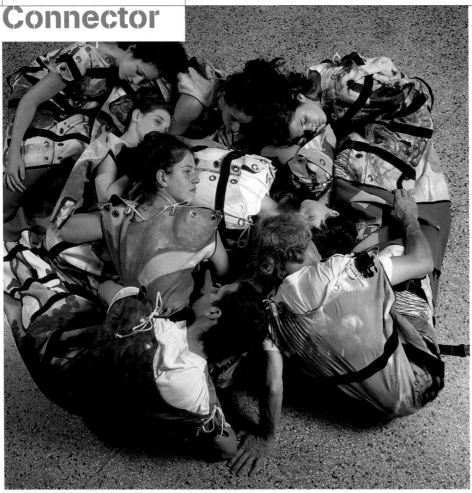

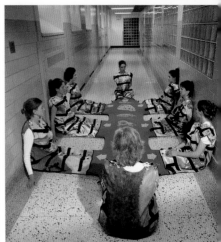

**Connector Mobile Village**
2000–2004 / Workshop with Lycée
de la Mode Cholet, France.
Computer renders and drawings.

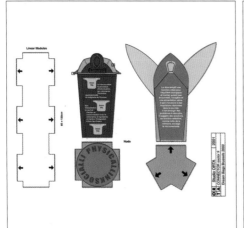

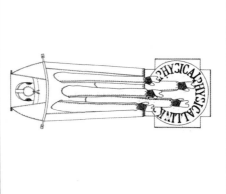

process

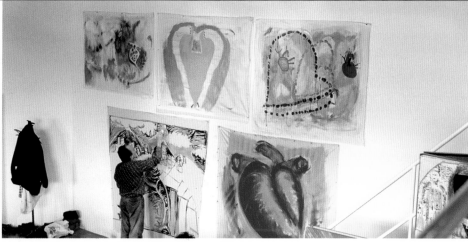

Connector Mobile Village III–
Robert Giffard Psychiatric Hospital
2000–2002 / Workshop with Folie
Culture instructors and residents
at the Robert Giffard Psychiatric
Hospital, Quebec.

Connector IV–Bunt City
2000–2001 / Collage representation
of _Bunt City_ by children from the
Metropolitan Ministries Hostel,
Tampa, Florida.

Connector

LE MONDE

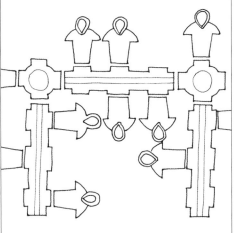

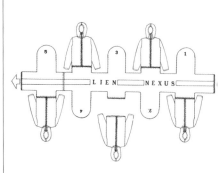

L I E N N E X U S

Connector V–Tokyo Japan
2000 / Workshop proposals for
Connector Units by students from
the Musashino Art University
Tokyo, curated by Kazuko Koike.

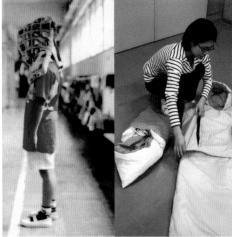

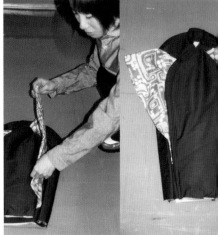

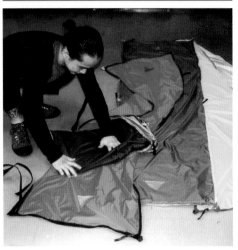

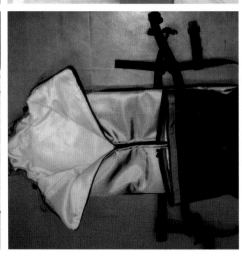

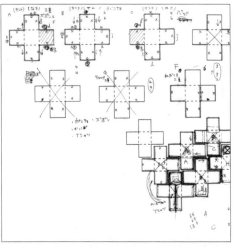

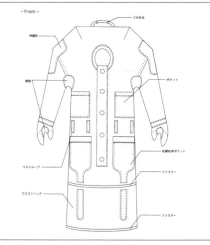

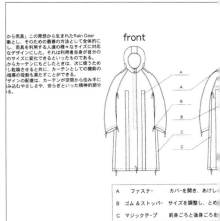

- front -

front

process

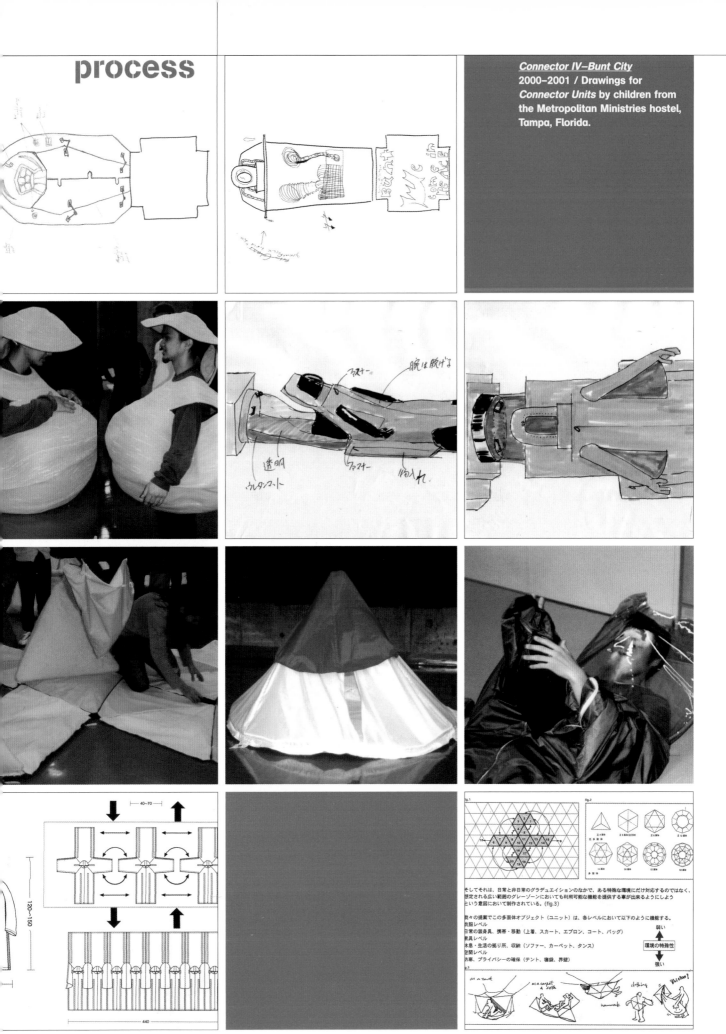

Connector IV–Bunt City
2000–2001 / Drawings for
Connector Units by children from
the Metropolitan Ministries hostel,
Tampa, Florida.

53

Connector

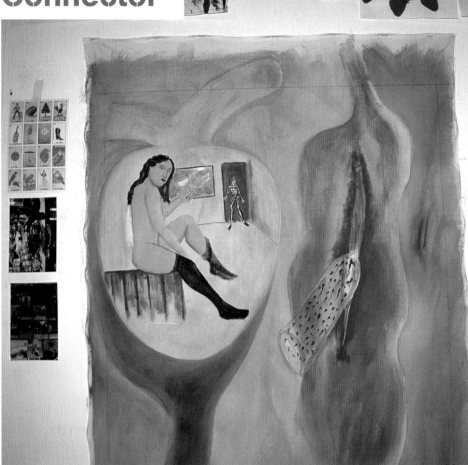

*__Connector Unit VIII–
Guardian Angel__*
**2001 / Drop-in workshop with
community groups around the
Zocòlo district of Mexico City.**

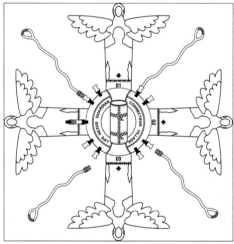

process

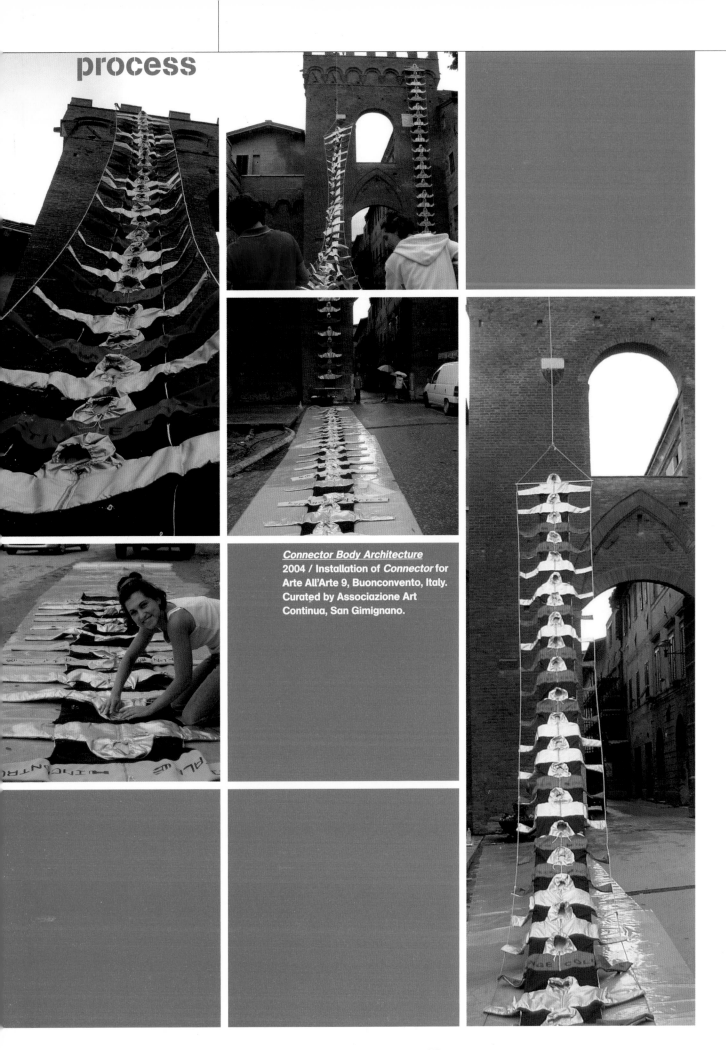

Connector Body Architecture
2004 / Installation of *Connector* for
Arte All'Arte 9, Buonconvento, Italy.
Curated by Associazione Art
Continua, San Gimignano.

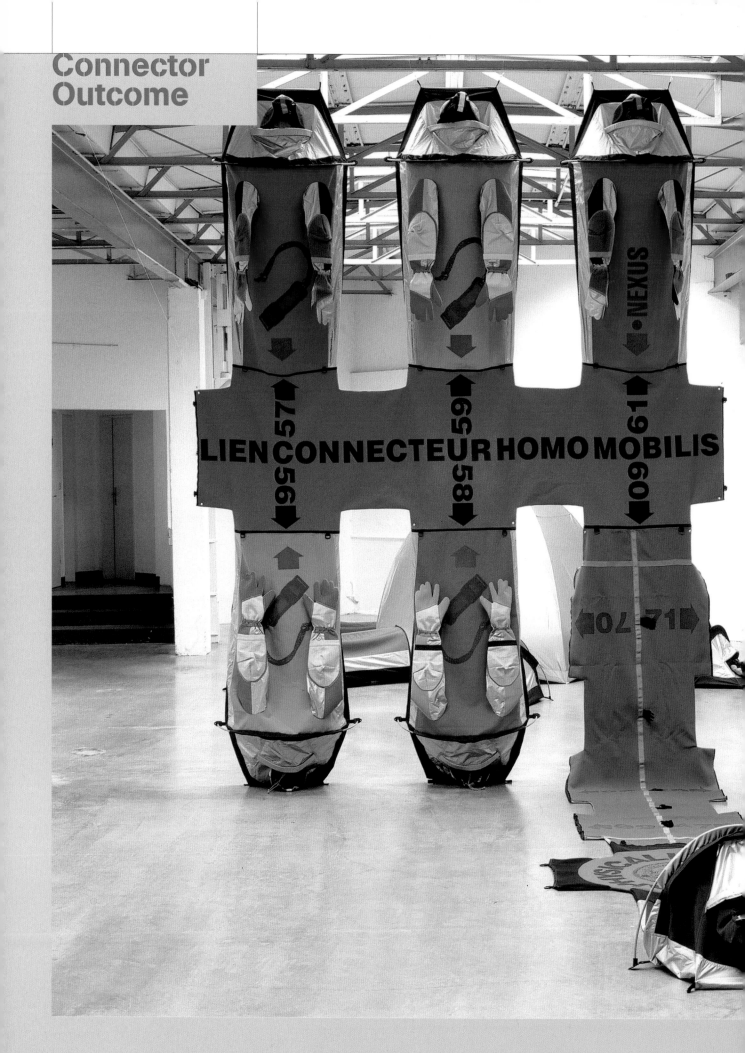

Connector–Mobile Village I
2001 / Aluminium-coated polyester, reversible
Solden Lycra, open-cell polyurethane, silk
screen print, zips / 570x700cm.

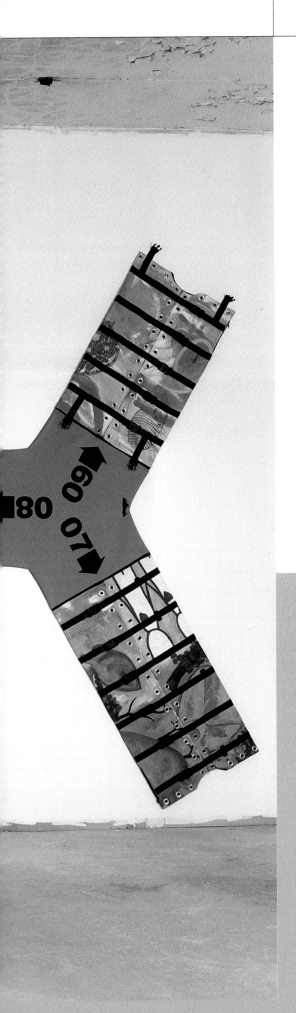

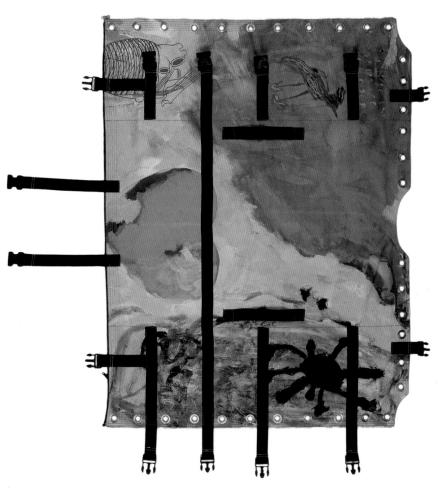

Connector–Mobile Village III, Robert Giffard
Psychiatric Hospital
2000–2002 / Reversible Solden Lycra, open-
cell polyurethane, canvas, acrylic paint, silk
screen print, zips / 400x430cm.

Connector
Outcome

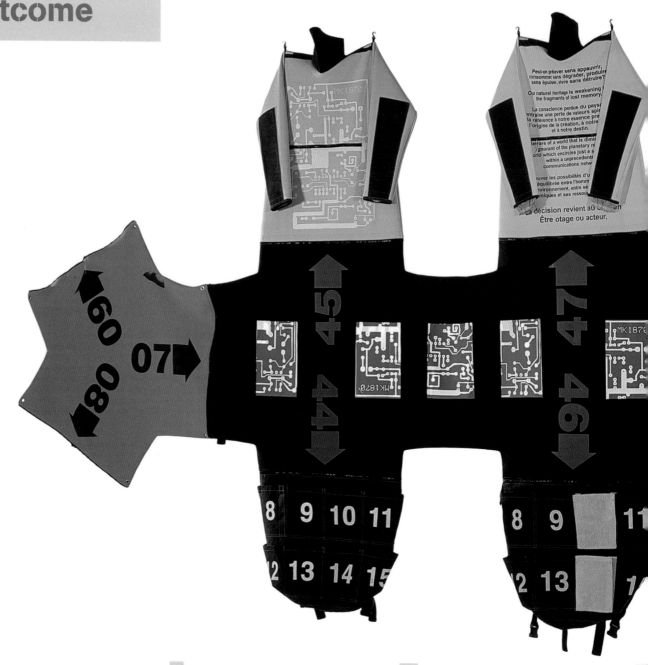

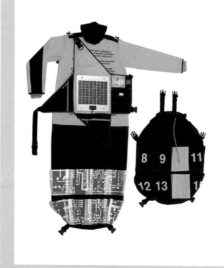

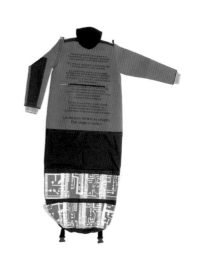

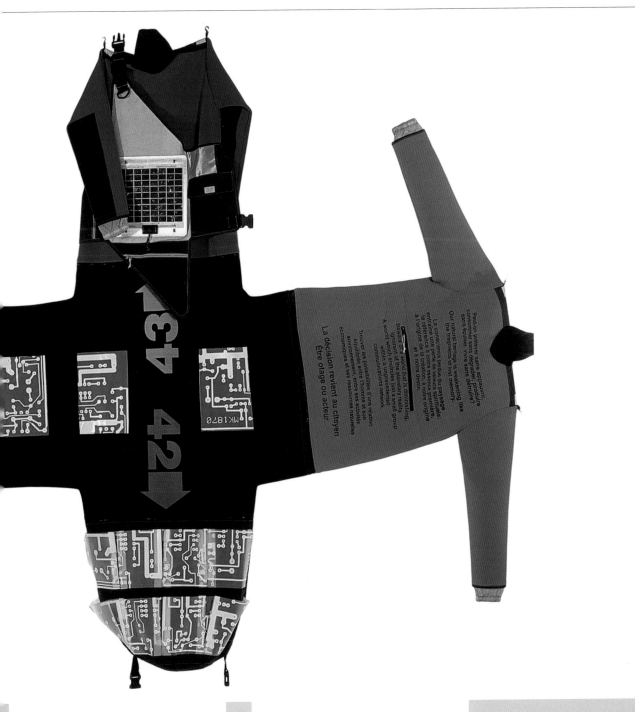

La décision revient au citoyen.
Être otage ou acteur.

Trouver les possibilités d'une relation
équilibrée entre l'homme et son
environnement, entre ses activités
économiques et ses ressources naturelles.

Peut-on protéger sans appauvrir,
consommer sans dégrader, produire
sans épuiser, vivre sans dételure?

La conscience pense ou s'appauvrit,
entraîne une perte de valeurs spirituelles,
la référence à notre essence première,
à l'origine de la création, à notre origine,
et à notre destin.

Our natural heritage is weakening like
the fragments of lost memory.

Bonus, a world that's commuting.
A world which encircles just a small group,
ignorant of the planetary reality.
within a unprecedented
communications network.

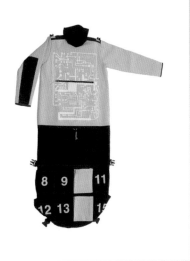

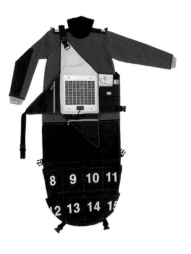

Connector—Mobile Village VI, Makrowear
2002 / Aluminium-coated polyester,
reversible Solden Lycra, open-cell
polyurethane, solar panel, silk screen print,
zips / 690x340cm.

61

Connector
Outcome

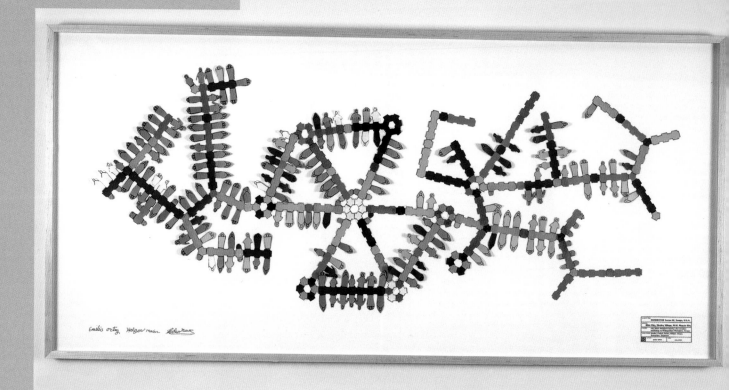

Connector IV–Bunt City
2000–2001 / Collage by children from the
Metropolitan Ministries Hostel Tampa, Florida
/ 100x50cm.
Collection of the Contemporary Art Museum University
of Tampa, Florida

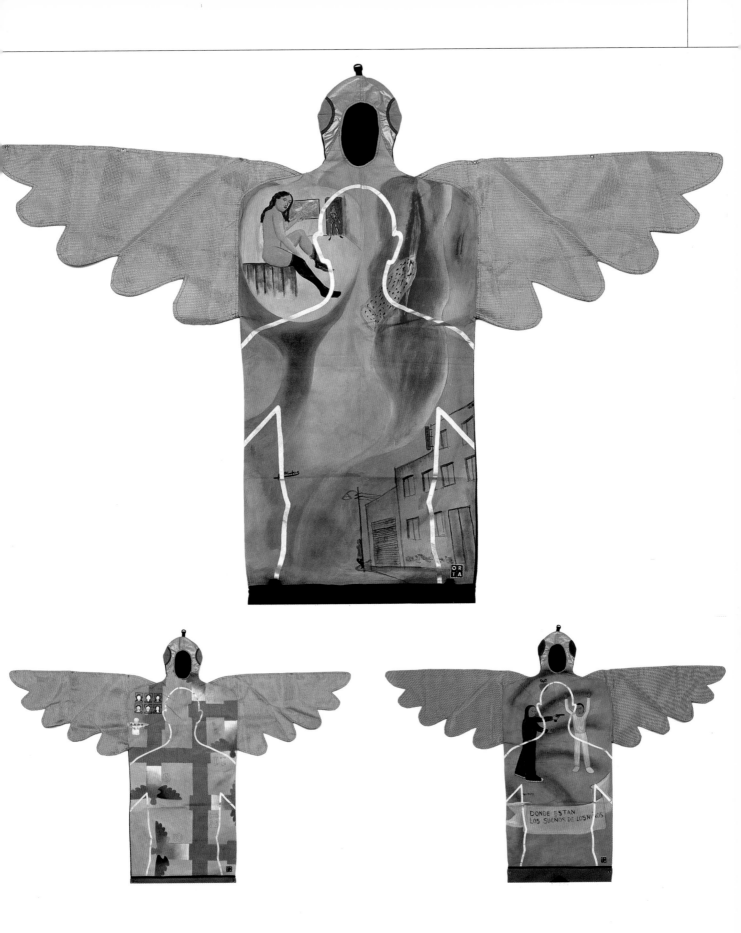

Dwelling

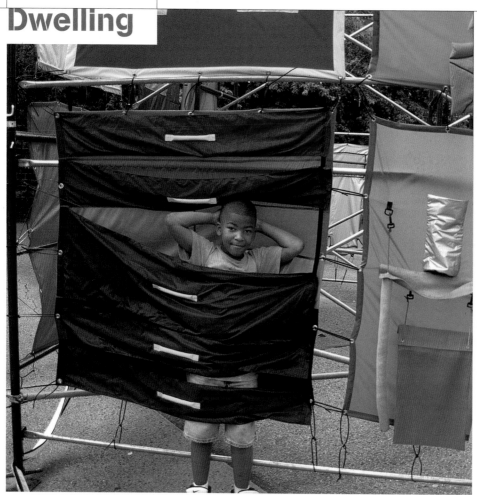

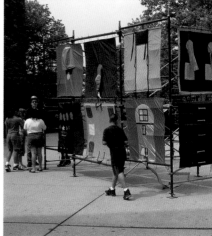

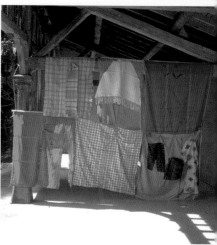

Dwelling Workshop, Act VIII and XI
2003–2004 / Students from
Cicignon School, Friedrikstad,
Norway and 15 young adults from
Speakout and Brisbane Youth
Service, Australia.

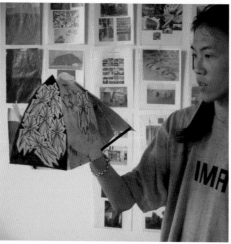

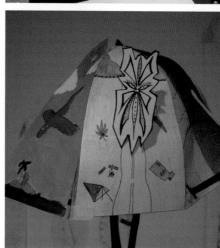

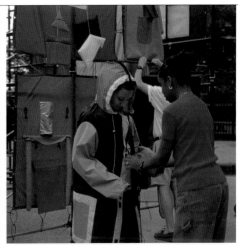

Dwelling Workshop, Acts I, II and III
1997–1998 / Children from Arc-en-Ciel foster home and Lycée Sonia Delaunay, Thiers, France. Exchange with teenagers from the Henry Street Settlement and St Mary's Church Lower East Side, New York.

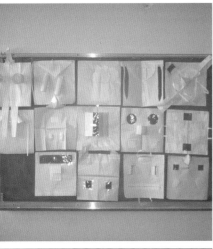

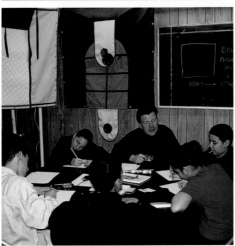

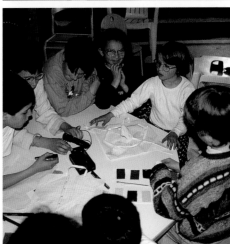

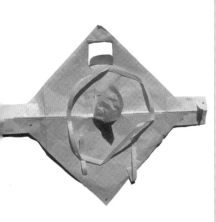

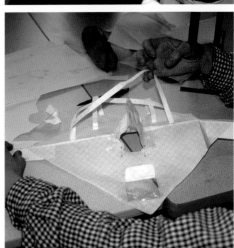

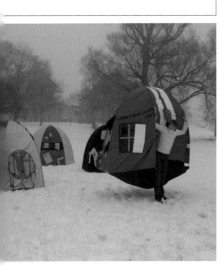

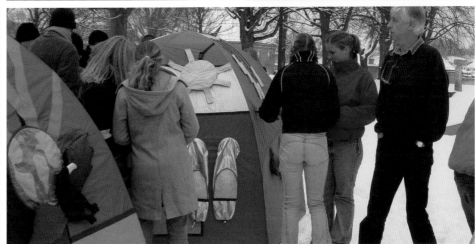

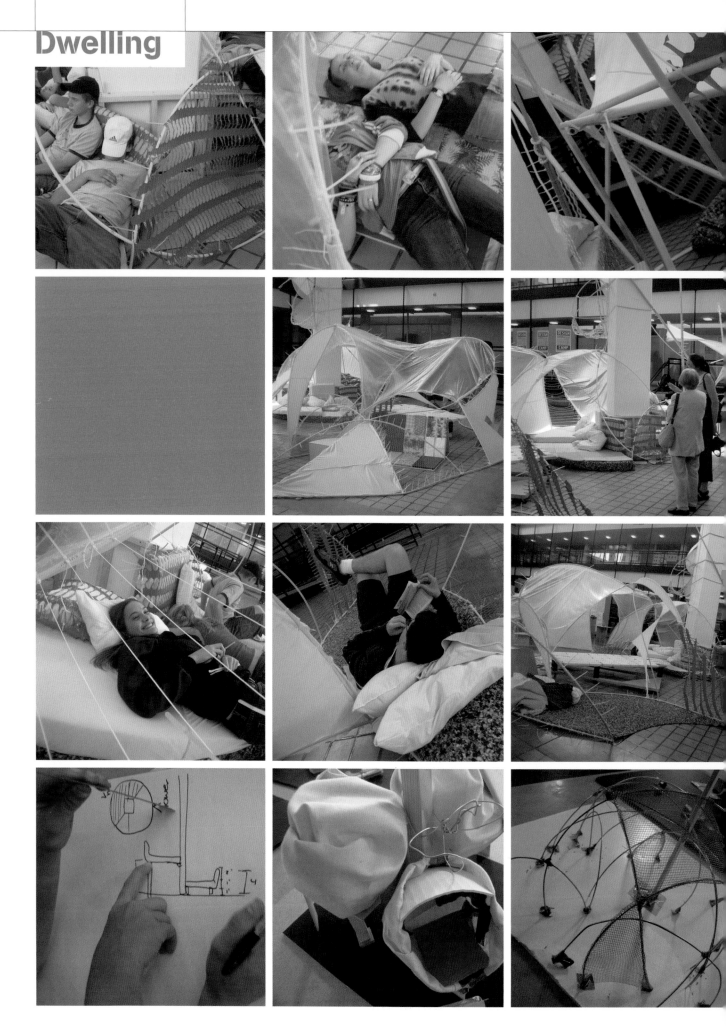

process

Dwelling Workshop, Act IV
2004 / High school students taking part in the _Design Camp_ at Minnesota University, Department of Architecture. Collaboration with Dre Wapenaar.

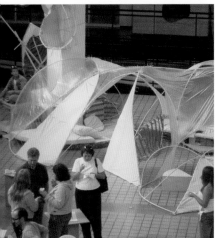

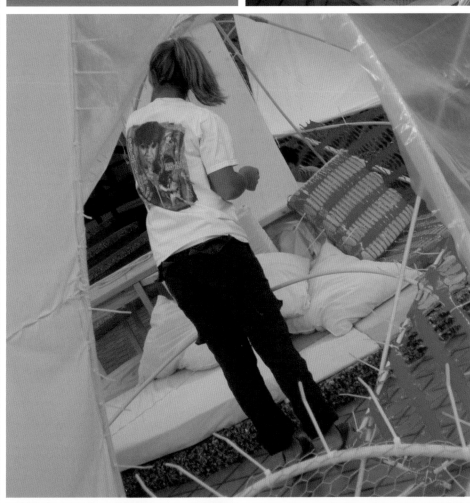

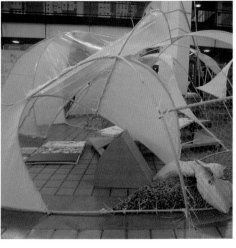

Dwelling

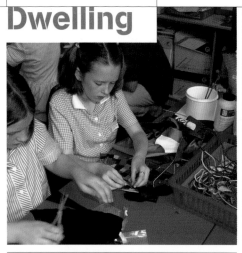

Dwelling X–Ideas Transfer
2003 / Workshops at Studio-Orta
Paris, Atelier One London and
Inflate London.

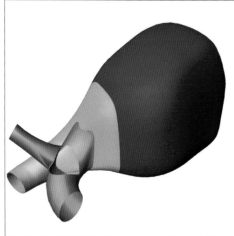

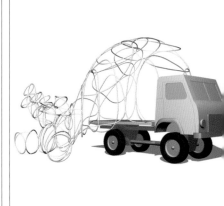

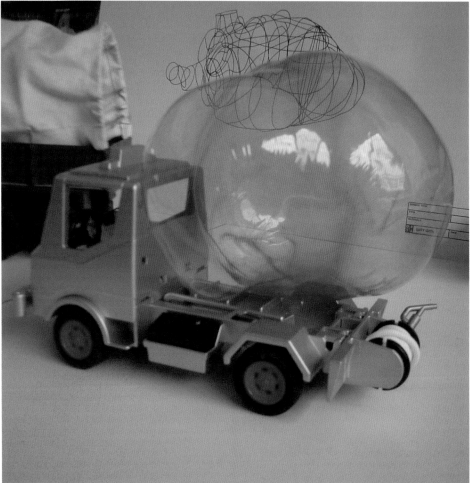

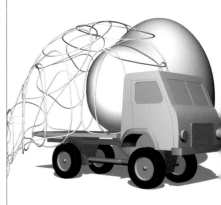

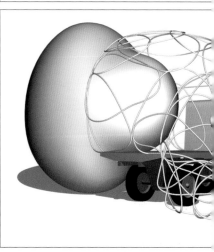

process

Dwelling Workshop, Act X
2003–2004 / Nottingham
community groups working with
local artists Trish Bramman, Trish
Evans and Marcus Rowlands,
curated by Katy Culbard.

Dwelling X–Production
2004 / Silk screen printing
and inflatable trials.

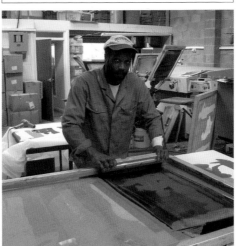

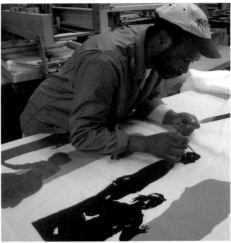

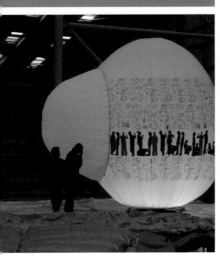

Dwelling

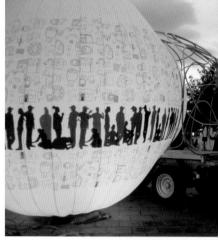

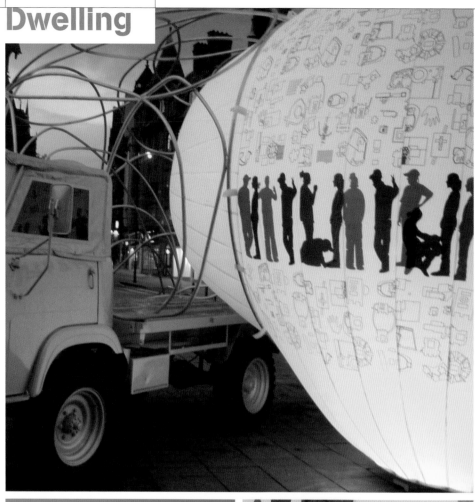

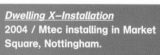

Dwelling X–Installation
2004 / Mtec installing in Market
Square, Nottingham.

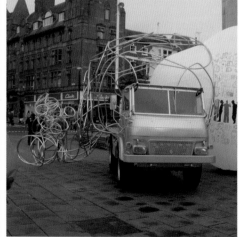

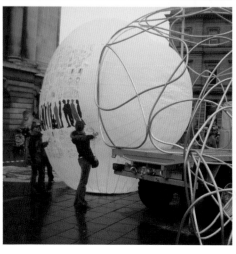

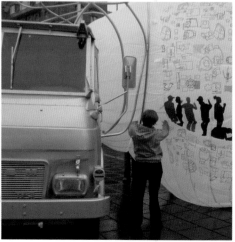

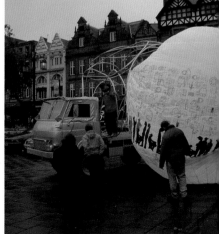

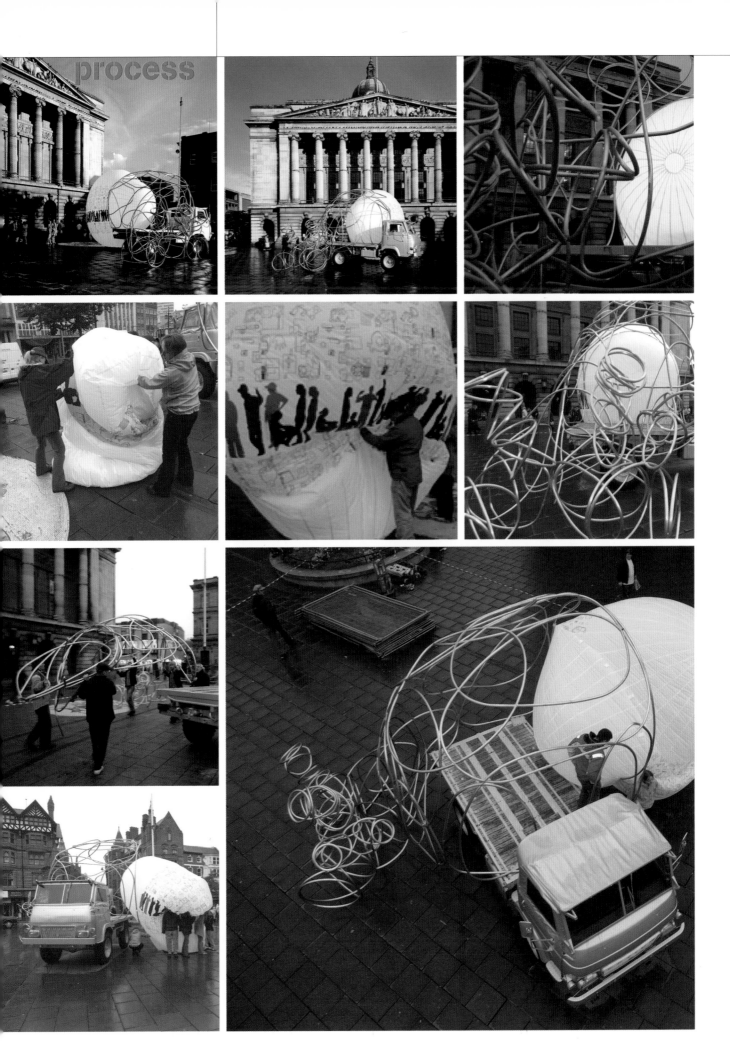

process

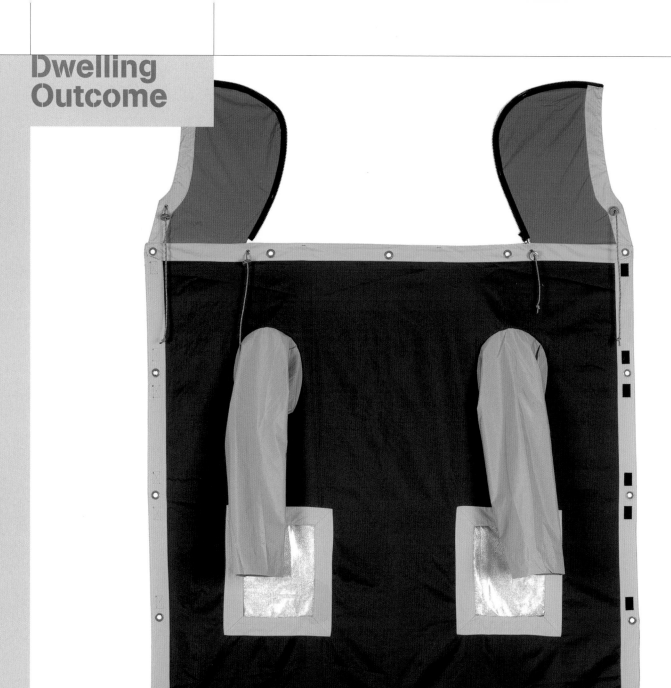

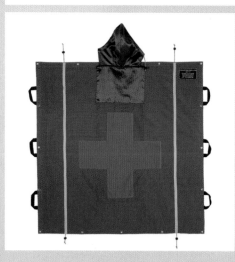

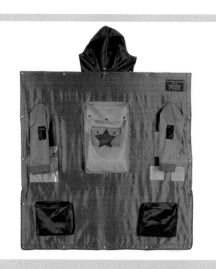

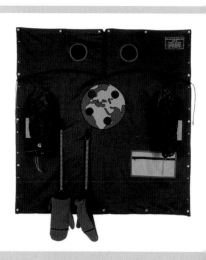

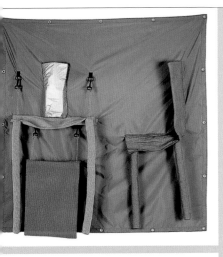
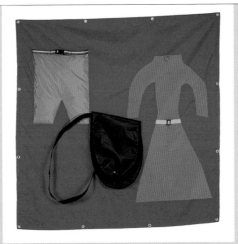
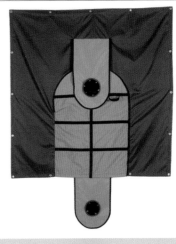

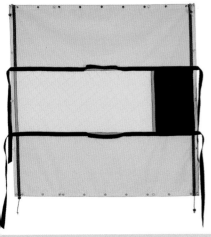
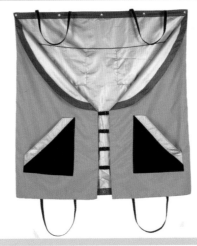
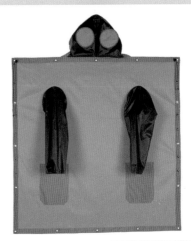

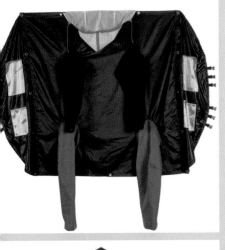
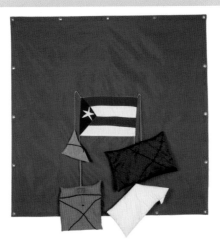
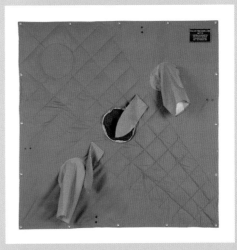

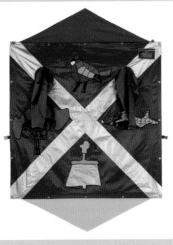
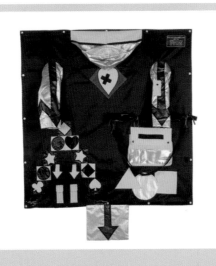

Dwellings—Modules
1997–1999 / Diverse textiles, webbing. Lycée
Sonia Delaunay and Arc-en-Ciel, Thiers;
Henry Street Settlement and St Margarets
Church Lower East Side, New York; Gorbals
Glasgow, Scotland / 120x120cm (each).

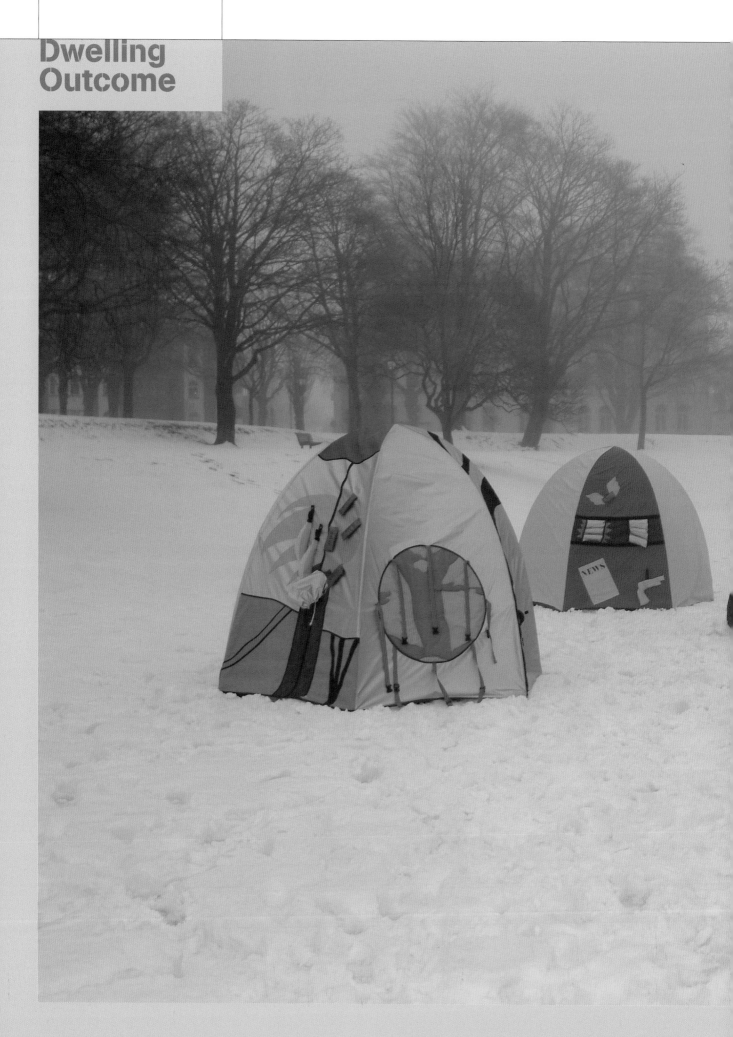

Dwelling
Outcome

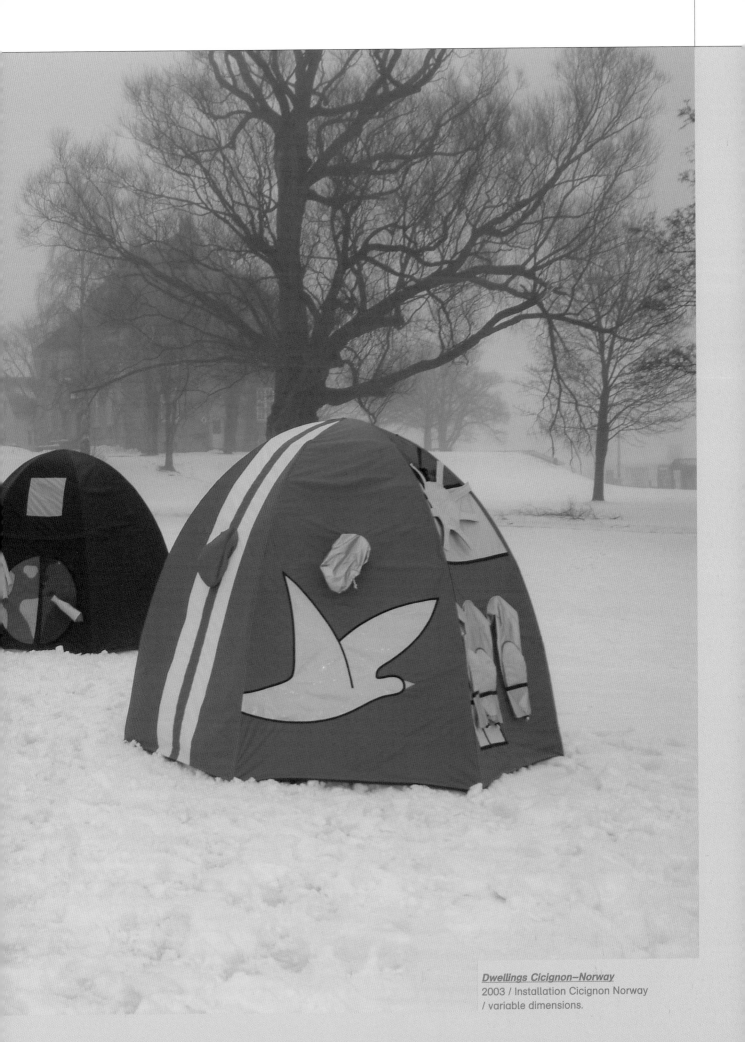

Dwellings Cicignon–Norway
2003 / Installation Cicignon Norway
/ variable dimensions.

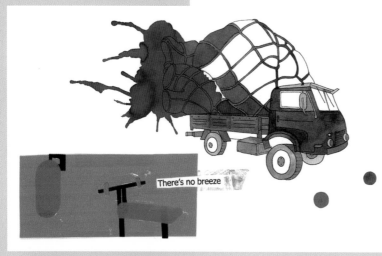

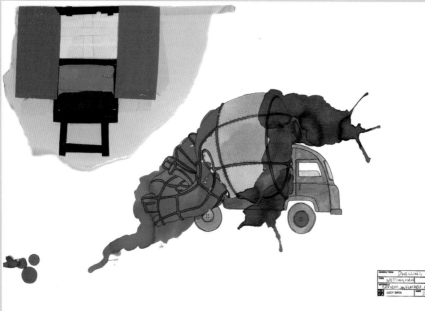

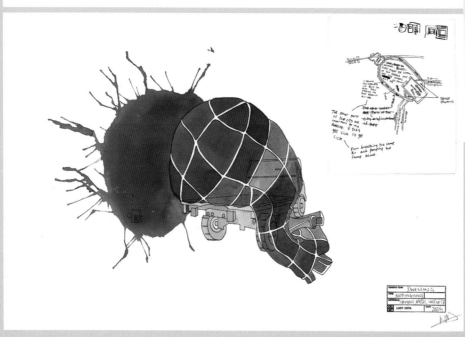

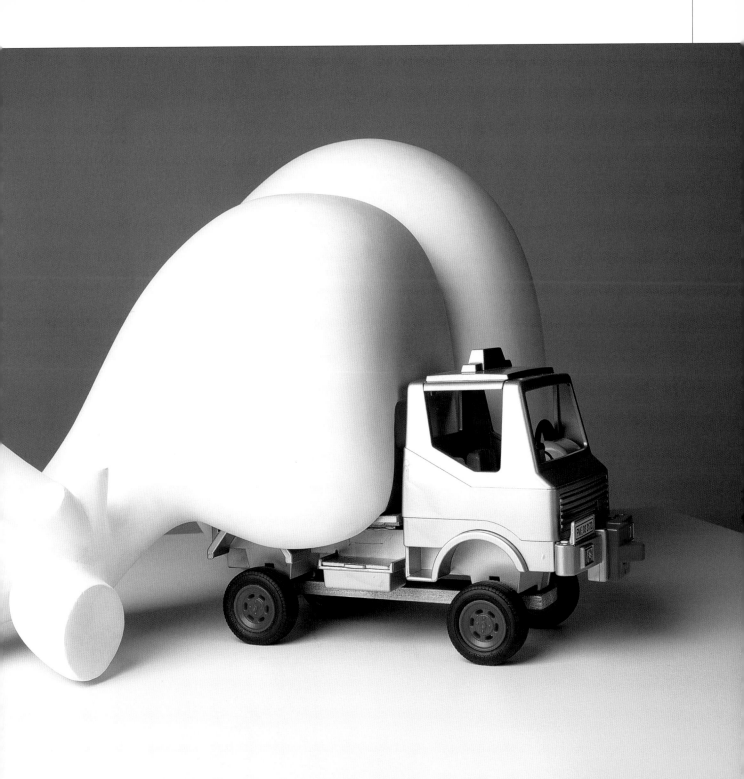

OPPOSITE
Dwelling X–Sketch Proposals
2004 / Watercolour, collage
/ 38x57cm (each).

TOP:
Dwelling X–Maquette
2004 / Polystyrene, resin, toy lorry
/ 50x50x30cm.

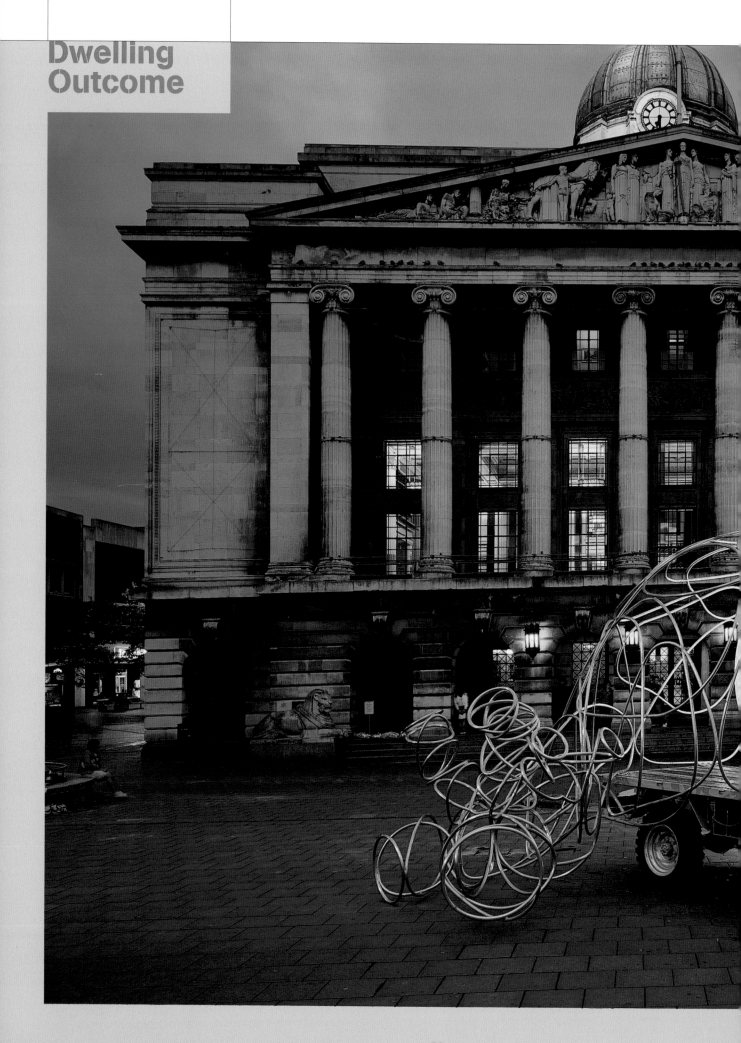

Dwelling
Outcome

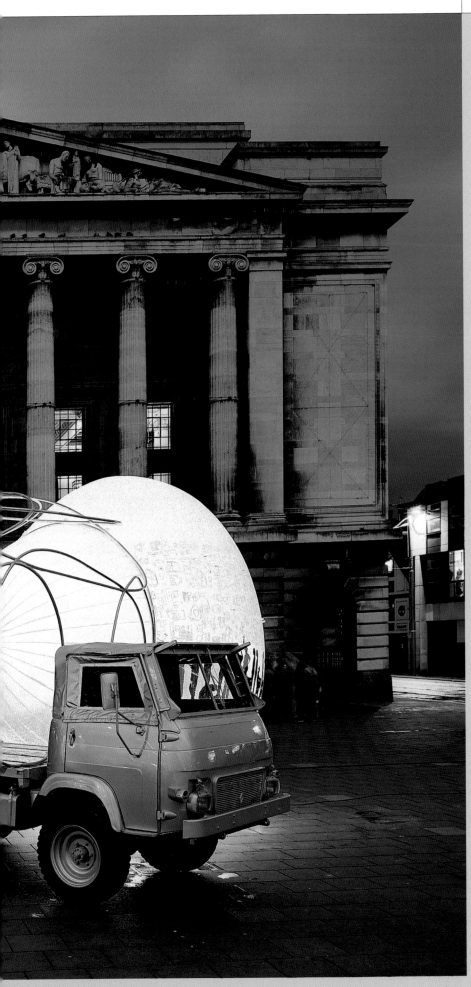

Dwelling X–Installation in Market Square
Nottingham
2004 / Reconditioned Saviem army lorry, steel
structure, inflatable, silk screen print, pump.
Curated by Paula Orrell for Angel Row Gallery
and Now festival / variable dimensions.

OrtaWater

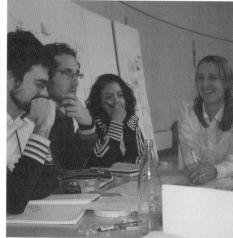

ORTA WATER

OrtaWater 01
2004–2005 / Fabrication of arworks at the Dairy and Tosco Aquario welders in Tuscany. Delivery to the Gallerie Fondazione Bevilacqua La Masa Venezia.

OrtaWater 01
2004–2005 / Workshop conducted at Fabrica, Benetton Research Centre in Treviso, Italy and the Dairy. Researchers from Fabrica were joined by students from London College of Fashion, MA Fashion Curation and Design Academy Eindhoven, MA Man + Humanity. Three projects were selected and developed for the exhibition at the Fondazione Bevilacqua La Masa Venezia.

DRINK WATER

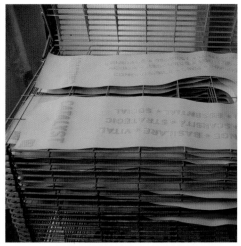

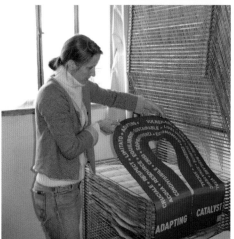

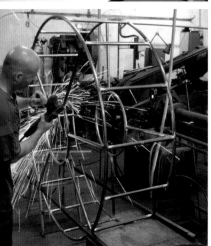

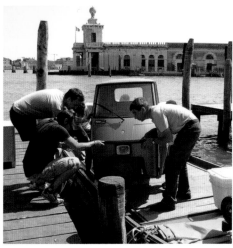

OrtaWater

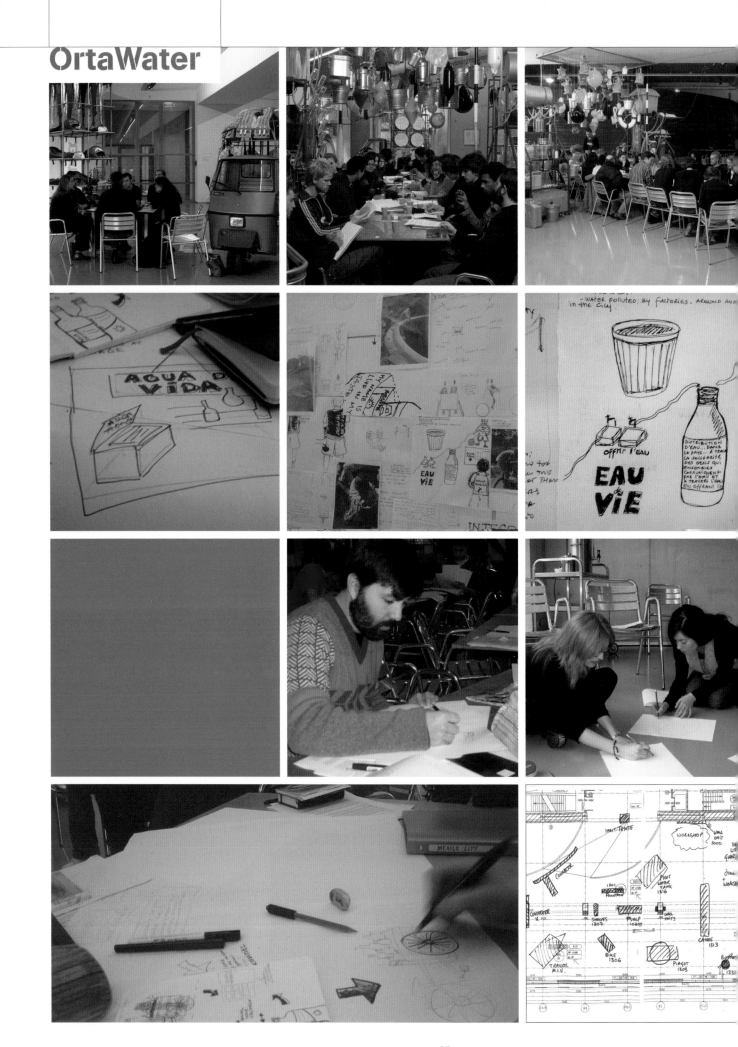

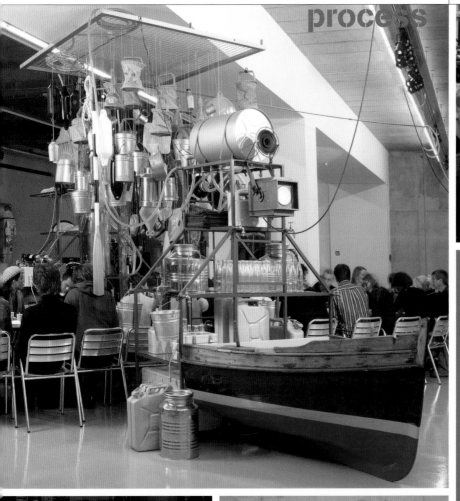

OrtaWater 02
2005–2006 / Workshop conducted at the Museum Boijmans Van Beuningen Rotterdam. Curated by Annemartine Van Kesteren and Bregje Van Woensel, research assistant Danny Sutjahjo, supported by the H&F Patronnage. Post-graduate and MA students from Delft University, Industrial Design and Engineering; William de Kooning Academy, Rotterdam; Design Academy Eindhoven; Aqua Alta and Groupe el Puente at CittàdellArte, Pistoletto Foundation developed proposals for 'Clean Water' initiatives in three developing countries.

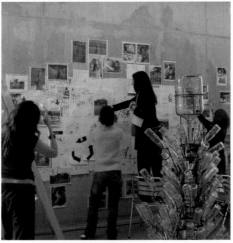

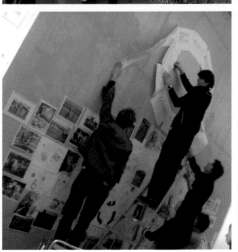

OrtaWater
Outcome

OrtaWater–Urban Intervention Unit
2005 / APE 50 Piaggio, steel structure, 15
life jackets, silk screen print, nine buckets,
eight taps, webbing / 250hx320x200cm.
Courtesy of Galleria Continua San Gimignano-Beijing

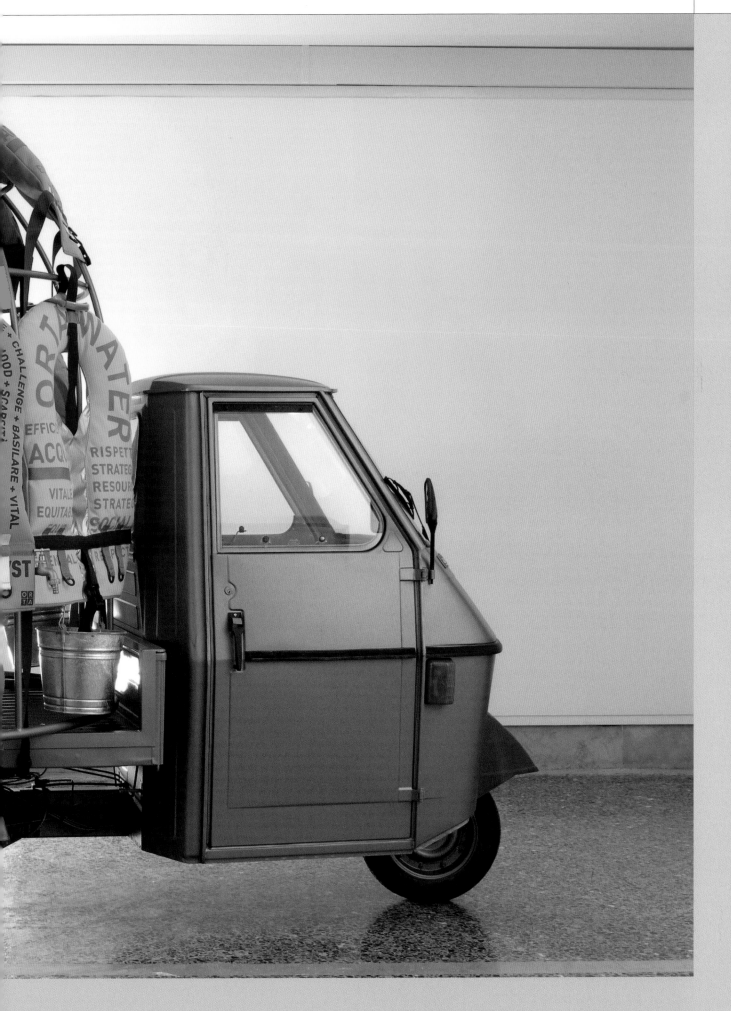

OrtaWater
Outcome

OrtaWater–Glacier Wall Unit
2005 / Steel structure, laminated photgraph,
glass, Royal Limoges porcelain heart, 20
bottles, two taps / 125x70x40cm.
Courtesy Galleria Continua San Gimignano-Beijing

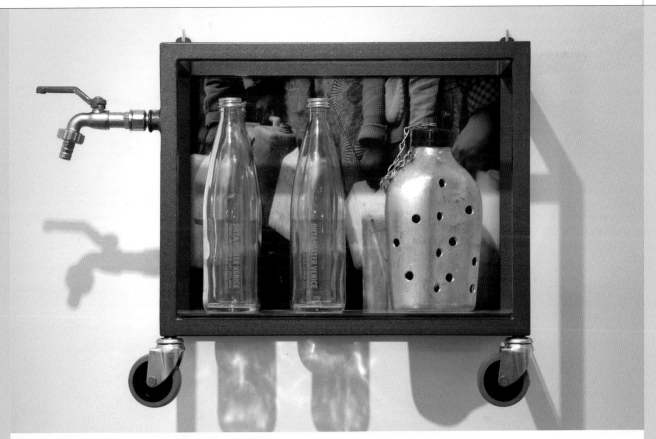

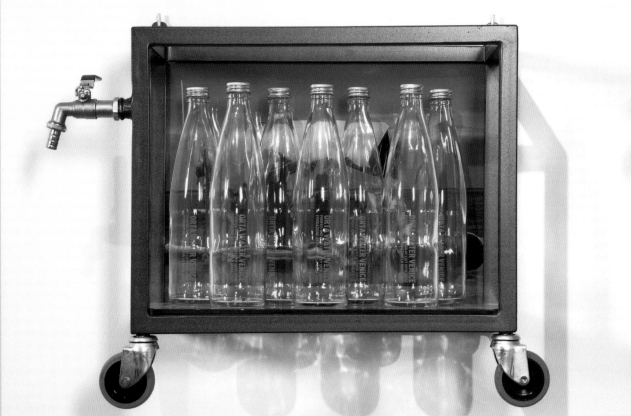

TOP:
**OrtaWater–Vitrine**
2005 / Iron structure, glass, mirror, five
OrtaWater bottles, pierced aluminium flask,
tap / 45x45x52cm.
Courtesy Galleria Continua San Gimignano-Beijing

BOTTOM:
**OrtaWater–Vitrine**
2005 / Iron structure, glass, mirror,
seven OrtaWater bottles, tap / 45x45x52cm.
Courtesy Galleria Continua San Gimignano-Beijing

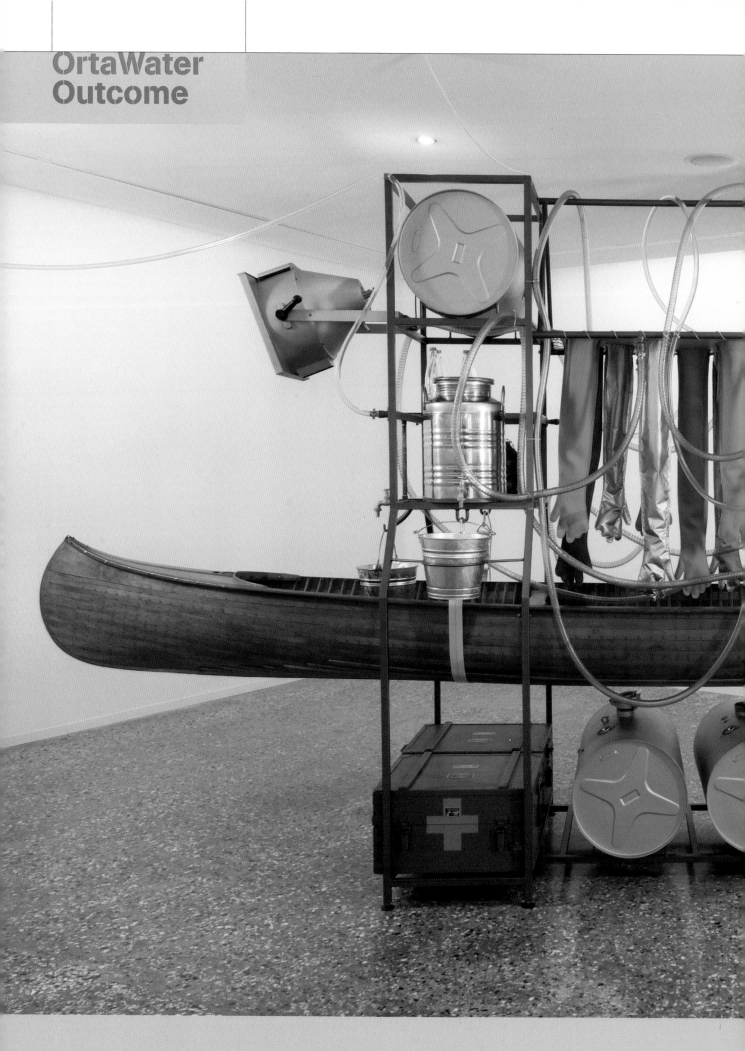

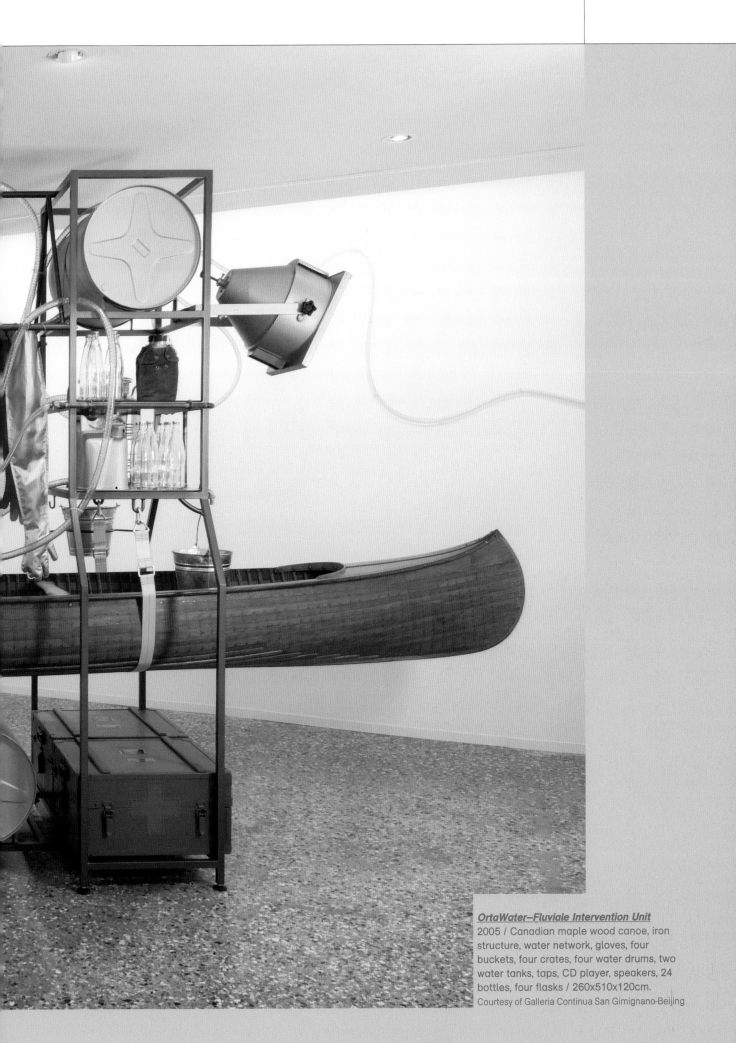

OrtaWater–Fluviale Intervention Unit
2005 / Canadian maple wood canoe, iron structure, water network, gloves, four buckets, four crates, four water drums, two water tanks, taps, CD player, speakers, 24 bottles, four flasks / 260x510x120cm.
Courtesy of Galleria Continua San Gimignano-Beijing

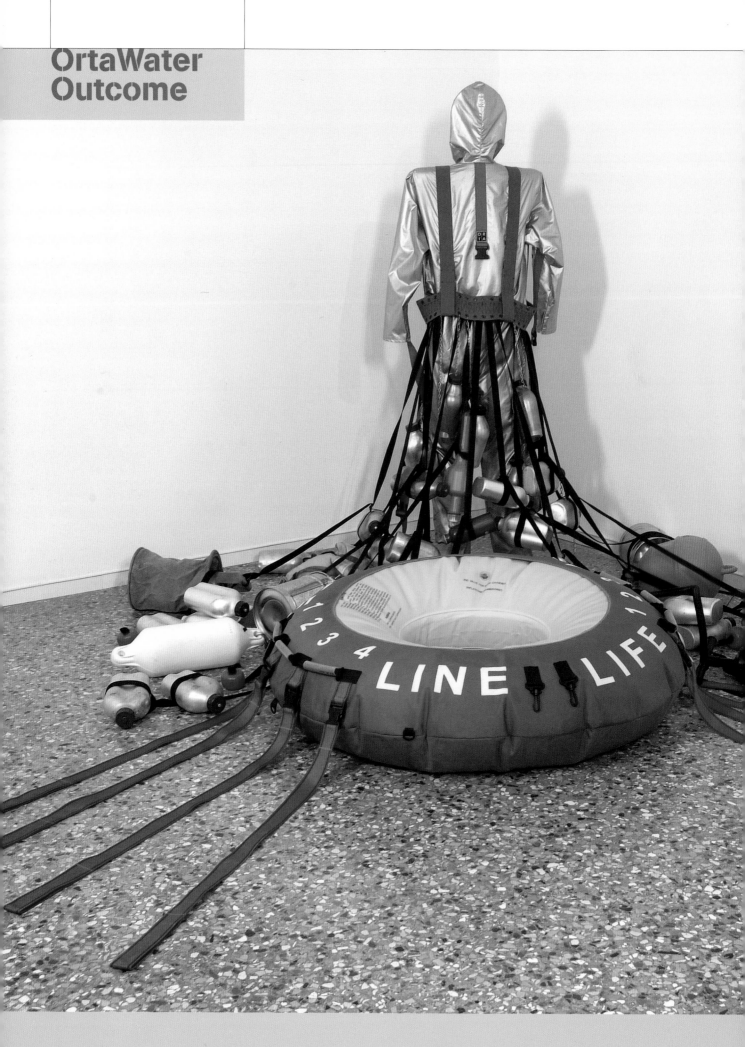

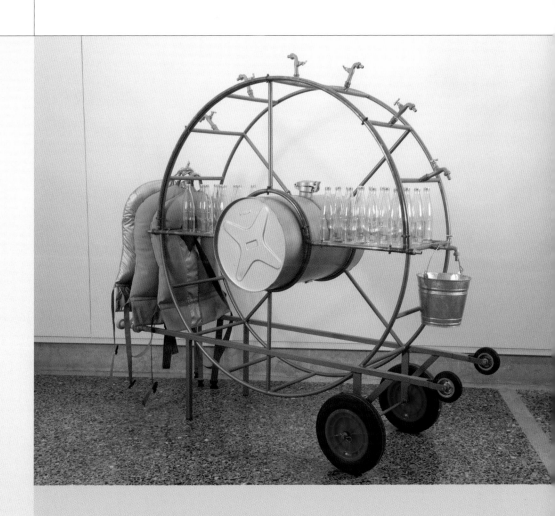

OPPOSITE:

__OrtaWater–Urban Life Guard__

2005 / Various OrtaWater objects, aluminium coated polyamide, inflatable life ring, PU coated polyamide, clips, webbing, silk screen print / 180x270x290cm.

Collection E Righi

TOP:

__OrtaWater–Portable Water Fountain__

2005 / Iron structure, water drum, rubber wheels, life jacket, silk screen print, copper tube, bucket, taps, 33 OrtaWater bottles / 80x190x50cm.

Courtesy of Galleria Continua San Gimignano-Beijing

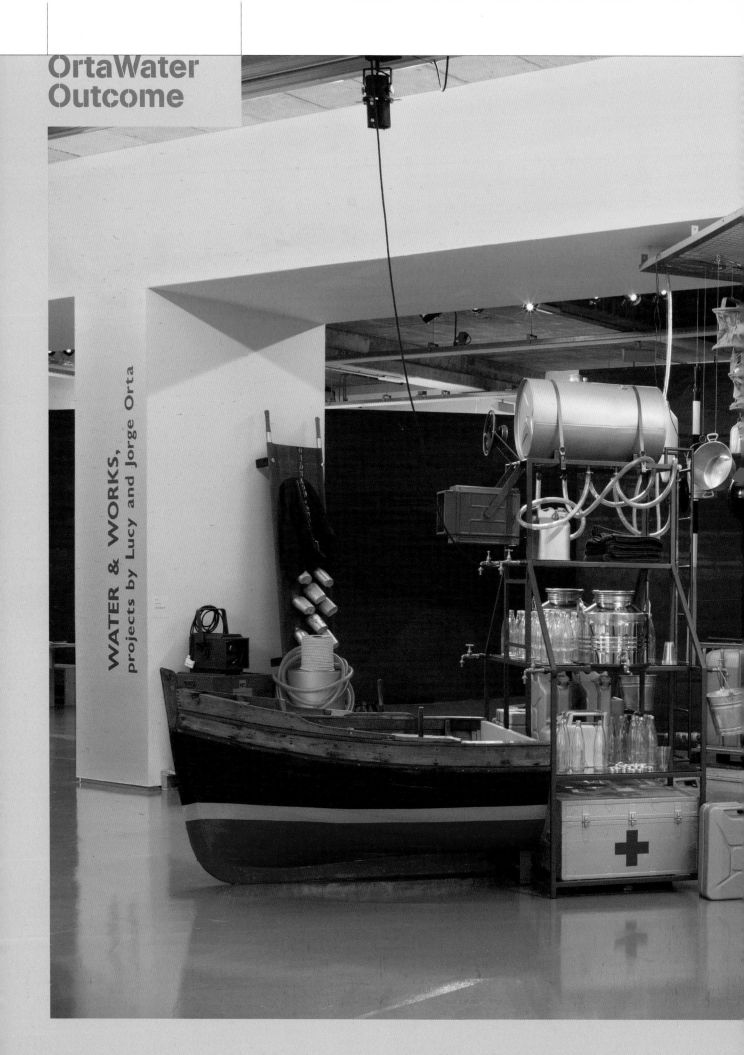

OrtaWater
Outcome

WATER & WORKS,
projects by Lucy and Jorge Orta

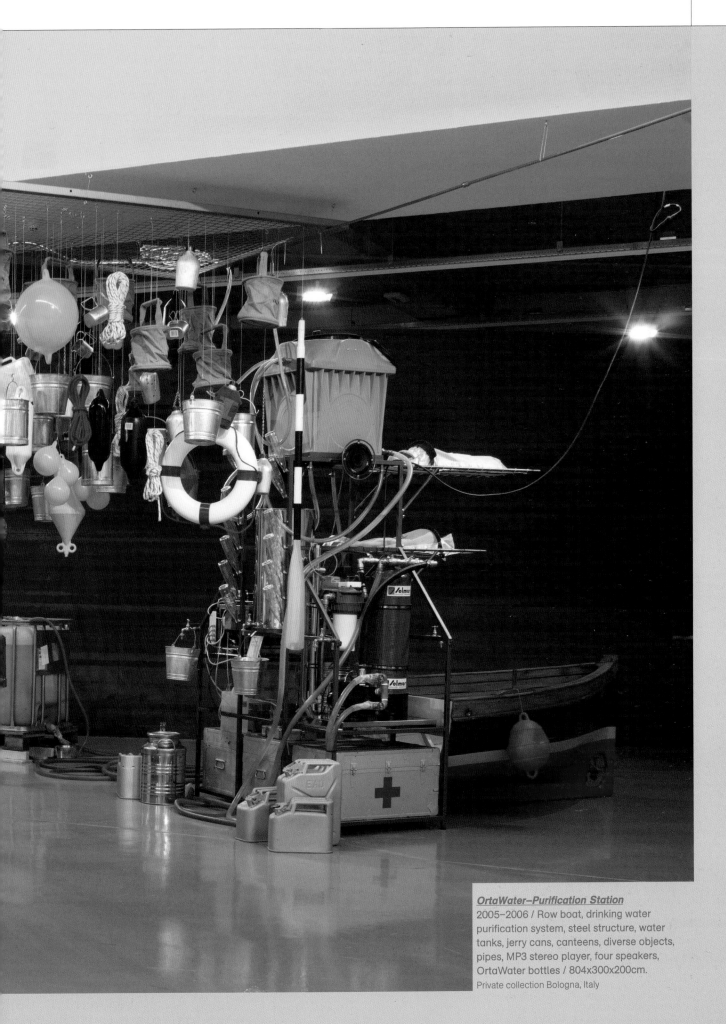

OrtaWater–Purification Station
2005–2006 / Row boat, drinking water
purification system, steel structure, water
tanks, jerry cans, canteens, diverse objects,
pipes, MP3 stereo player, four speakers,
OrtaWater bottles / 804x300x200cm.
Private collection Bologna, Italy

Nexus

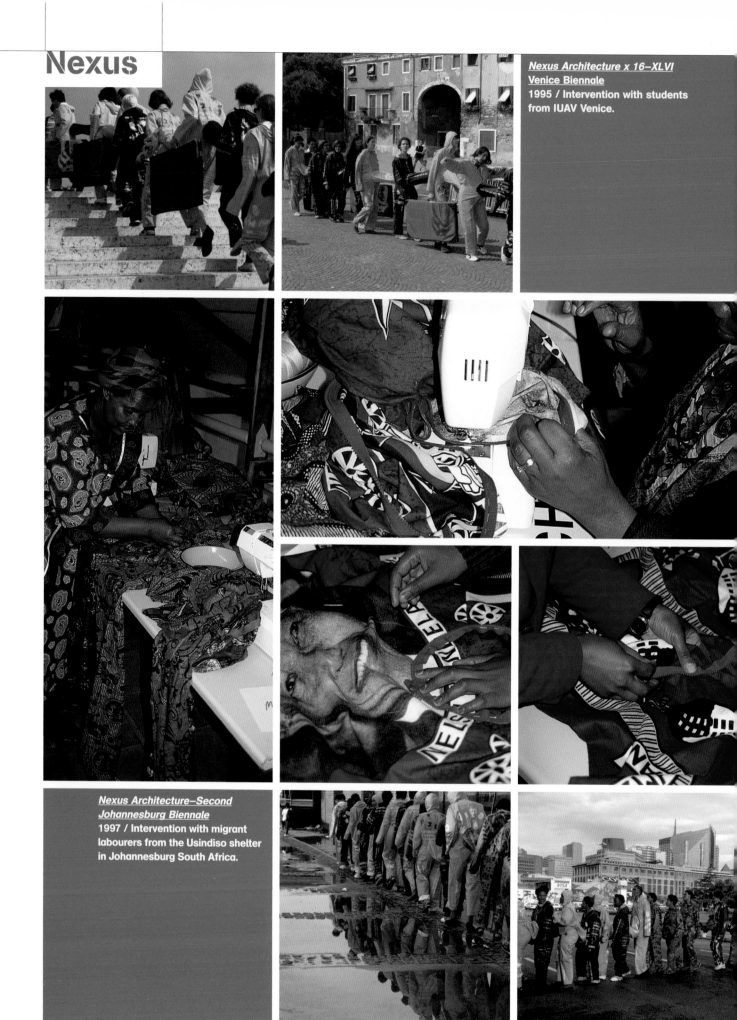

Nexus Architecture x 16–XLVI
Venice Biennale
1995 / Intervention with students
from IUAV Venice.

Nexus Architecture–Second
Johannesburg Biennale
1997 / Intervention with migrant
labourers from the Usindiso shelter
in Johannesburg South Africa.

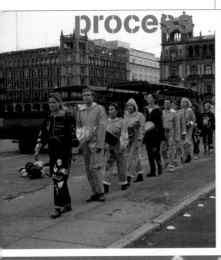

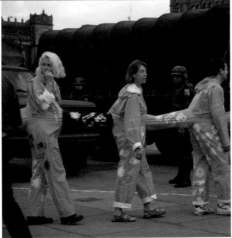

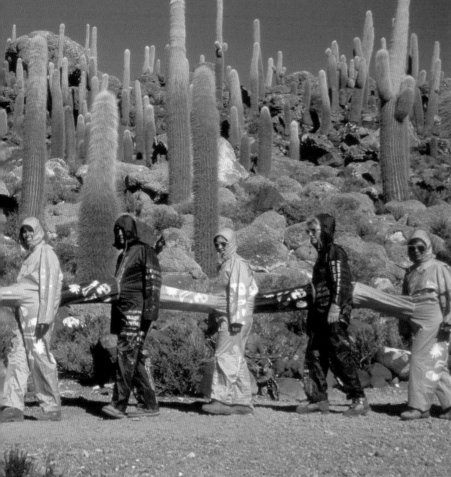

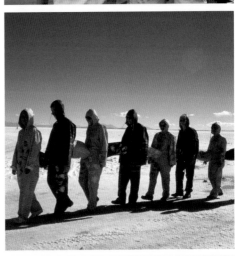

Nexus Architecture—Bolivia + Mexico
**1998 / Interventions in Uyuni Salt
Desert and Mexico City.**

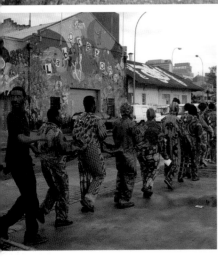

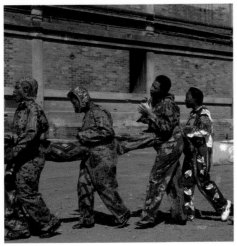

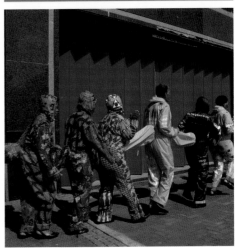

Nexus

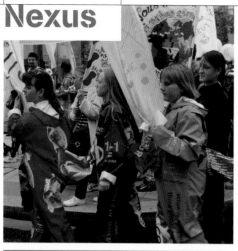

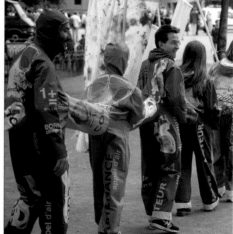

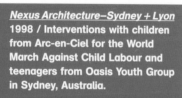

Nexus Architecture–Sydney + Lyon
1998 / Interventions with children from Arc-en-Ciel for the World March Against Child Labour and teenagers from Oasis Youth Group in Sydney, Australia.

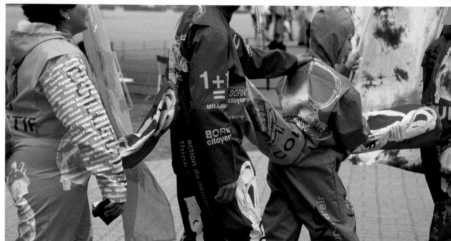

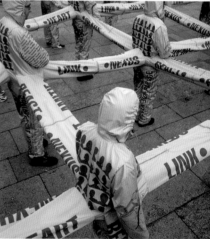

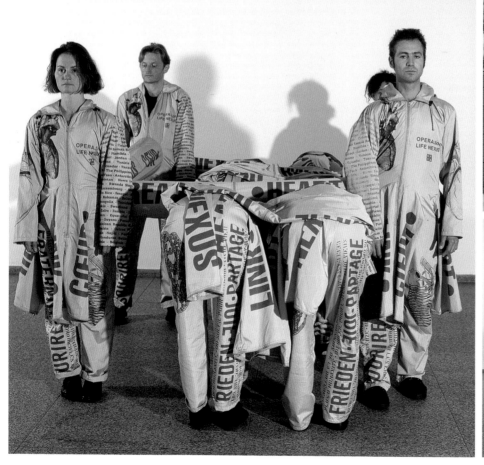

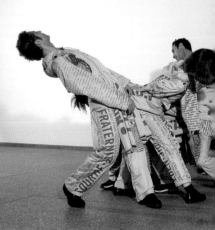

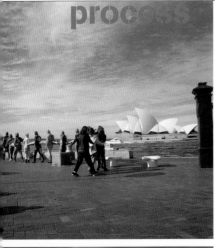

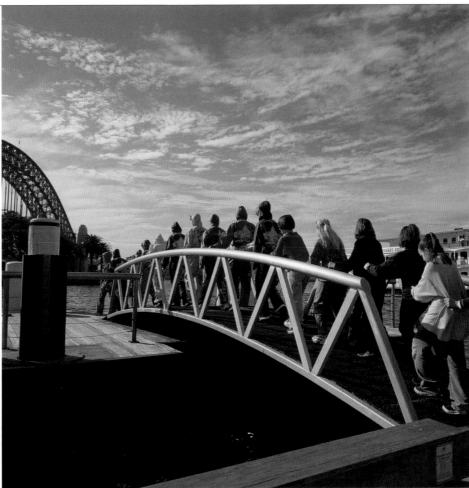

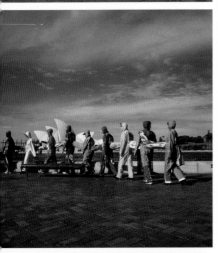

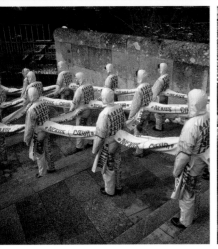

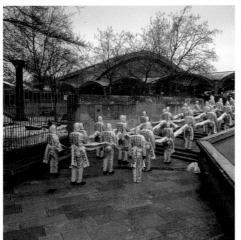

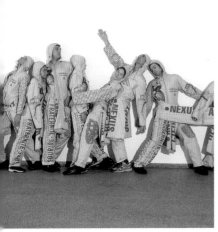

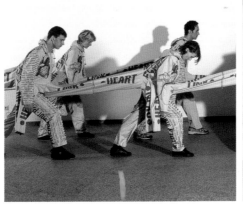

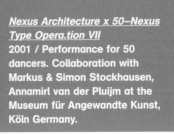

Nexus Architecture x 50—Nexus Type Opera.tion VII
2001 / Performance for 50 dancers. Collaboration with Markus & Simon Stockhausen, Annamirl van der Pluijm at the Museum für Angewandte Kunst, Köln Germany.

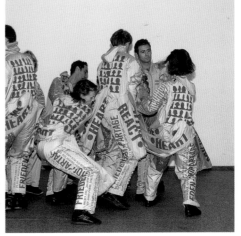

Nexus

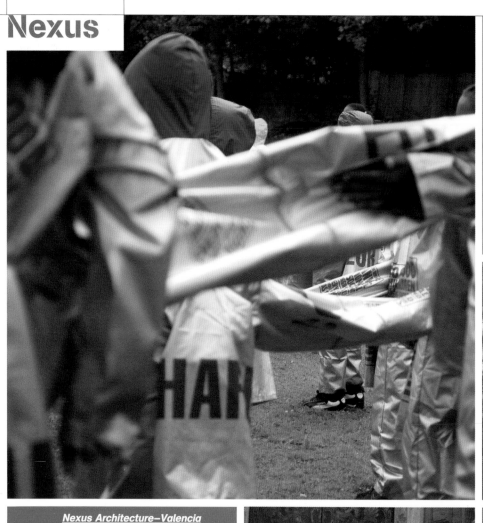

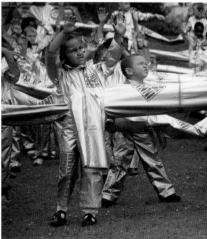

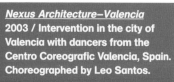

Nexus Architecture—Valencia
2003 / Intervention in the city of
Valencia with dancers from the
Centro Coreografic Valencia, Spain.
Choreographed by Leo Santos.

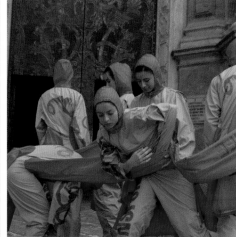

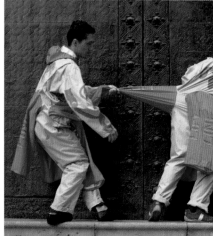

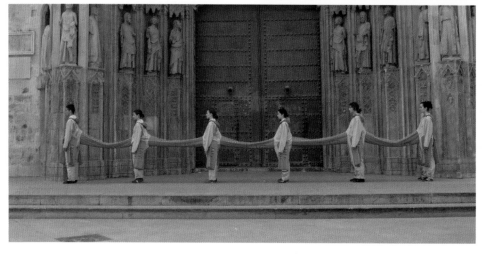

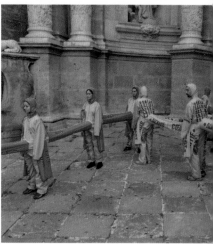

process

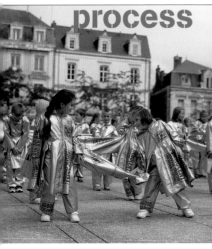

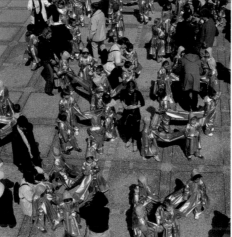

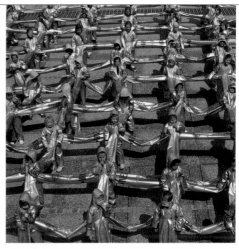

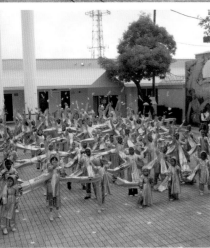

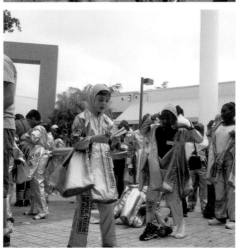

Nexus Architecture x 110 Cholet
2002–2004 / Interventions with
children and their families from the
town of Cholet; Miami DASH for
Art Basel Miami; and Atwood
Green, Birmingham.

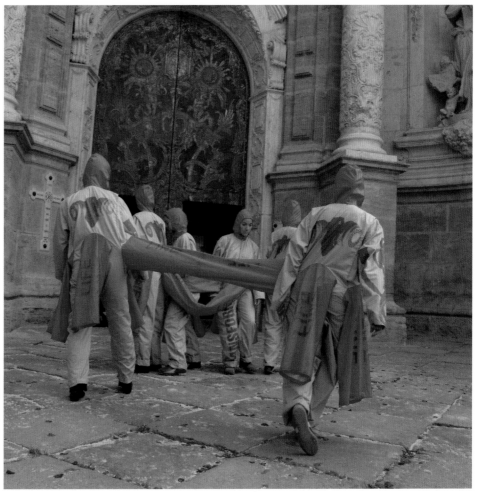

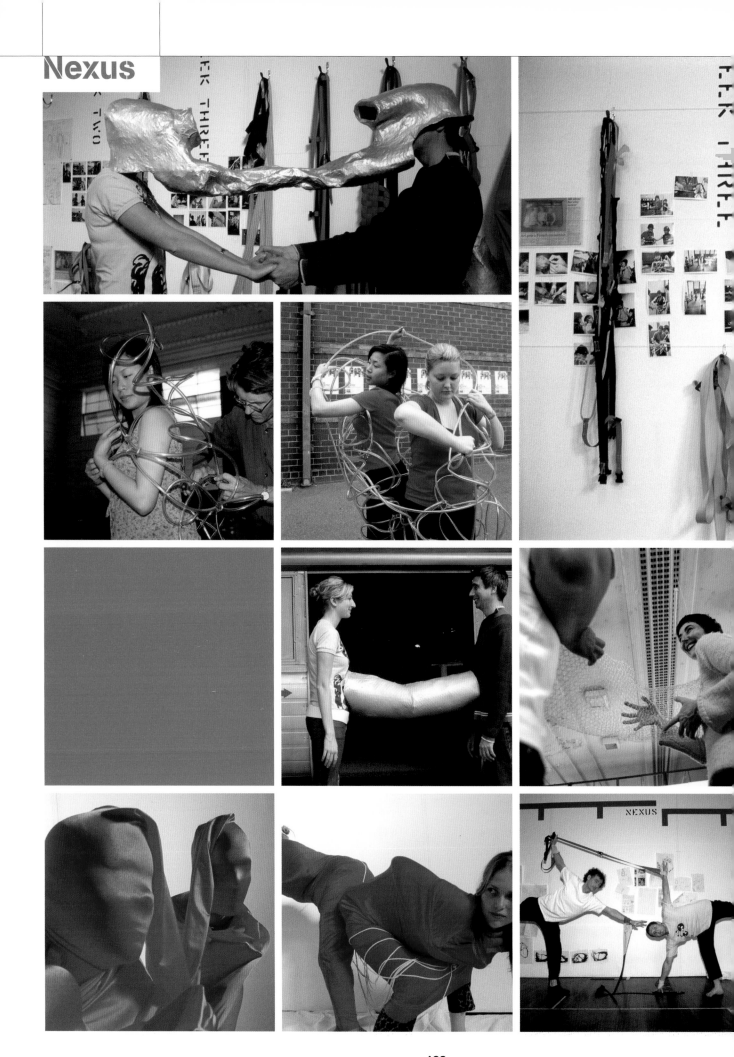

process

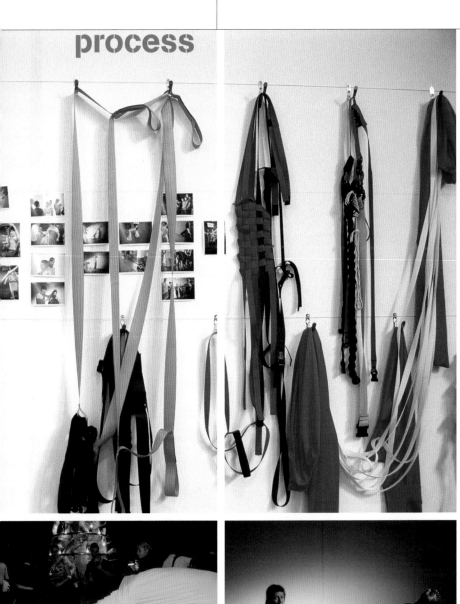

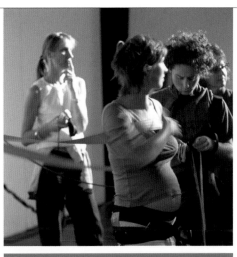

Nexus–Fluid Architecture
2004–2006 / Workshops with local community groups in Melbourne Australia, curated by Jane Crawley, and Tampa Bay, Florida, curated by Joanne Steinhardt.

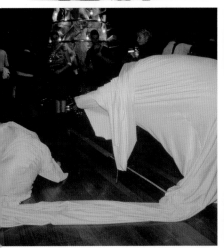

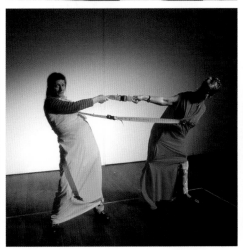

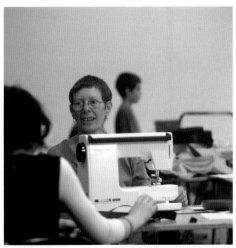

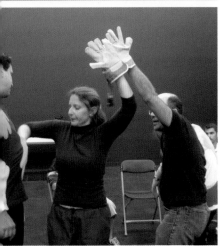

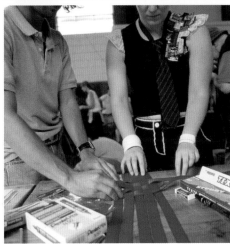

Nexus
Outcome

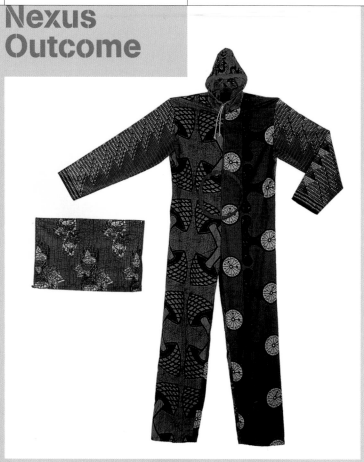

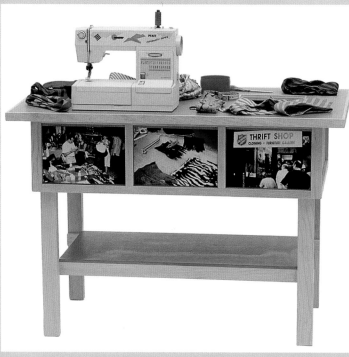

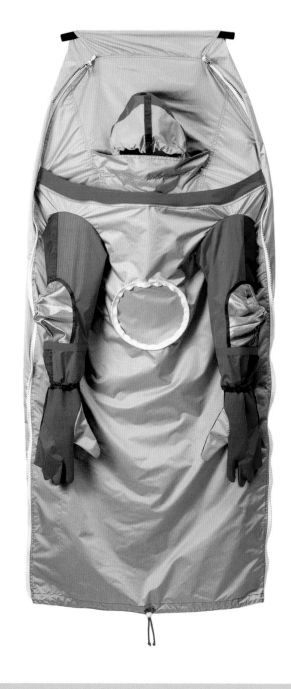

TOP TO BOTTOM:
Nexus Architecture–Second Johannesburg
Biennale
1997 / Dutch wax printed cotton, kanga,
zippers / 170x100cm.
Nexus–Work Bench
1995 / Table, sewing machine, wheels,
laminated photographs, various thrift
materials / 120x65x80cm.

TOP:
Modular Architecture–Nexus Architecture x 3
1996 / Microporous polyester, diverse
textiles, zips / 170x80cm.

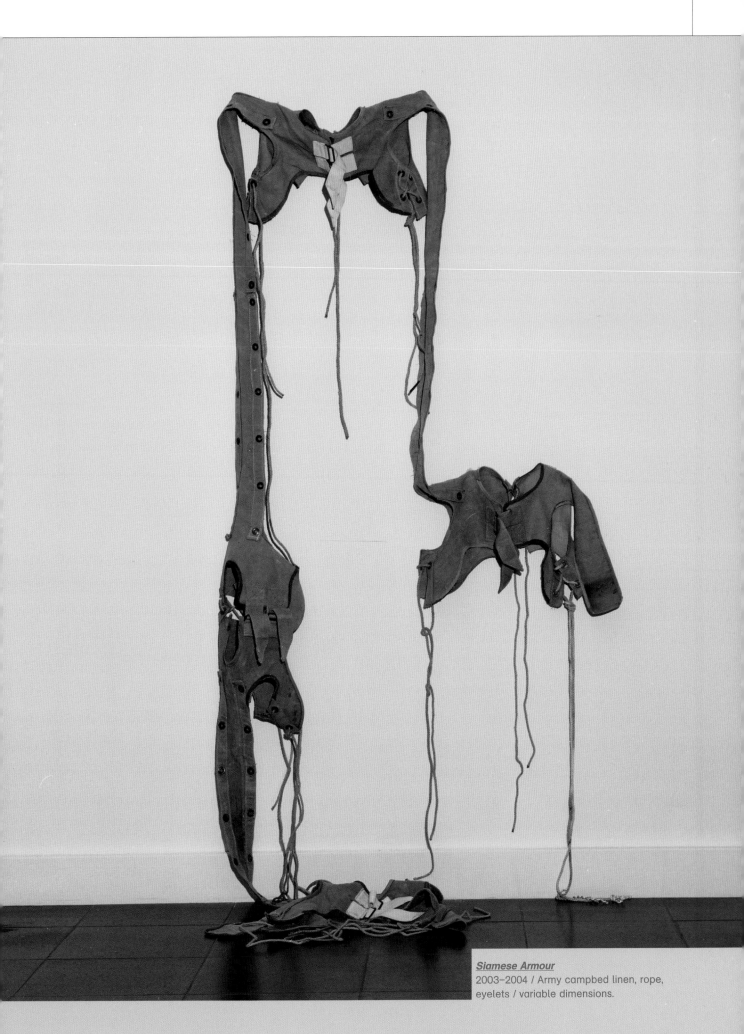

Siamese Armour
2003–2004 / Army campbed linen, rope,
eyelets / variable dimensions.

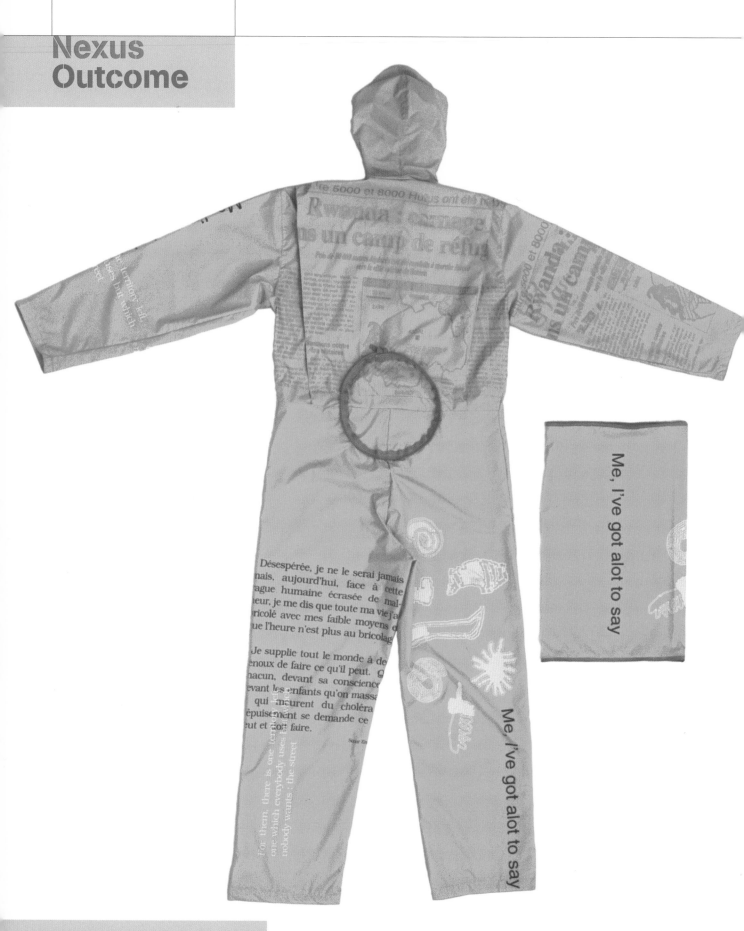

Nexus Architecture x 16 XLVI–Venice Biennale
1995 / Waterproof microporous polyester, silk screen print, zippers / 170x120cm.
Private collection Brussels, Belgium

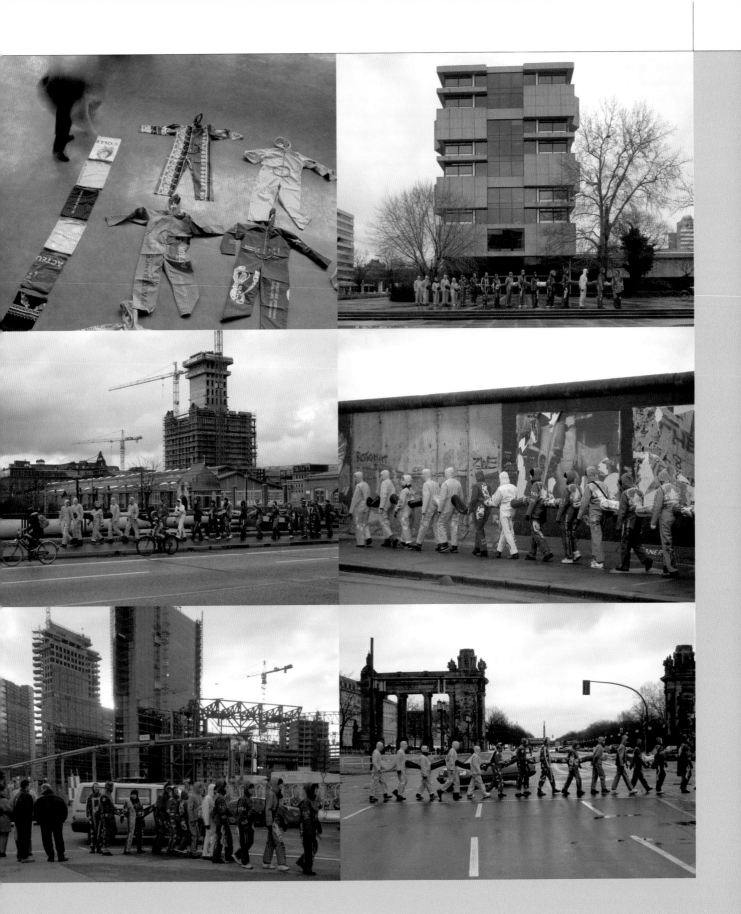

Nexus Intervention with Architecture Students
from the Technische Universität Berlin
1998 / Original Lambda colour photographs
backed on Dibon, six modules / 200x170cm
(60x80cm each).

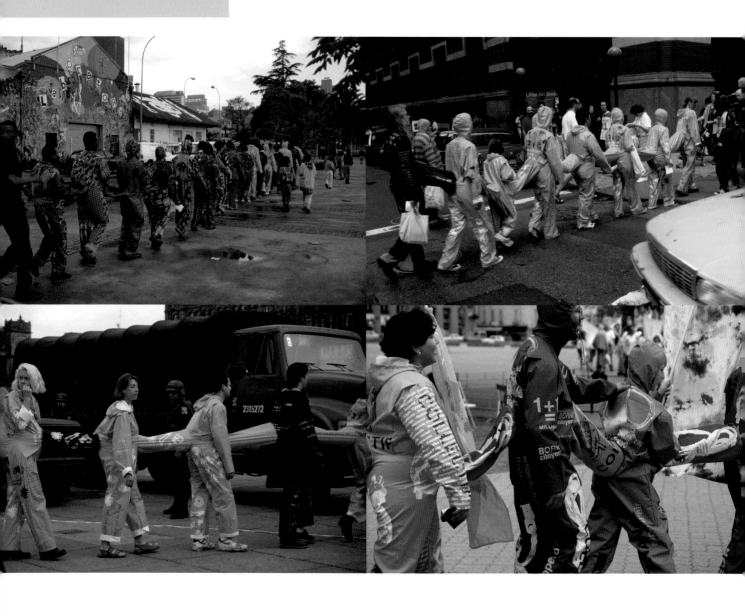

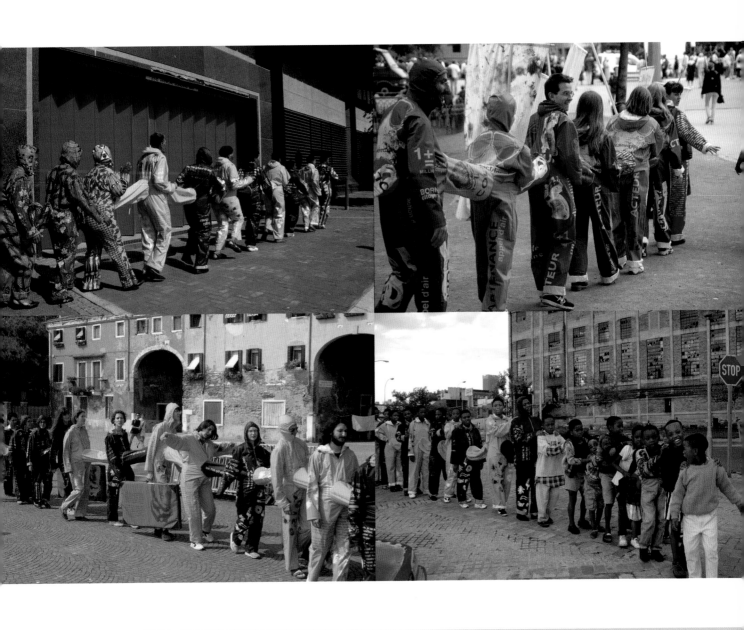

Nexus Architecture–Interventions
1993–1998 / Original Lambda colour
photographs, backed on Dibon, eight
modules / 60x90cm (each).

Nexus Outcome

_**Nexus Architecture x 50–Nexus Type
Opéra.tion**_
2001 / 25 Nexus overalls, microporous
polyamide, silk screen print, zippers
/ approx. 400x400x200cm.

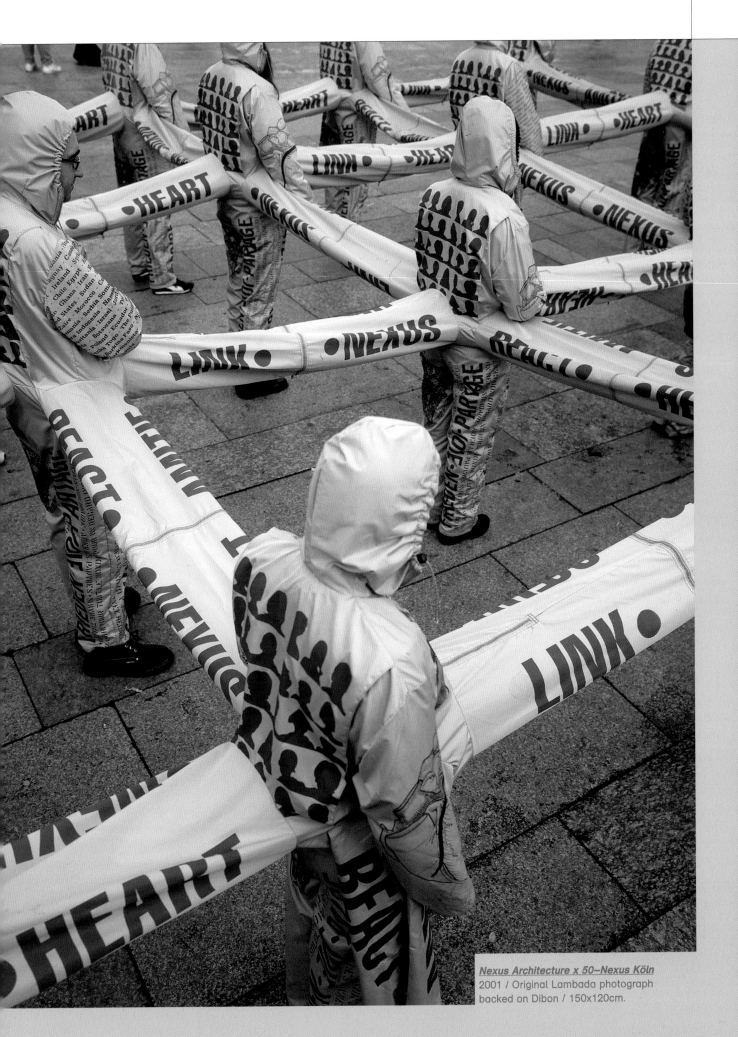

Nexus Architecture x 50–Nexus Köln
2001 / Original Lambada photograph
backed on Dibon / 150x120cm.

Vision

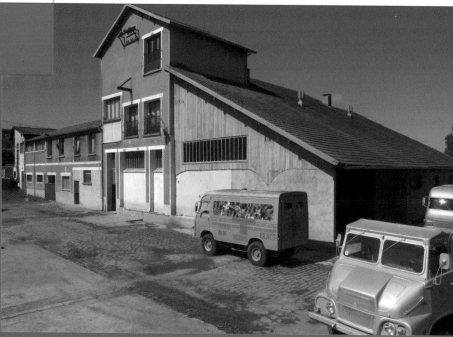

THE DAIRY—The Artist's Studio.

THE DAIRY—LA LAITERIE MODERNE is situated in the Brie region of France, along the banks of the Grand Morin River in the hamlet of Saint-Siméon. One of the last remaining examples of late nineteenth century 'modern' dairies, it employed over 300 workers in its heyday, supplying milk by train to Paris and the regions.

When Lucy + Jorge Orta purchased the factory at auction in 2000 very little remained of its pioneering past. Many of the architectural features had been neglected, the immense workshop with splendid beamed ceiling, vaulted brickworks, typical Briard style outhouses and railway traction station had all fallen into disrepair, resulting in an interior of rusty steel, crumbling paintwork and cracked cement.

Immediately the artists began the laborious task of renovating the workshops, to re-locate their research, production and storage facilities from central Paris. As the charisma of the Dairy was uncovered from under the layers of neglect, a new social enterprise began its gestation.

THE DAIRY—A Collaborative Creative Forum

THE DAIRY has become an extension of the artists' practice: the staging of a social bond. Rooted firmly in the belief that the creative disciplines should debate and rethink the traditional principles of social structures and introduce new ideas that have a profound engagement with society, urban planning, cultural heritage and political and ecological policies.

After the years of working experience with the community and the rhizome networks, the Ortas have started a dialogue with like-minded thinkers in arts universities and academies internationally, the Dairy has begun hosting workshops, residencies and curatorial projects for young and established creative thinkers.

it is here that the artists hope that new ideas will go on to trigger new creative mechanisms for the work and reflections of others.

THE DAIRY—Think-Tank

UNIVERSITIES AND SCHOOLS: Design Academy Eindhoven; University of the Arts London; Ecole Nationale Supérieure des Arts Décoratifs Paris; Lycée Technique et Agricole Commune de Saint-Siméon; School of Architecture Bogotà. CURATORS: Edith Doove, Bergit Arends, Mark Sanders. ARCHITECTS: Fiona Meadows, Frédéric Nantois, Shigeru Ban, Nasrine Seraji. ARTISTS: Andrea Zittel, Mark Dion; J Morgan Pruett; Christiane & Ralf Dellbrügge & De Moll, François Girbaud. LANDSCAPE ARCHITECT: Alain Freytet. COMPOSER: Simon Stockhausen. GALLERIES: Galleria Continua San Gimignano-Beijing; Peter Kilchamnn Zurich; Motive Gallery Amsterdam; SPIRITUAL: Tibetan Monks. LOCAL: SNCF; Regional Council for Architecture Heritage ACT ART (Seine-et-Marne). NON PROFIT: ATD Quart Monde Paris, Les Deux Morins, Saint-Siméon and more to come.

Discussion Janna Graham

Participation, Becoming, Action

Janna I never know where to begin, but perhaps, in this case, given that this is the first time you have been interviewed together, we should begin at the beginning. How did you encounter one another and then come to work and be together?

Lucy We met in 1991 in Paris at the opening of an exhibition of Jorge's recent work at the Galerie Paris-Bastille. It was the outbreak of the first war in Iraq. Jorge was frantically preparing a street action with the help of young artists and peace protestors, creating banners and protest documents using silk screen techniques. They resembled nothing of the traditional anti-war protest media and this intrigued me. My mother had been an ardent activist during my youth, involved in actions and causes such as Greenham Common, environmental, heritage, and social welfare for immigrant Asian women, to name but a few. I was a recent fashion school graduate, establishing a successful career in the Paris fashion scene and had been involved in small pockets of activist work. Frustrated by the lack of a social or political agenda within the fashion world, I joined Jorge's collective in his Bastille studio and this sparked a greater awareness of the potential of our creative powers and how these could be of more benefit to society. As well as Jorge's socially motivated processes and outcomes, I was interested in the pedagogic dimension of his artistic practice. This played an important role in my early intellectual and artistic development. Meeting Jorge marked my gradual entry into the domain of contemporary art.

Janna It seems that there is a very particular pedagogical approach that has endured in your collaborative work, aligned with traditions of radical or even anti-pedagogy that are being recuperated in current art and activist practices. How did pedagogical interests enter into your working process?

Jorge My passion and engagement for art was an extension of the youth movement ideologies, in particular the obsession that we needed to build a more equitable world. Convinced that art had an important role to play in this process, it was important that we look for new audiences beyond the closed conservative circuits that existed in Rosario in the 1970s. I explored and experimented with all kinds of new approaches to making and diffusing art to the public at large; infiltrating the poetic aspects of art into people's daily lives, removing art and the artist from their pedestals. The reverberations of the youth movements were dying out in Europe, but gaining in strength in Latin America as a result of the Che Guevara utopia and the new liberation theology. It was period of revolutionary ideas involving the universities and elitist intellectuals.

As a consequence, the dictators General Pinochet in Chili and General Jorge Rafael Videla in Argentina took over power between 1976 and 1983. The state of siege banned the organisation or holding of private or public meetings. To counteract this, we engaged in unofficial modes of organisation. For example, we used the phone book as both a way of structuring chance encounters and creating communication pedagogies. We chose 500 people by chance over several pages, and contacted them one by one using human messenger services and coded postal mailings and sent a mini-exhibition to each person's home. Sometimes we telephoned a few and conducted a poema-concert (concert poem) over the phone. The interrelations we wove together in this process prefigured the work that is conducted by the internet today. Our work was done collectively, with the complicity of young artists, friends and a group of my art school students.

Lucy Orta Jorge Orta

Janna Did the political situation necessitate a collapse between what elsewhere might be distinguished as artistic and organising practices? How did you conceptualise the relationship between the two?

Jorge We definitely invented our own ways of existing as artists. Of course, the museums were not interested in this art form, we were too far removed from traditional aesthetic preoccupations of that period, there were no commercial art galleries as we know them today, and we didn't even have anything to sell. Most of our work was given away for free. This is why we developed our own distribution/communication strategies. With my personal mentors and friends, artist Edgardo Vigo and Graciela G Marx in Argentina, Clemente Padín in Uruguay and Damaso Ogaz in Venezuela we developed Mail Art, to exchange our ideas and strategies in Latin America and elsewhere overseas. We believed in the statement: "an art from the base upwards, without artists!" The relationships: artist, artwork, production, diffusion and spectator, were the centre of my personal preoccupations, I thought that the artist, in his new role, should be the mediator of a collective process, someone who could develop the subjacent 'feasibility structures' that could help realise the ideas and projects.

Janna Did this notion of a "an art from the base upwards, without artists!" develop in relationship to the re-arrangements of power taking place in the self-organised 'base communities', that were growing out of the liberation theology movement in Latin America?

Jorge This notion was omnipresent, my stance was opposed to the general Marxist tendencies of the universities, which advocated the armed cause symbolised by Che. In this very Catholic continent, I was close to the young pastors and very active in the new theology, which supported the underprivileged and minority communities, opposing the pressures from the extreme right wing and conservative church, which in fact formed the structural pillars of the dictatorship. I thought that the artist should disappear behind a form of collective dialogue and be representative of those that took part in it. There were no participants, I believed in co-creation, the possibility of a shared creation supported by a professional who could construct the 'feasibility structures'. This principle instructed our methods and guided us. We worked from the experience of the vivencia (lived experience), of contextuality, to render more radical our daily lives, each one of us knew that the experience of working together would someday be taken away from us. For a contextual art.

Janna I'm really interested in what you are saying about the work being representative of the people involved but am wondering if the aim was really to seek representation. My impression is that this was a context in which representation was nearly impossible, and art-making and organising converged to try to re-compose a set of social relations and orientations to power.

Jorge Yes, it's true. All of our energy was utilised to create interaction, a transmission about a shared moment in life. Often, at the end of each project, we would take apart the tangible things we had produced. People would create beautiful artworks for days and nights, to the point of exhaustion only to then dismantle them or to burn them to ashes and begin once again. The experiences we lived through and the accounts of these experiences were proof of the legacies of this living work that the static object was often not able to convey.

Janna This is such a different context from Paris in the 1980s, when you began your collaborative work. Was there any degree of translatability between what you were doing in Argentina and the way in which you approached your work together?

Jorge Coming to Paris in the 1980s was a complete shock and it took me several years to overcome it. In Argentina there was no economic goal in our work. We wanted to provoke and stimulate a collective voice and act for the transformation of society through artistic channels. We all had parallel jobs to finance our art and often deprived ourselves of our family lives. When I arrived in Paris, I encountered a commercial art world with no social goal or interest. The FIAC art fair was the parameter of professional achievement. I was enrolled as a PhD student at the Sorbonne and attempted to reproduce some of the actions and performances from Argentina. No one wanted to collaborate. My colleagues were interested solely in their work as individual artists and obsessed by sales. But then the first war in Iraq broke out in 1990, the stock market crashed and the wave of impact on the world economics led to a terrible recession. The art system disintegrated, imploded, and finally there was a reason to platform the issues I had left in Argentina. The Kurdish refugee exodus, street protests, the visibility of homelessness brought the possibility of engaging directly with new audiences.

Lucy The economic situation Jorge described led to deeper social catastrophes, but also a general sense of negative fatalism and that there was nothing worth fighting for. He was working collectively with a wide variety of people, mainly non-artists. Here their attitude was different—optimistic and constructive. There was a sense of community and shared ideology that was more fraternal than in existing Parisian artistic circles. This reality was also a million miles away from the mainstream egocentric contemporary art world and the world of fashion, where I was operating.

Janna This convergence of the two practices—one oriented towards object or commodity production and the other resistant, working socially and ephemerally—still seems very present as a tension in your work. On one hand, there is a clear social and pedagogical process and often a political stake, on the other a kind of condensation of this process into forms that can circulate within the mechanics of distribution in the mainstream art system (no longer in a state of implosion). How do you negotiate this?

Lucy I don't necessarily see it as a tension. The object is really important and can speak for itself. It is an extension of the collaborative process, enabling us to communicate these huge issues to a wider public. The object has a kind of universality and exists on a much longer trajectory. Look at the example of *Refuge Wear—Habitent*. This portable shelter was created back in the early 1990s. It has subsequently travelled around the world and is the most published and exhibited artwork from our archive. It was made at a time when homelessness was not part of public discourse, but it should have been. Now, 15 years later, we see tent cities cropping up all over France surrounded by unprecedented media attention. The project *Identity + Refuge* was conducted in collaboration with the residents of the Salvation Army. This work resulted in producing very unique items of women's clothing, which have been re-appropriated many times by eminent designers and fashion brands. The object has invaded different cultural domains, been reinterpreted, changed resonances, registering and re-registering. The object has the possibility to move between contexts in a way that processes or emotions cannot always do.

Jorge Lucy often made the remark to me, that the more I invested my energy in the process, the more removed I was becoming from art and the market that was beginning to take foothold and impose its rules, once again. It was a difficult period. How can we make art without giving way to a whole series of concessions or risk being excluded from the mainstream? Finally we took a decision and decided to work together, and produce a number of artworks that would be evidence of the numerous actions we had put into place. The strategy has proven appropriate and the repercussions of the artwork/process have multiplied.

Janna So the object is a kind of interlocutor shuttling between contexts and producing additional dialogue. But how does this relate to the political motivations in the work—the re-orientations of power in social and communicative relations—that seems to resist or problematise this kind of legibility? Are you concerned that the experiences of participants become homogenised and packaged into lifestyle products or reduced to simplified identity categories like 'homeless people' through this process?

Lucy When I created the *Refuge Wear* sculpture, there was a huge void of understanding between my activist motivations and the object. The formal aspects of the object were accepted but not its social implications. They would say, "The design technology of the tent-cum-poncho is amazing." I even won an award for innovation. On the other hand I heard: "What has this got to do with the problem of social housing. Art should not make a social critique." Maybe those that critiqued wanted to avoid discussing the problem altogether and suddenly the tent on a plinth was disruptive because it was too confrontational. Despite this, I must say that the circulation of the artworks within the museum or gallery circuit has been extremely important because they have established a dialogue with the critical domain and posed the questions that later were answered. Don't forget that historically, artists have depicted scenes of deprivation and horrors of war and we have a broader vision of our society thanks to these visual representations. Thankfully more and more contemporary artists are exposing us to our own reality and allowing us to reflect on our surroundings. Just look at the proliferation of the new photodocumentry techniques. But, aside from the museums, it is equally as important that the work engages in dialogue with a broader non-cultural audience, and in areas usually abandoned by the cultural sector. The director of the Cité de Refuge, Salvation Army in Paris wrote in the exhibition catalogue *Art Fonction Sociale!*: "Art and culture should be included in the world of exclusion, if we can't go towards it, it should come to us."

Jorge From my perspective, the development of an object per se was never the issue. It is more the process of collective reflection and communication. The object creates a passage through which we create a dialogue, it's a mediator.

Janna Jorge, this reminds me of a term you used earlier '*vivencia*', which is very familiar within the context of participatory action research and popular education methods that were developed by people like Paulo Friere—I'm thinking here of the way that objects or externalised representations function in his *Culture Circles* as catalysts for collective reflection upon which processes of analysis and action can be built.

Jorge For those of us involved in liberation struggles, the first question was always to consider the context that one lives in, and to consider from here how to articulate this in a communal voice. It was at this time that I created the

manifestos *Contextual Art*, and *For a Catalyst Art*, considering that the context is
the root, and the dynamics of art is the catalyst that encourages the process of
renovation. Lucy and I have incorporated this idea into the way we work, but this
is one of many methodologies we employ.

Janna Could you say more about these methodologies?

Jorge Sure. We work with four primary approaches. The first is close to the way
that we worked in Argentina. Within this approach we see ourselves as artists who
do not operate as individuals but as facilitators of a process for communicating the
sentiment or feeling or the direction of the group. The issue of investigation in this
practice is the communal sentiment. With our collaborators, we want to capture
the feeling of the time and to create a dialogue around the issues of the time. Our
process always begins collectively as a discussion through sketching and drawing
around a subject such as water. We jot down ideas, conduct visual and textual
research about the subject and begin to refine the issue until a common voice or
idea surges from the mass.

The second approach—and this is undertaken with or without community
collaborators—is to represent what is not being discussed. When we began, the
subject of migration, *sans-papiers* (without identity papers) or homelessness were
not part of the mainstream discussions. We felt we needed to intervene in this
subject. Lucy began working on *Refuge Wear* in 1990 as a result of the exodus of
the Kurd refugees. Later we focused on the problem of food distribution and
consumption, waste and recycling in the projects *All in One Basket* and
Hortirecycling. This research has been ongoing since 1996 and now food has
become an important part of the public agenda. From 1996–2006, with *Opera.tion
Life Nexus—The Gift*, we focused on organ donation. A friend who died waiting for
a heart transplant made us aware of the fact that there are thousands of deaths
per year in France due to lack of organ donations—in a country that can afford
solutions. The role of art in this approach is to generate workshops, actions, to
awaken consciousness. Over the 15 years and in the 40 cities in which we worked
on the issue it has become adopted as a public agenda item.

The third approach is to generate broader social processes through contamination,
by bringing together a wide diversity of partners from very different domains.
We are not animators, but a coordinators of a much larger structure, instigating
a whole series of processes, creating a longer-lasting ripple effect.

Lucy An example of this was *Escuela 21*, a project promoting popular education
in South America. In Medelin in Colombia, together with architect Juan David
Cavez Jorge instigated a series of community workshops around the project *Life
Nexus*. As a result of this sequence of actions a common desire emerged which
was the renovation of a rural school in Palmichal. The ambitions far exceeded
what we had originally intended. Together with the National Faculty of
Architecture, the Bolivariana Faculty in Bogota and the local community, we
actually constructed the school, which is also a sculpture. It functions as an
educational machine. Marina Rothberg is currently animating a similar project in
the Escuela Morena in Buenos Aires. We know that if we could mobilise more
people, institutions and partners, we could develop many more schools like this.

Janna In at least two of the three approaches, there seems to be an emphasis
on manifesting concrete change in the world and building transformative
processes of becoming—based on open, collaborative explorations of desire.

This is both incredibly important and incredibly dangerous, given the current trend toward instrumentalisation in public arts policy and the use of the arts within some development frameworks. In many places, these kinds of measures subject socially engaged practices to highly rationalised, outcome-based evaluative frameworks, requesting that artists do everything from bringing conflicting parties together in harmony to assuaging tensions between real estate developers and local residents. Beyond their bureaucratic excesses, what is often so problematic about such frameworks are their assumptions about what social transformation would look like. Their conceptions often neutralise, replicate and consolidate current structures of power, or pacify what might otherwise be a process of radical resistance. How do you negotiate these frameworks, and how do you register or understand the impact of your projects beyond these controls?

Jorge This is something we've been thinking about quite a bit. The question for us is how do we now act upon a process of real social transformation. Not within a theoretical paradigm, but through actions, not talking about transformation in the way that all of art becomes a discussion, but something concrete, sometimes even scientific, in a way that actually engages in social intervention and modification.

You talk about becoming. For us, the subject (or 'cause') of the work has not been the most important thing. It is the process that is used. When a painter chooses his subject matter, it's not whether it is a still life or nude, it's the analysis. While the issues that we have chosen to work with are important, the real subject is the transformation of relationships between people. The problematic is always the same, whether someone is sleeping in the street and we don't see them, or someone dies anonymously because no organ is available for them, or the tens of thousands of children die due to lack of water, it is always social fragmentation and the lack of opportunity for collective voicing, analysis and action. It is the neglect that we've had for each other.

Janna This production of disaggregated subjectivities is also a result of the way technologies of power operate. This is why working from effect to processes of group analysis seems so important in your attempts to inspire constituent power through actions and actualisations. But then again, we have the problem of how the processes are then signified. The framework for understanding the projects you describe, sounds quite different from the formal and symbolic analyses of 'relationships' that are often attributed to it by critics. How do you articulate these processes for yourselves? You used the term scientific?

Jorge Yes, sometimes I think you could use the same critical text for any artwork. But this brings me to the fourth approach. We try and employ a scientific methodology, which I learned from my director of research Professor Ricardo Bruera, ex-Minister of Education in Argentina. Dissatisfied with the current trend of art where anything is permitted, we try to incorporate a notion of evaluation into the processes and resulting artwork. After defining an objective or formulating a hypothesis, we then begin the stages of experimentation and development using all forms of collaboration. An objective system of evaluation can either confirm or re-position the initial hypothesis, which means that we need to start the process all over again.

Lucy The *Life Nexus—The Gift* project taught us this lesson. It was initiated in 1996 when we began questioning people about the problem of organ donation, organ trafficking and their experience of the unnecessary deaths due to lack of

information or understanding of the problem. We workshopped these issues with groups of people, sketching, painting and modeling heart forms with the various participants and they would talk about organ donation and the notion of gift for life. The more the heart representations proliferated, amongst the various communities, the more people began to discuss the issue and even dialogue between each other. Doctors, heart specialists and non-profit organisations became interlocutors, and interdisciplinary networks of people emerged. About eight years into the project, cultural institutions started paying attention, many of whom had been negative in the beginning. After the *World Transplant Games* in Nancy, 2003, an external audit was conducted to evaluate the increase in awareness of the issue of organ transplants as a result of the multiple actions we had initiated in the Meurthe-et-Moselle region. The results were incredible, 30 per cent more people in favour of organ donation. We realised that the only way that we could attain this depth of result was to sustain the work over time. Since then our research and projects extend over a period of five to ten years minimum.

Janna It's interesting that the project far exceeded its affiliation with formal arts organisations. For me, the format of the exhibition, or programme have always been difficult to reconcile with ongoing processes of social production. Have you found a way to register the experiences of participants in your gallery exhibitions? Is it important that they be understood in this context?

Lucy Until recently, museums or galleries were not so interested in exhibiting these kinds of processes, or fully recognising the contributions of participants, stating that it was too pedagogic. We have also refused to exhibit really significant collective work because the participatory element was not sufficiently recognised by the curatorial staff. It's a difficult negotiation that we have had to overcome. It's important that the voices of the groups have a place within the institutions, and that the productions that come out of this process are of a quality that makes them significant evidence of that process.

In the museum exhibitions, whenever we have had *carte blanche* from a curatorial perspective, we have included aspects of the process, through photography, texts, recordings, web forum projections. We have made a whole range of beautiful objects to contain the tangible results of the collaborations, such as the crates, shelves, kits, vitrines or work benches (*Container; Data Draw; Magic Carpet*). Each of these artworks archive the collective endeavour in whatever form the workshop took: drawings, moulds, objects, notes, and sound recordings. Wherever possible, the artworks have even been signed by individual members of the group.

Some of our most interesting projects have been running the workshops as part of the exhibition, actually being present to dialogue with the public visiting the show rendering totally transparent the process from all angles—*Fluid Architecture* at Stroom Centre for the Arts in The Hague; *OrtaWater* at Boijmans Van Beuningen Museum in Rotterdam.

Janna Is this the process of 'contamination' that you described earlier? In this sense, has there been a difference between working in the context of an exhibition and working with education departments in galleries?

Lucy Working with the educational departments, outside of the exhibition environment has always been open, fluid and challenging and above all a real team endeavor. At stake are actual people and their feelings, so the human factor is a prime consideration. It's obvious that static exhibitions are easier to install

because curators only need to deal with inert objects. But there is a veritable new model of curating emerging with education departments playing a more critical role in the life of the work on exhibit, exhibiting more of the processes and less of the outcomes. This is what we have been searching and bargaining for over the last 15 years.

Janna I suppose here there is an issue with how we understand aesthetics. It seems as though that in these processes you are attempting to articulate a definition more akin to what theorist Suely Rolnik describes as "mutations of the sensible"—whether they be subjectivising affects or the kind of aesthetics that Jacques Rancière describes as a distribution or re-distribution of what is seen/not seen, what is heard/not heard. This became really clear to me in *Commune Communicate*—the work that you did with prisoners, in which their recorded testimonies were taken into the street and the responses of people on the street were taken into the prison. Elsewhere, you have described an "aesthetics of ethics". Is this what you mean?

Jorge The aesthetic of ethics is a manifesto, which explores the poetics of an ethical action, through the mutation of the object's formality towards the behavioural aspects, which in turn becomes the aesthetic work. This is founded on the principle that art is a catalyst and contains a real capacity to transform. The total realisation or total aesthetic is in direct correspondence with its ethical coherence. The idea is to build and construct and build again, not to destroy. This goes beyond the intentions of traditional aesthetics, and is more involved in an ethical dynamic, which defines the artwork.

Janna This dual emphasis on production and communicative transformation reminds me of Deleuze when he talks about the relationship between the wasp and the orchid, each imprinting another, so that some other form of subjectivation or subject-making process occurs. Is this how collaboration functions within your relationship with one another or do you maintain separate identities? How does this function within your relationships with other collaborators?

Lucy Over the years it has become very difficult to separate who did what. We are too finely woven together. The art context often wants to attribute a more defined separation to our independent practices, but eventually we hope there will be just one Orta.

Jorge Yes, Woman/Man, Fashion Designer/Architect, English/Argentine, Lucy/Jorge. It is, of course, much less clear. All the time we have been living, working, parenting, being in love. This complimentary fusion is now more evident in our work.

Lucy With our community collaborators, the identities are more evident in the outcomes of the work, which differ from project to project. We are beginning to experiment a new collaborative methodology, where we become more removed from the participants, working closely with a team who act locally/contextually and on a more sustained level a 'franchised action'. *Dwelling X* is an example of this. Director of Education at Angel Row Gallery, Katy Culbard approached local Nottingham-based artists Trish Bramman, Trish Evans and Marcus Rowlands, to work on an intensive level with the community, developing the themes and working methodologies from our previous *Dwelling* workshops to incorporate new techniques and experiment with new materials. The result of the process is quite astonishing.

Jorge The projects become channels for all kinds and categories of emotions and needs which differ depending on each individual. We conceive of this as co-creation. We are professionals with certain competencies who are capable of guiding a process that can result in an artwork. It is a combination of vision, of poetics, of *vivencia* and techniques, which set about the process of materialisation and transfer of experience.

Lucy This was very clear in *Fluid Architecture*, a project that we developed with architects, designers and theorists in Melbourne. Michael Silver from RMIT Industrial Design, proposed the idea for the *Nexus* strap or harness that would develop new connectivities between people, many participants expressed a profound shift in their perception of the other as a result of the process of co-creation. The methods Michael employed have been duplicated in many workshops, producing the most extraordinary experiences and artworks.

Janna Materiality and the concrete are recurring themes in your work/lives. It seems, however, that you are moving toward a kind of materialism that manifests itself in the encounter (Althusser), rather than in the creation of an object *per se*. How are you approaching 'the future' in more recent processes (I'm thinking in particular of your creation of a series of workshops)?

Lucy + Jorge We would like to fuse the actions and the resulting artworks, the immateriality of the process and the resulting durable object, into one indissociable whole.

Now that the museums are absorbing the processes, it's time to move on together. We can no longer be present in all the different places at one time, work with so many communities simultaneously, we have tested different collaborative methodologies including even simultaneous online workshops and the new 'franchise actions'. Now it's time to consolidate our energies, think of a new long-distance, collective way of working that is even more focused than before. Huge obstacles are to be overcome and to accomplish them we need to exceed the simple Lucy + Jorge actions. We are constantly experimenting with a way of building this common energy, to become veritable catalysts. We would like to become active agents in a world that we are all dreaming of.

Do It Yourself Emma Gibson

www.studio-orta.com/dform_project/

DFORM–Emotive Nexus

Dform experiments an interactive design programme that enables the modification of the basic worker's overall pattern-block. Key pattern-lines on the block are linked to the slide-bar tool enabling designated traces to be shortened, elongated or curved to predifined conceptual and technical parameters.

The navigating participant responds to personal questions to alter the pattern-block thus creating a symbolic/emotional relationship with their garment. The transformations are recorded and can be printed on a desktop printer, enlarged and marked, ready for making-up.

The garment's root remains constant, yet the final visual manifestation is unique to each author. All participants are inextricably linked through their design process visible in the online gallery.

create a new pattern

pattern-block archive

Studio-Orta / Interactive design by Nicolas Myers / Pattern design by Isabelle Lintignat / Pattern cutting by Peter Cox.

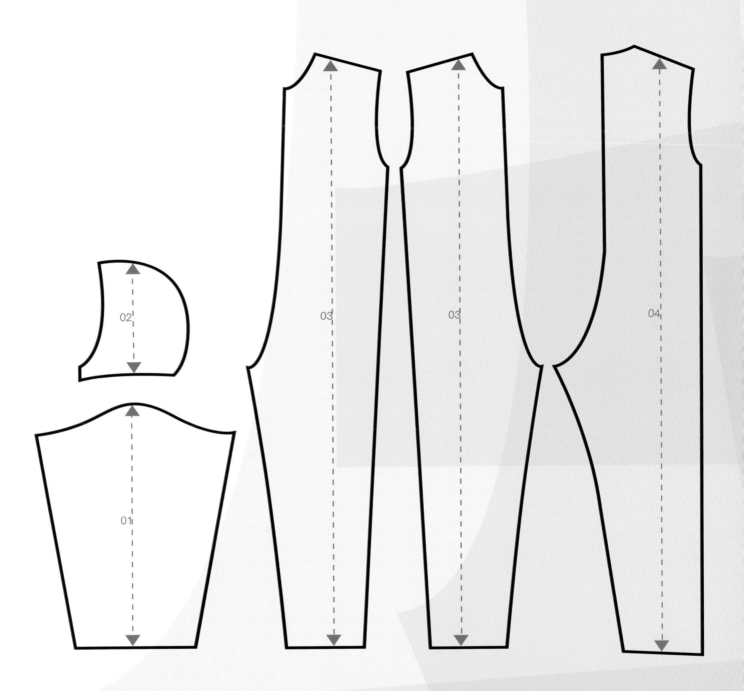

01 SLEEVE

126

Move the slide bar to play with the pattern volumes according to your temperament.

OFFENSIVE	❤	**DEFENSIVE**
DISTANT	❤	**DEMONSTRATIVE**
FRAGILE	❤	AFFIRMATIVE
AUTHORITARIAN	❤	NONCHALANT
AMBIVALENT	❤	**TENACIOUS**

➤ **next step**

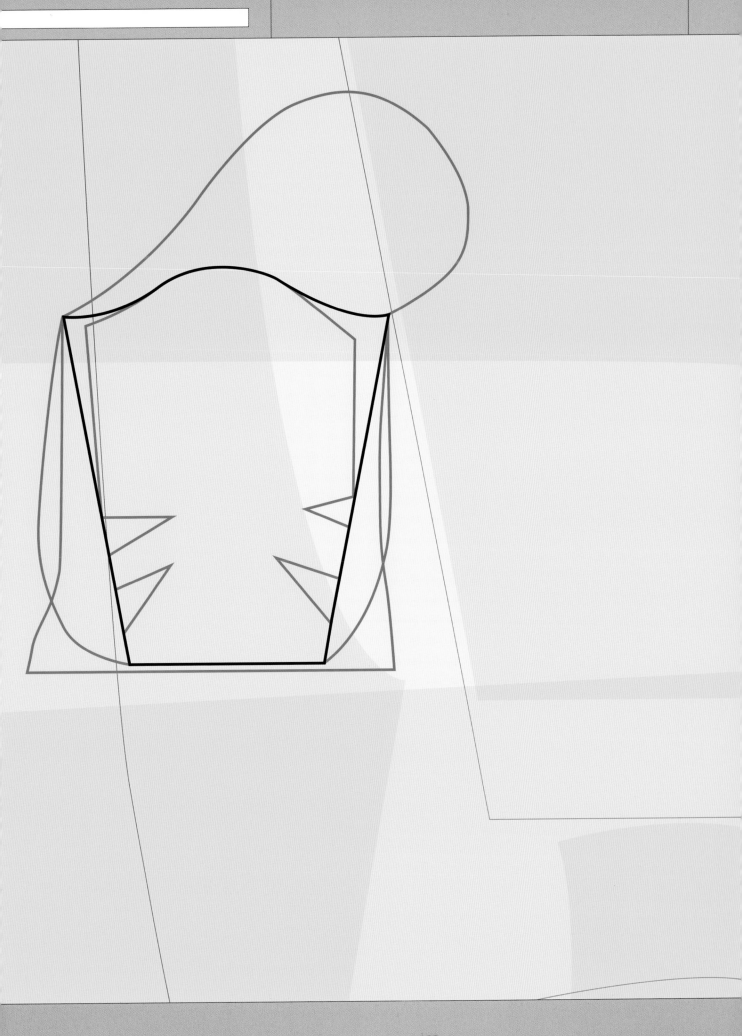

02 HOOD

The volumes can be changed as often as you like.

LOGICAL ❤ CONFUSED

UTOPIAN ❤ PRAGMATIC

INTROVERTED ❤ ACCESSIBLE

➤ **next step**

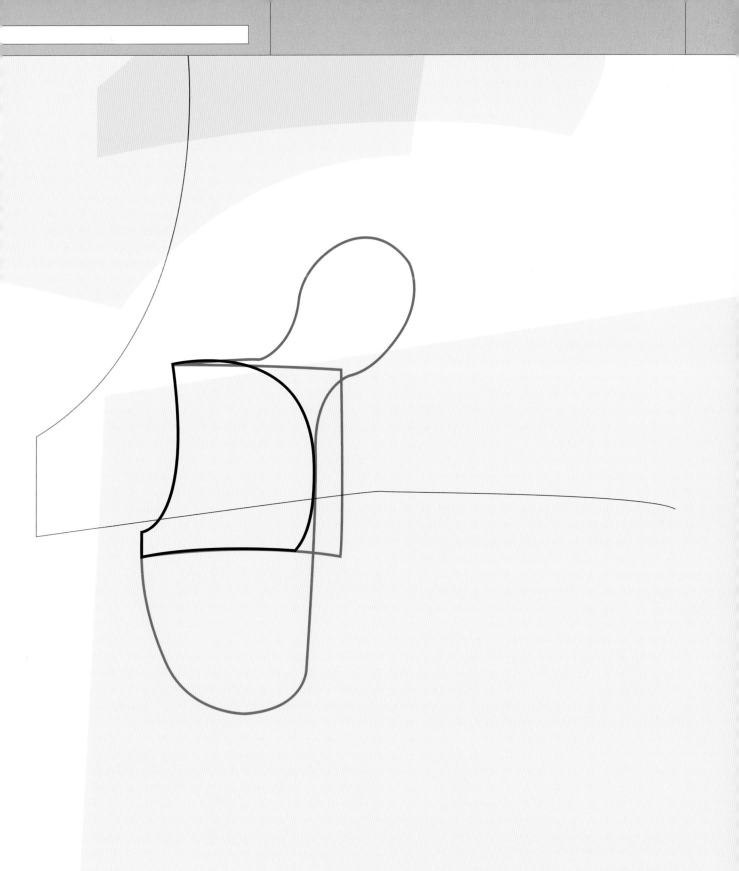

03 FRONT

The layering of the traces reveals the final pattern.

RATIONAL ❤ INDIFFERENT

UNDECIDED ❤ **CONVINCED**

COMPLEX ❤ STRAIGHTFORWARD

CLUMSY ❤ **AGILE**

➔ **next step**

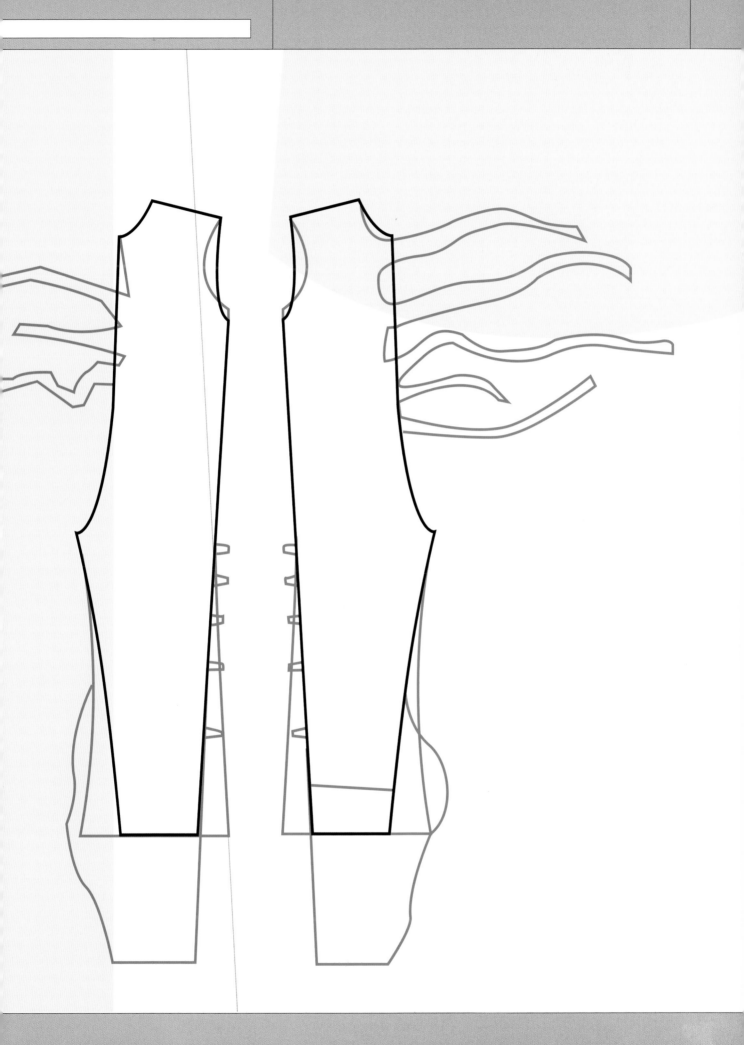

05 ORTA LUCY

→ **print the pattern**

→ **home**

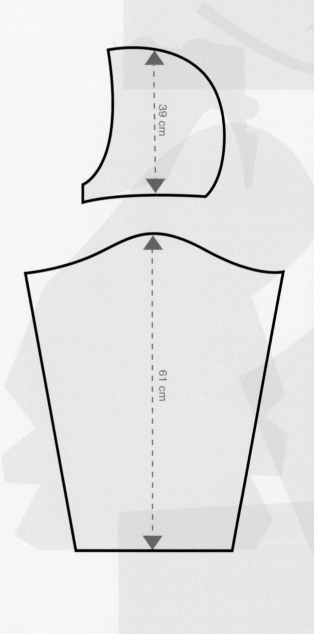

39 cm

61 cm

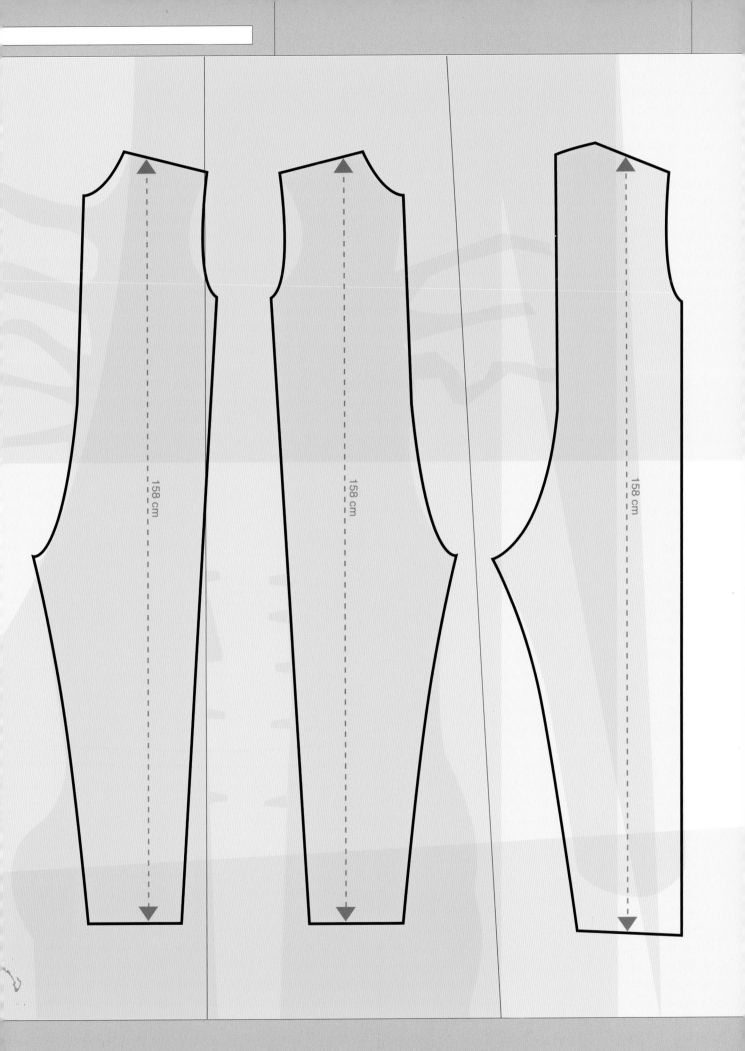

158 cm

158 cm

158 cm

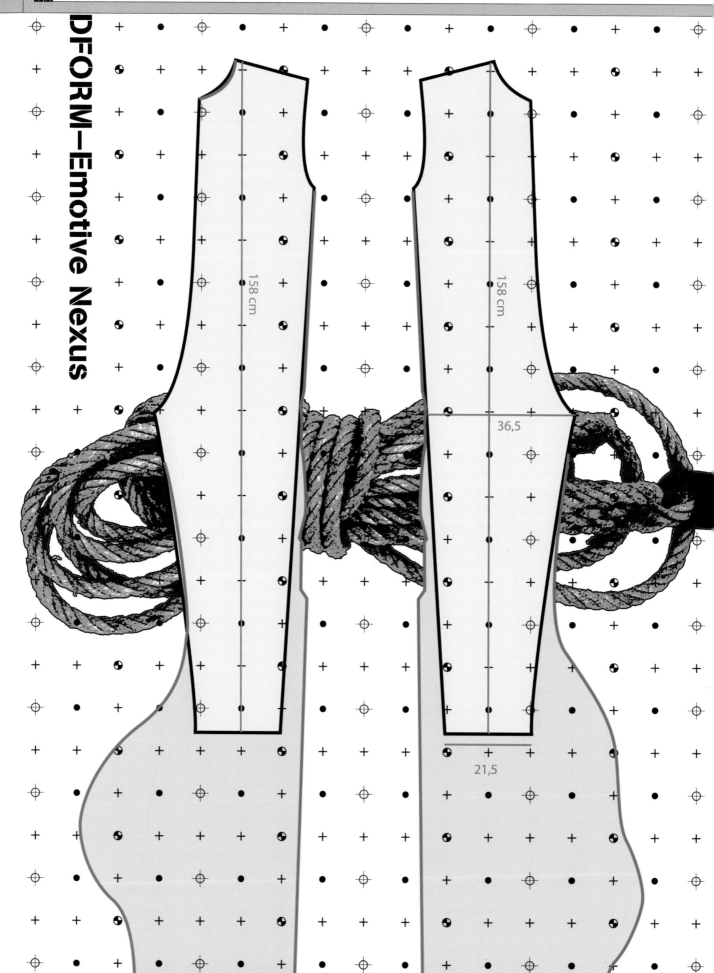

DFORM–Emotive Nexus

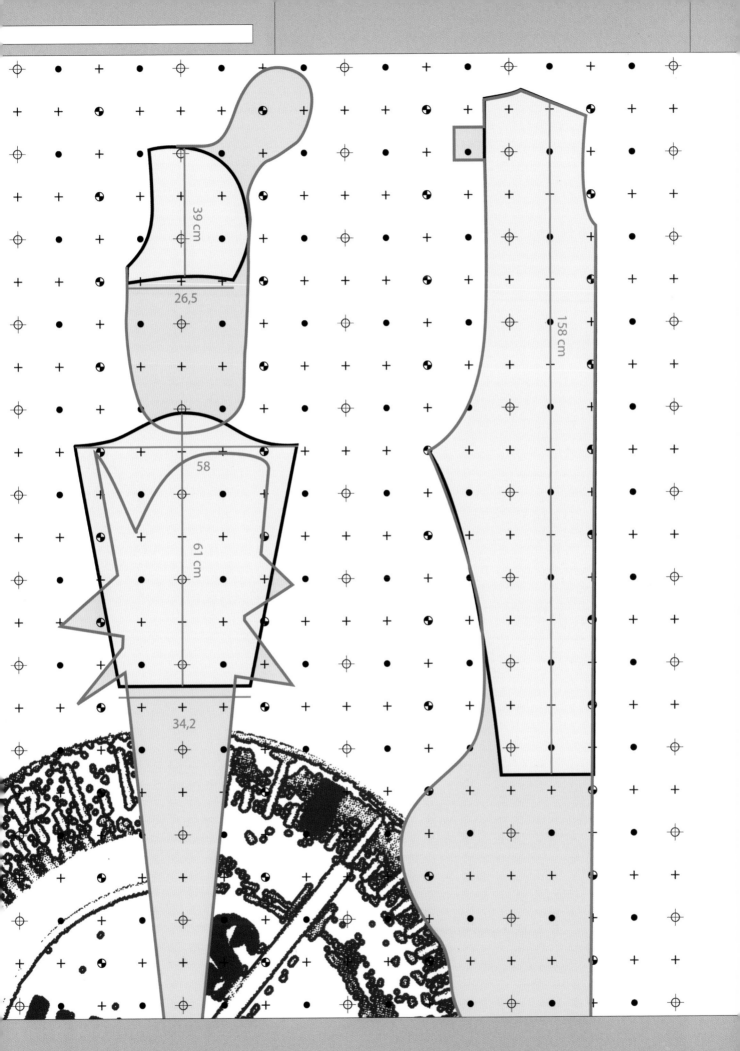

39 cm

26,5

158 cm

58

61 cm

34,2

Challenge Chris Wainwright

LIVING WITH(IN) THE ACADEMY

The inclusion and acceptance of socially aware practice in the art academy is seemingly not a contentious debate anymore. It is broadly recognised that there is a need, even a responsibility, for students and artists to reflect and comment on the complex, often contradictory or binary positions of personal reflexivity in relation to broader contexts of political or social conditions. Equally the debates surrounding the importance of research, the function of discourse, process as practice and the role and purpose of the artefact are well articulated and continually interrogated within a critical academic climate. There is a danger, however, for these debates to become hermetic.

Studio Orta with its ideological positioning and proven tactical approach to cross-disciplinary cultural production, provides a compelling model that demonstrates how artists can contribute to and influence the creation of a socially engaged community of artists/educators. Through well-researched collaborations and partnerships, Lucy + Jorge Orta make a valuable contribution to the propositions for an expanded agenda and function of the art academy in the twenty first century.

There are inevitable problems with adopting such a model that raises questions both for artists and institutions when initiating projects based on a responsible, socially engaged practice. These relate in part to questioning the nature of collaboration, authorship, reception, sustainability and the ability and need for artistic intervention to raise awareness and contribute to change. There are fundamental issues concerning the redefinition of the academy itself when challenged by a model that proposes legitimate questions around areas such as creative intervention, participation and audience in a more fluid and contingent relationship where the art academy is only one of a number of engaged agencies. There is also a need to recognise the participatory nature of this approach to cultural production that acknowledges and reflects the conditions of those placed in the assumed position of its receivers, or audience and how they in turn participate in the conceptualisation of projects. In other words, how to avoid the familiar scenario of high profile public interventions that cease to maintain significance or purpose once the art circus has left town and moved on to another place or community within which to establish and initiate another project.

The art academy's relationship with its external communities is central to its purpose, going beyond the traditional function as a detached onlooker, a commentator and reflector of the world seen and interpreted through the eyes of a privileged creative class. There needs to be a considered and strategic approach to positioning itself, and being identified, as a generator of progressive and inclusive educational opportunities and as a centre for innovative cultural production that creates social as well as intellectual capital.

This of course raises further questions about how the academy is both populated and supported. How it develops pedagogic models that embrace the need to contribute to and influence society in order to amplify both individual and collective voices speaking on important and increasingly pressing social and political issues affecting our lives. How it achieves this whilst retaining independence and promoting experimentation and originality is arguably one of its greatest challenges.

Resource Sophie Hope/B + B

142 Mediation

145 Participation

148 Politics

151 Utility

Introduction
12 projects / 14,235 days / 156 places / 1,240 people

This chapter revisits 12 art projects initiated by different arts-based practitioners. These brief, one-page encounters aim to provide extra reference points, which the reader can use to plot Lucy + Jorge Orta's practice. The selected works do not offer direct comparisons to their work, but instead rethink ways to represent both the poetic and pragmatic elements of projects that are often invisible, misrepresented or taken for granted. These projects have been included for the way in which they animate discourse, creating an eclectic resource for critically exploring art as a contentious location for social change, co-production, political activism and participation. The 12 projects presented here are at times mediated by artists, often initiated and directed by artists and nearly always leave behind memories of experiences that carry on down a multitude of untraceable avenues for years to come. The projects are reliant on people described as audiences, participants, sometimes co-authors, or even consultants. They can be labelled 'political' in terms of attempts to change something, express solidarity or engage in protest. Those involved (either directly or on the edges) identify something useful about the experience, although what it is they find useful is not always the same.

These projects are articulated through four themes that relate to the Ortas' work: mediation, participation, politics and utility. These four strands can be found across the work of Studio Orta. For example, *Fluid Architecture* and the Dairy are templates for interaction and sites of mediation for the staging of a social bond; utility is demonstrated in their project *Escuela 21* in Colombia where a series of workshops led to the establishment of a school; Studio Orta are also interested in developing concrete, scientific modifications to try and influence political change, for example, following their project *The Gift–Life Nexus* of ten years across 40 cities, organ donation is being adopted as a public agenda in some of those places; and in the production of *Refuge Wear* and *Survival Kit*s people are invited to participate in collective acts of designing and making.

These project files provide further instances of mediation, participation, politics and utility such as an interpretation of the role of artists Helmut and Johanna Kandl as mediators between communities living on either side of the Czech, Austrian border and a look at the utility of a team-building weekend initiated by Anna Best for staff of [a-n] THE ARTISTS INFORMATION COMPANY. Where possible, I have also included quotes from interviews with participants, audiences or artists of the projects.

This chapter stems from my work on the B + B Archive, an ongoing collation of material, stories and contradictions within socially engaged art practices that have cropped up on B + B's radar over the past six years (B + B is a curatorial partnership between Sophie Hope and Sarah Carrington). The B + B archive, as well as a physical resource, represents a way of working. It presents a framework for revisiting art that resists straightforward representation in gallery settings. Thank you to Jennifer Maddock for contributing to the writing of these profiles.

http://www.welcomebb.org.uk/

Mediation

Participation

Politics

Utility

Mediation
dünya dinlemiyor

Representation, the voyeuristic gaze, collaborative transactions, access to authorship and the consumption of the image are concerns that are exposed through the work of film and video artist Phil Collins. By embracing opportunities for exploitation, cross-cultural communication and self-representation Collins critically examines the power and potential encoded in the artist's role as mediator.

Filmed in Istanbul in 2005, *dünya dinlemiyor* is the second in *the world won't listen* video installation series. The first instalment of the trilogy was produced in Bogotá in 2004, and the final film was made in Jakarta in 2007. Using a karaoke machine, Smiths fans are given the opportunity to perform their favourite song from the album *The World Won't Listen*. Each individual is filmed before the camera attempting to keep up with hits, such as "There Is a Light That Never Goes Out" and "That Joke Isn't Funny Anymore". Collins uses The Smiths' music to transmit culture and establish identification between one and an 'other'. *dünya dinlemiyor* diminishes the distance between the viewer and the 'subject' through a mutual pop culture connection. Working in locations continually pictured in the media as sites of conflict and political unrest, Collins disrupts conventional and homogenising media overrepresentations of a geographical place. In *dünya dinlemiyor*, Collins constructs a community, or an understanding of one, around an alternative pole of representation and point of reference. The artist stages an event for the individual to perform an identity within the pop cultural framework the artist provides. Rather than seeking to unambiguously 'represent' a community or individual through mediation Collins presents a condition for critically drawing attention to the staging of representation itself.

By creating conditions for self-representation, in *dünya dinlemiyor*, Collins also performs a temporary, yet ambivalent, disruption in the social relations of production between 'author' and 'producer'. Through their participation, the singers in the video gain access to the means of production and authorship. However, Collins retains ultimate authorship and it is within specific instructions that the participants act. Rather than a collaboration, Collins' practice can be viewed as centring on transactions that expose the tension between desire and exploitation involved in representation. The viewer treads the fine line of voyeur; placed at a remove by the camera. *dünya dinlemiyor* initiates a transaction characterised by generosity and trust, but within which the artist retains authorial control.

dünya dinlemiyor is an example of Collins' nomadic strategy of temporarily occupying and representing people whose cultural and social situation he is outside of. The tensions and ambivalences in this practice engage with processes of appropriating experience, authorship, objectification and voyeuristic consumption. However, the artist exposes and engages with these tensions by deliberately positioning himself within them. Employing a practice steeped in romanticism and desire, carrying the possibility of shared experience and beauty, Collins uses his camera as an equivocal tool to seduce, to stage transactions and to interrogate the artist's role as mediator.

_ Phil Collins, dünya dinlemiyor, 2005
Part two of the world won't listen, synchronised three channel colour video projection with sound, approx. 60 min, and poster installation.
Courtesy of the Artist.

Date	2005
Place	Istanbul, Turkey
Support	The Artist

"In my recent work I would say that although I'm engaged with social and historical conditions, I'm not focused on biography or autobiography but am reflecting on modes of perception: the ways we might see or think of another, and the politics and problematics of these ways of looking."

Phil Collins

Mediation
Silwood Video Group

Working with different interest groups, the Silwood Video Group places emphasis on building and establishing partnerships between and among different people and communities within an area. The Silwood Video Group was initiated in 2001 by Spectacle, an independent media company that critically embraces a myriad of issues and challenges particular to contexts of urbanism, regeneration, social exclusion and community-led documentary filmmaking. Spectacle's practice is to create a video group wherever possible. The Silwood Video Group began with an invitation to Spectacle from Groundwork, the environmental regeneration charity, to use media as a strategy for outreach within the community on the estate. The project then grew beyond its original remit, in various self-funded forms. Currently Silwood Video Group is without a stable and fixed home. Past footage is kept in the CyberCentre and the Silwood Estate awaits a proposed community centre planned for 2008.

The Silwood Estate in Rotherhithe, south east London, is an area of continuing development and urban regeneration. Initiated by Spectacle in 2000, the Silwood Video Group is active in recording and intervening in the changes taking place in the area. Through the facilitation of workshops and resources, the project develops skills and tools essential to a process of resident documentation, representation and decision-making. For example, residents film monthly meetings held with planners. This footage then functions as evidence that demonstrates promises made and decisions negotiated. Using this media, community issues can be voiced, questions can be raised and information shared. The project constitutes an integral strategy for maintaining a 'written' record of what is going on and a tool for resident and community-led action. A member of LOOP (Lifestyle Opportunities for Older People) and a long-term active member of the local Tenants Association on the Silwood Estate, Doreen Dower is more than familiar with the value of community activity and the support of social networks. As a participant in a Silwood Video Group film, both in front of and behind the camera, Doreen was involved in making a documentary about LOOP. She describes the significance of such a project in terms of ownership, skills and representation. The film provided an opportunity for participants to learn new skills, while illustrating the positive work of LOOP and the community it represents, encouraging pride in those that made the film. Doreen explains; "We got our names up on it… It's good to think I helped to make that".

Within this project, Spectacle can be seen as a mediator facilitating access to resources and negotiating the issues at stake within a particular context. The project resists the possibility of being subsumed into a PR exercise for local regeneration. This is not a project that functions to brand or gentrify a place by citing art or culture. This is a critical enterprise that is aware of the problematic outputs demanded by funders and is vocal about the difficulties of achieving funding while maintaining a critical stance. Spectacle embrace these contradictions within a holistic practice that facilitates access to decision-making powers while making social comment. In this process as residents, the Silwood Video Group become mediators of their own experience and the changes happening in their community.

_ Silwood Video Group, 2000–ongoing.
Images courtesy of www.spectacle.co.uk.

Date	2000–ongoing
Place	Silwood Estate, South London
Support	Spectacle http://www.spectacle.co.uk/

"Regeneration; if it doesn't benefit local people is nothing but a land grab."

Mark Saunders, Spectacle

143

Mediation
Two Towns on the Thara: Laa / Znojmo

The towns of Laa in Austria and Znojmo in the Czech Republic are geographically only 17 miles apart, but represent drastically different histories, traditions and cultures. This legacy of political and economic differences has created prejudices and cultural stereotypes on both sides of the border. In 2004, Austrian artists, Helmut and Johanna Kandl were increasingly aware of a sense of skepticism in Austria about the impending expansion of the European Union.

Inextricably interrelated in terms of culture for centuries, the two cities were hermetically sealed off from each other for 40 years. Thus the region's inhabitants experienced the period of post-war renovation in different ways. English was taught on one side of the border, Russian on the other; Austrians preferably went to Italy on holiday, whilst the Czechs drove to Bulgaria or Romania.

Between 1989 (with the fall of the Berlin wall) and 2004 (with the expanding of the European Union), the politics and economies of the two cities began to overlap. The border no longer had the same role or significance as it had in the past. Znojmo's rapid transition into a capitalist city brought with it fear of rising crime and worries over increased competition in business and employment. The Kandl's were witnessing a widening gap between the two cities rather than a unification of these traditionally distinct places. They wanted to find a way of tackling this perceived fear between two territories that lie so close geographically whilst remaining so culturally distant.

Helmut and Johanna Kandl sought to engage people on either side of the border by inviting them to show their holiday snapshots to each other. They advertised for participants by giving a presentation in Laa and holding a meeting in Znojmo. They then distributed posters and called for participants using interviews with the local media. The photographic images worked to explore and deconstruct cultural, social and economic preconceptions of the 'other' from either side of the border.

By asking residents to share their images of holiday destinations, people were able to focus on their experiences, memories and dreams of a 'foreign' place. The Kandl's were mediating a dialogue between inhabitants on either side of a border by recognising a shared urge for travel and experience of destinations other than their own. The project also highlights how everyone is a mediator of their own experience, demonstrated here through the act of taking holiday snaphots. Both these and the artists' own photographs of the cities then provided Johanna Kandl with raw material for a series of paintings. The images and experiences of these territories and the individuals that visited them were then further mediated through the act of painting, extending the act of mediation as communication. Eventually the stories are removed and only the images remain.

_ Milena Vancurová, Bulgaria, 1983.ß
_ Johanna Kandl, *Untitled*, 2002, 80x56.5cm, tempera / wood.

Date	2004
Place	Laa, Austria and Znojmo, Czech Republic
Support	The culture department of the government of Lower Austria and Kontakt, The Arts and Civil Society Program of the Erste Bank Group.

"The meeting of the people was very important, because the relations between the two countries have not been very friendly during the last decades and there are a lot of prejudices about the 'others' on each side of the border."

Johanna Kandl

Participation
The Third Ward Archive

"Next week I move to the Third Ward in Houston. It is a ghetto. A crack edge community, the Third Ward sits on the southern fringe of downtown. It just borders the affluent Rice University, M D Anderson Medical and Hospital, and Museum district, but it is a world away."—Tracy Hicks

Tracy Hicks was returning to *Project Row Houses* in the Third Ward, a project initiated by artist and community activist Rick Lowe and colleagues in 1993 at an abandoned site of 22 shotgun-style houses. Lowe invited other artists and local people to help rebuild the area, with the aim of creating a sense of community based on African-American history and culture. Project Row Houses continues to this day to develop an arts-based process of preservation and community development.

One of the many *Project Row Houses* initiatives was the *Third Ward Archive*, first developed by Tracy Hicks in 1996. For this project, Hicks delivered 150 disposable cameras to local residents, inviting them to take pictures of what they treasured and wanted to preserve. He filled one of the Project Row Houses with shelves containing over 3,000 glass canning jars into which he placed the photographs. Written notes inspired by or detailing the images were also added to the jars. Pamela Seymore, for example, contributed a photograph of herself holding a portrait of her mother, who had been raised in the house Hicks was working in, the same place her father had died. The memories become specimens and the subjects for advancing knowledge and understanding of the Third Ward community.

Hicks revisited The Third Ward Archive again in 2002, creating an opportunity for people to add to the archive. As a white American, he recalls the role he played as an outsider in a community. Through the process of doing the project and people participating in it, he became more accepted, to the extent that, one of the residents thought Hicks was "a light-skinned brother". Hicks reflects: "We decided I was, even if I don't know of any black blood in my ancestry, its probably there." This combination of acceptance and alienation is captured in Hicks's work and the overall Project Row Houses programme. "The Third Ward feels like home in more than some *deja vu* sort of way. I am accepted here and appreciated for what I do."

It is perhaps inevitable that Project Row Houses would become a victim of its own success. After 14 years of intense artistic activity, the area is becoming gentrified. To counteract this process, the Row House Community Development Corporation was set up to secure extra buildings for low-cost housing and commercial use. While acts of participation in community life by Hicks, Pamela and many others are informal transactions, a more sustainable framework has had to be introduced in order to enable such participation to resist extinction.

_ Pamela Seymore holding a photo of her mother (photo by Pam's daughter Jasmine), one of the contributions to the Third Ward Archive, initiated by Tracy Hicks, 1996.
_ Detail of installation of the Third Ward Archive, Project Row Houses, 1996.
_ Installation of the Third Ward Archive, Project Row Houses, 1996.

http://www.projectrowhouses.org/

Date	1996 and 2002
Place	Project Row Houses, Houston, Texas
Support	Project Row Houses

"While at any one time people and place are the ingredients of a community, the past and present are the ingredients of the future... and, after all, that is what we preserve for—the future."

Tracy Hicks, 1996

Network of Embroideries

The artist collective Skart (Dragan Protic and Djordje Balmazovic) have found
a framework through which people can express their own thoughts, experiences,
concerns and passions: illustrated two-line rhymes on tea-towel-shaped pieces of
white cloth. Taking this Balkan folk tradition of embroidery as a starting point, they
have been inviting groups and individuals in Belgrade, Graz, London, Seoul,
Stuttgart and various Serbian villages to join them in embroidery sessions. The
informal workshops are opportunities for people to freely discuss issues relating
to contemporary life. Participants in the network include the Single Mothers
Association in Belgrade, various women's refugee groups, village embroidery clubs,
the activist group, Women in Black, and elderly residents of Hackney in east
London. The resulting pieces each hold their own stories and collectively they raise
a cacophony of issues, experiences and causes, all overlapping and intertwining.

Motivations for participating in the Network of Embroideries vary widely. The project
requires people to commit time for conversations and making. The process of
talking, thinking and putting needle to thread is a slow one and it is often those
with the 'free time' who are able to get involved and participate. Those who tend
to have that time are older people, unemployed people, children and sometimes
their mothers or fathers. Lenka Zelenovic, an unemployed single mother, living in
Zemun-Belgrade, has made many pieces illustrating the social consequences of
the closures of the factories in her town. Skart have also worked with existing
groups, such as Women in Black who have contributed to the network, expressing
their concerns about human rights in the embroidered pieces.

When Skart came to London to continue the network, there was no time to fit
in such a slow activity as embroidery so they used 3-D paint to replicate the
embroidery process more quickly. Skart met friends and new acquaintances to
talk about personal thoughts and public woes. These conversations then led
to either participants or Skart devising short two-line rhymes and drawings.
The embroideries represented quotes from a particular person, creating a sense
of ownership over the work, even if they did not construct the piece themselves.

Content is created by participants and manifested through embroidery. Ranging
from anti-war statements to personal loss, the rhymes and stitching become
vehicles for self-expression—of personal battles or social ills. Skart create the
framework and mediate the content being provided by the people they meet.
What first appears to be a friendly domestic medium and scene often reveals
a compelling message from its maker.

_ Lenka Zelenovic, Zemun–Belgrade, Serbia 2003
(translation: "Machine Dust, Factory Silence a
Must").
_ Ingo, WOTEVER club, London 2007. Bernard
Miller, resident of Dayton Court, Hackney, 2007.

Date	2001–ongoing
Place	Belgrade, Graz, Seoul, Stuttgart, London
Support	B + B, Maronien Art Center, Rotor, Schloss Solitude, Skart, Visiting Arts.

"The Network of Embroideries encourages
witnesses of political / social transformations to
shape, show and share their personal thoughts."

Skart

Participation
The Model. A Model for a Qualitative Society

In 1968 the Danish artist Palle Nielsen was invited to participate in *Aktion Samtal* (or Action Dialogue) in Stockholm; a series of activist interventions to promote the activity and freedom of children. *The Model. A Model for a Qualitative Society* constituted the culmination of this series. Held in the Moderna Museet, Stockholm, *The Model* was a self-financed initiative that transformed the exhibition space into a free playground for children. Organised by Palle Nielsen and his activist friends, the project saw 30,000 people visit the gallery, 20,000 of whom were children. Over three weeks people witnessed and interacted with the swings, jungle gyms, ropes, slides, foam, paint and fabrics filling the space. Towers of speakers also adorned each corner of the gallery, projecting the sound of records selected by the attending children.

Nielsen's project emerged during an historical moment in which protest culture and civil rights movements were attempting to revolutionise the face of society in the 1960s and 1970s. As Lars Bang Larson explains in *Play and Nothingness. The Model for a Qualitative Society, an Activist Project at the Moderna Museet*, it was in this very year that the rights of children were being fought for by child power militants in Stockholm. *The Model* existed in dialogue with a very particular context. The project sought to enact a form of social experiment where children were given the conditions to exercise their liberty and creative decision-making powers. This action was in pragmatic response to what Nielsen saw as a need for recreational space within the urban environment. The project also sought to re-imagine the exhibition space of the 'white cube'; it was an attack on the establishment. The gallery was deployed as an experimental and interactive site that relied on participation in order to create and explore social bonds. After the project in the Moderna Museet, Nielsen reconstructed *The Model* in the suburb of Västerås in 1969. Nielsen continued to make illegal playgrounds and speak with local people about these actions in a process of what he terms "action science work"; creating temporary models as political ideas that inspired further DIY initiatives.

_ *The Model. A Model for a Qualitative Society*, Palle Nielsen, Moderna Museet, Stockholm, 1968.

The power of *The Model* lies in its subversive value as a prototype of critical participation. Nielsen's action worked to destabilise the form and function of the traditional art space in order to create a site of open interaction and participation; the children themselves determined the outcome of the exhibition. This process of participation worked to explore the social development of a generation while calling for recreational spaces for play within the urban environment. The artist now explains that the art institution can no longer be re-appropriated as an alternative space. Describing the social aesthetic of art and social activism within the art institution in the contemporary moment as depoliticised and somehow annulled, Nielsen's comments call for a new revolutionary alternative.

Date	1968
Place	Stockholm, Sweden
Support	Moderna Museet, Stockholm, The State council for Architectural Research, The City of Stockholm's Children's Council, Swedish Housing and Ministry of Education.

"There is no exhibition.
It is only an exhibition because the children are playing in an art museum.
It is only an exhibition for those who do not play.
That is why we call it a model."

Palle Nielsen, in a pamphlet accompanying the project.

Politics
ANTI-DOG

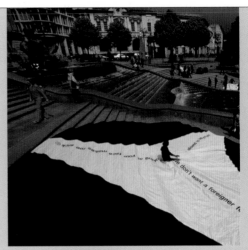

As a tactic for innovative protest, ANTI–DOG is a fashion label initiated by Alicia Framis that is performed in public to raise awareness of violence and racism towards women. Framis is concerned with personal safety in a globalised world of surveillance. The artist describes her own individual experience as inspiration for addressing universal issues in a series of performances realised across Europe. When living in Berlin, as an immigrant woman, Framis was warned against walking through a particular area of the city occupied by racist gangs with aggressive dogs. ANTI–DOG is a statement against violence towards women and a medium within which to address personal issues in a public forum.

ANTI–DOG took place in the United Kingdom in 2003. The project evolved from within the particular context of Attwood Green, an area of inner-city regeneration in Birmingham. The Attwood Green estate is owned by Optima Community Association, in partnership with the Ikon Gallery, Optima sought to engage the community in the area in a process of social and environmental regeneration. Working with individuals from existing organised communities such as Fiveways Estate Women's Group, the artist created a context for people to raise their individual concerns. Alongside powerful issues of gendered violence, fears concerning regeneration and change also emerged from discussions of protection and safety.

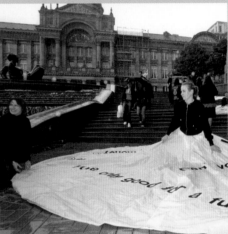

The women contributed sentences that they did not want to hear anymore. These statements (such as "this is not your country" were then copyrighted, implying that they could not be spoken in public without risking a fine. The sentences were transcribed onto outfits co-designed by the artist and fashion students from the University of Central England. These beautiful and futuristic dresses function as both symbolic and actual garments of protection. The skirts of the dresses are epic in size (five metres in diameter) creating space between the wearer and the outside world. The material used to make them is a reinforced high-protection, bullet-proof fabric called Twaron (made by Teijin Ltd, Amsterdam) and the transcriptions embroidered on the fabric are poetic articulations of ambition and uncertainty. The women who had contributed the copyrighted sentences modelled the garments in Birmingham's city centre square with outspread skirts, assisted by pupils from St Thomas' Primary School. The outfits voiced loud public declarations and articulated individual statements against vulnerability, invisibility and violence on a grand visual scale.

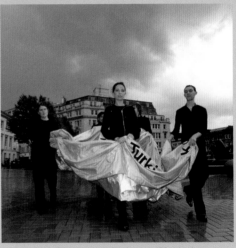

Framis' practice enacts a strategy for public protest and individual protection; it is a process of collaboration and innovation where confidence and creativity can become a form of political demonstration.

_ Anti-Dog © Unwanted Sentences, Birmingham, 2003. Photographs by Adrian Burrows.

Date	2003
Place	Birmingham
Support	Ikon Gallery, students from University of Central England's Fashion Department, pupils from St Thomas' Primary School, Optima Community Association and Mondriaan Foundation.

"... [ANTI–DOG] makes us aware of the fact that the way we usually protest against violence and racism lacks variety and originality... With her contribution, Framis makes the act of protest attractive and powerful at the same time."

Lilet Breddels, coordinator of ANTI-DOG

The Battle of Orgreave

On 17 June 2001, former miners and policemen, local people and professional battle re-enactors came together to relive a strategically crucial picket operation in the 1984 National Mineworker's strike that took place at the Orgreave coking plant, South Yorkshire. Initiated by Jeremy Deller and commissioned by Artangel, this event and the documentary film by Mike Figgis screened by Channel 4, created a testimony to a recent and politically-charged history. In 1984 the National Coal Board, under the Conservative government announced they were to close 20 coal mines because they were deemed economically unviable. The threat to jobs and impact this would have on entire communities where mining was the primary source of employment, triggered the Yorkshire miners to defend their pits against closure. The National Executive Committee of the National Union of Mineworkers and the Union's president, Arthur Scargill, endorsed these strikes and an official national miners strike was declared.

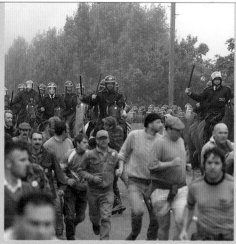

_ Still from the *Battle of Orgreave*, image courtesy of Artangel.

Orgreave became a central picketing point to rally support for action. David Douglass, former miner, strike leader and mining historian says: "There was the hope that all of the Left, who never tired of talking of revolution, could actually put their papers down and come and do something constructive and fight in that field alongside us. So the idea was that we could get everybody there together and we could make this into a mass battle." The violent clashes between police and miners in Orgreave on 18 June 1984 (labelled by some as the Battle of Orgreave) came to represent a much wider resistance to the privatisation of Britain's industries and the subsequent threat to working class communities and the industries' unions.

As artist and author of the concept of the re-enactment of the Battle of Orgreave, Jeremy Deller stresses in the film footage: "This isn't about healing wounds, it's going to take more than an art project to heal wounds, but it was definitely about confronting something and not being afraid of looking at it again." *The Battle of Orgreave* works to reclaim an event and reinstate it within the popular and contemporary imagination. It is both a symbolic gesture and a political act. Bringing together personal accounts and re-staging actual events, the work memorialises, historicises and documents a historical landmark, the aftermath of which continues to affect living communities. Through participation, those who were involved in the original strike honour this history while also redressing any inaccuracies and untruths they feel have been wrongly told about the strike. It can be argued that art is used here as a site of exploration and narration, a process with a political objective. Deller claims a social and political issue as subject matter and raw material. In this process the protagonists become the authors of the history being re-told. By reclaiming this event within the contemporary moment, Deller and Figgis re-politicise this history and make it visible across generations, calling for people to reassess its meaning and impact. As Dave Douglass explains when discussing the aftermath of the event on the local community: "The impact on the community was good, a chance to take a step back away from the bitterness and re-assess the real event that they were part of."

Date	2001
Place	Orgreave, Yorkshire
Support	Artangel, Channel 4 http://www.artangel.org.uk/

"It gave me the chance to challenge some conventional views about that struggle, and suggest apart from the miners being very heroic, we were also misled... It gave me the chance to suggest we were set up for a kicking."

David Douglass, former miner, strike leader and mining historian.

Establish a Community Centre for Senior Citizens

The Austrian activist art collective, WochenKlausur, develop projects out of invitations from art organisations that have an infrastructure and capital to support their work. They work to a strict timeframe of (usually) eight weeks. This enables the group to research and identify the specific local political circumstance of their commission and work quickly and efficiently to leave something concrete behind.

In 1994 WochenKlausur were invited to carry out a project in Civitella d'Agliano in Italy as part of Progetto Civitella, an annual summer workshop for artists. The small medieval town of Civitella, north of Rome, is home to a large number of elderly people. WochenKlausur aim to tackle "socio-political deficiencies" and in this instance, they discovered that the older residents of Civitella were lacking in a communal place to meet each other. They started to work with Circolo Anziani, a senior citizens association (aligned with the left-wing local government that was in power at the time). There were plans to renovate the ground floor of the Town Hall for their use but the project had not begun, despite promises from the local government. WochenKlausur set out to help make it happen. They did this by raising public awareness of the needs of the older community and therefore placing pressure on the local government to keep their promise of a new centre for senior citizens and start the building work.

_ Seniors Association Circolo Anziani, Civitella d'Agliano, 1994. The Photo Action, Civitella d'Agliano, 1994.

WochenKlausur rallied support from a wide range of people, demonstrating thier solidarity with Circolo Anziana and their commitment to the providing a communal place for elderly residents by purchasing furniture for the new centre. In order to raise money for this initiative WochenKlausur painted a large mural of the old town and photographed local people in front of it during the annual village festival. This public action drew attention to the cause, putting further pressure on the local government.

Their tactics worked and the centre was completed before WochenKlausur left Civitella. The centre has since expanded and is still used extensively 12 years after the renovation. With the change in local government this year, however, the future of the community centre is uncertain. The initiative did not just provide an improved facility, however, it also stimulated recognition of the political status of older people in society; creating an organisation allied to a national organisation and establishing the needs of seniors in providing key local services. According to Roberto Caiello, who was the mayor of the town in 1994: "The community was deeply involved. The inhabitants really felt part of the project. The painting became part of the identity of the town and is still used in various initiatives."

Roberto goes on to point out that the response to subsequent additions to the centre became inextricably linked to political attitudes. Those in favour of the party in power were supportive, those who were not, withdrew their support of the centre. For a project that engaged local people and encouraged the completion of the centre in the space of six weeks, its long-term sustainability is in the hands of its current users and local politicians.

Date	1994
Place	Civitella d'Agliano
Support	Progetto Civitella d'Agliano http://www.wochenklausur.at/

"An art debate that merely serves as entertaining reading between two political outrages... is nothing more than a hand warmer for the self-satisfied bourgeoisie."

WochenKlausur

Utility
Away Weekend

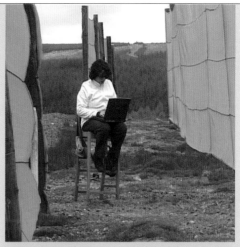

Anna Best was invited by [a-n] THE ARTISTS INFORMATION COMPANY to carry out a Year of the Artist National Media Residency at their offices in Newcastle in 2001. The Year of the Artist was an Arts Council, National Lottery funded programme that involved the commissioning of over 1,000 artists to work in organisations across the country from June 2000 to May 2001. [a-n] is a national agency that supports artists' practice through publications and professional services. Anna proposed a surprise weekend away for the staff that would reflect [a-n]'s vision as an information provider and facilitator of artists. While Anna consulted the individual members of staff the destination of their trip away remained a secret until they were put on a bus and taken to a team-building centre in Northumberland.

Alongside the usual team-building exercises such as paint-balling, archery, quad biking and group tasks, Anna invited four artists to deliver alternative sessions: Neil Chapman organised an "interesting lecture"; Laura Trevail wrote a film script and Emily Druff led a yoga session. The *Away Weekend* was documented in the format of *[a-n] MAGAZINE FOR ARTISTS* in which Ana Laura Lopez de la Torre presented her commentary written during the weekend as an alternative to documentary video. *Away Weekend* also provided the starting point for *Team Build*, a weekend event exploring connections between team building and art practice (in association with [a-n], Baltic and B + B). Like Ana Laura's watchful eye, Anna Best's approach to the commission was as an observer of her host organisation. Rather than provide a useful service (as a team building weekend might suggest), organising the staff to participate in a performance meant Anna retained a critical distance from her 'subjects'. By framing *Away Weekend* as an art performance, where each participant becomes a live performer, the potential utility, in terms of it effecting change in the work place was brought into question as the [a-n] staff were not sure if they should take the activities seriously or not. "Are Best's participants learning anything or are they guinea pigs?" (Lucy Wilson, "Taking Control", *[a-n] MAGAZINE FOR ARTISTS*, September 2001). Is it inevitable for artists to be commissioned as catalysts for change and then not to be taken seriously? Being paid to be useful as an artist invites subversion of the expectations of the very definition of useful. One option is to reveal the useful in the futile moments, or vice versa, through projects like *Away Weekend*. By adopting the techniques of team building, *Away Weekend* challenged the staff at [a-n] to take on board the issues raised during the weekend, inviting them to examine their investment in the residency as a whole. The action had the potential to be a useful activity (if the instructions were followed), but it also questioned expectations placed on artists to act as catalysts for change in the workplace.

— Away Weekend, 2005. Images courtesy of Anna Best.

Best has described her approach as holding up a mirror to a situation by getting people to take responsibility for engaging with this act on their own terms. Her projects produce subtle comments rather than solutions and there is an intended humour and absurdity to *Away Weekend*.

http://www.annabest.info/

Date	2001
Place	Northumberland
Support	Arts Council England, [a-n] THE ARTISTS INFORMATION COMPANY

"This is a centre for training and development for senior executives, our objective in life is to be more effective."

Dave Routledge, Reivers Development and Ultraventure, team leader for Away Weekend

Utility
Dry Toilet

As part of the Caracas Case Project, Marjetica Potrc and Liyat Esakov worked with residents of La Vega Barrio, a district of Caracas that is not serviced by the municipal water grid. They constructed a dry toilet that does not need any water to operate and is made using locally sourced building materials. Potrc and Esakov were struck by the lack of energy infrastructure and non-existent public utilities in this informal, self-built part of the city.

"I knew only that we wanted to work inside the informal city and not merely analyse it from a safe distance." Marjetica Potrc, The People's Choice catalogue 2006

Potrc and Esakov entered the barrio as problem-solvers, but first they had to find out what the problems were. When asked by Potrc and Esakov about self-organising their own independent energy supply, however, the residents were not interested. This was because the residents had already found a way of stealing electricity from the main supply and sometimes even shooting holes in the water pipes to access water. These illegal methods of survival were short-term solutions for much larger political and infrastructural problems. Potrc and Esakov were interested in proposing long-term legal survival mechanisms. A dry toilet, for example, could be easily built by residents themselves and used no water.

_ Dry Toilet. Building materials and sanitation infrastructure La Fila, La Vega Barrio, Caracas. Courtesy of Liyat Esakov and Marjetica Potrc. Photo by Andre Cypriano.

The dry toilet they built in the barrio led to the construction of more dry toilets in La Vega barrio and in the formal city of Caracas. Hidrocapital, the municipal water company, was also planning to build dry toilets as educational props in every municipality, although this did not happen. The dry toilet experiment demonstrates a practical ecological solution to combating water shortages that could be adopted on a local and global scale. A prototype of a dry toilet placed in Caracas city centre, for example, increases the general awareness of such self-sustainable technologies, as does Potrc's presentation of variations of the toilet in international exhibitions. These 1:1 models advertise the dry toilet as a valid, necessary alternative to flush toilets by drastically reducing water usage.

By helping people to help themselves, the dry toilet becomes a legal form of self-initiation and organisation. The dry toilet's use-value depends on its ability to flush out inequalities in basic human rights and lead to more sustainable improvements to the infrastructure of the barrios. By presenting prototypes beyond the context of the area, the dry toilet campaign also draws attention to the public action required to address such global ecological issues.

http://www.potrc.org/

Date	2003
Place	Caracas
Support	La Vega community, Caracas Case Project and Federal Cultural Foundation of Germany and Ministry of Environment.

"My heart is intrinsically drawn to individually initiated small-scale strategies."

Marjetica Potrc, The People's Choice, 2006.

Utility
Valley Vibes

Valley Vibes functioned as a mobile device, ghetto blaster, karaoke, and research tool for picking up local vibes. This metal box, which housed recording and sound equipment, was hired out by local residents. Every interaction was recorded and added to an audio archive of over four years of informal, local activity throughout the Lea Valley in London. The project was initiated by artists Jeanne van Heeswijk and Amy Plant in association with Chora, Office for Architecture and Urbanism, who at the time were interested in mapping "London Sector A", a marked strip in east London designated as an area for regeneration.

The availability of the vibe detector was advertised in the areas it travelled to as a free service that included advice, a technician and publicity material for their events. While the project aimed to "give people a voice and enable them to influence a historical reading of their area and its image", the equipment was hired for practical purposes, such as for playing music and calling out the winning raffle ticket numbers at a Christmas Bazaar fundraising event for the London Chest Hospital; by students to practice their DJ skills and as a karaoke machine at the Bingo Club Pensioners Christmas Party.

Significantly, the onus was on residents to hire the equipment, it was not forced upon unsuspecting communities as something an artist or architect thought was needed in an area. Those hiring the vibe detector had identified a use for it. *Valley Vibes* foregrounded the tool, not the exchange between the artist and a specific audience. The use-value of *Valley Vibes* is pragmatic rather than cathartic and does not presume a lack of cultural activity that the artist tries to fulfill.

A small scale, intimate act is recorded and the potential to cross-reference, compile and map the various interactions with the detector also exists. *Valley Vibes* worked both on micro and macro levels as a tool for immediate use on the ground and at a distance as an audio map of a time and place. Both of these uses of *Valley Vibes* are perhaps better understood beyond an analysis of the piece as an artwork. *Valley Vibes* exists in micro (1:1) and macro (map) forms simultaneously. While the detector proved to be very useful on the ground, however, the role of the resulting audio archive is yet to be decided. With the dramatic re-landscaping of the Lea Valley for the 2012 Olympics, lost community vibrations will surely increase in value and vibe detectors could continue to be used by residents to map these rapid changes, making use of microphones and speakers in any way they choose.

http://www.valleyvibes.net/

_ A traditional performance sung by farmers working in the paddy fields of Goa, India. Open Day, Goan Community Centre, Keston Road, Tottenham, 20 March 2003. Valley Vibes booked by Candy Fernandes.
_ Valley Vibes leaflet/poster announces the Vibe Detector as it moves to each new area.

Date	1998–2001
Place	Deptford, Bethnal Green, Tottenham, Edmonton and London
Support	Mondriaan Foundation, Lewisham Council, London Arts Board, Lee Valley Park, Space Studios, Royal College of Art, Amassade van het Koninkrijk der Nederlanden, Halles Café, Oxford House.

"The Vibe Detector is not an art object but it is designed as a research tool to operate over a long period of time and to be integral to the life of certain areas rather than be intrusive."

Amy Plant

Biographies

Lucy + Jorge Orta

Trained as a fashion knitwear designer at Nottingham University, Lucy Orta began practicing as a visual artist after meeting her partner Jorge in Paris during 1991. Her early sculptural work investigates the boundaries between the body and architecture. She invented *Refuge Wear* and *Body Architecture*, 1992–1998, shelters that become overcoats, backpacks that become sleeping bags, prototype structures, light and autonomous for "emergency situations". She created *Nexus Architecture*, 1994–2002, in which a variable number of people wear suits connected to each other, shaping modular and collective structures that visualise the concept of social link. Professor Orta was a founding member of the Man + Humanity Masters programme in Industrial Design for the Design Academy Eindhoven, 2002, a pioneering master programme which stimulates socially driven and sustainable design solutions, alternative systems and products. She was invested as the first Rootstein Hopkins Chair at London College of Fashion, University of the Arts London, 2002–2007.

Trained in both fine arts and architecture, Jorge began his career as a painter graduating simultaneously from the Faculty of Fine Arts and the Faculty of Architecture at the University of Rosario. In response to the censorship of the Argentine military regime, his practice broadened to include the avant garde and alternative forms of visual communication such as *Mail Art* and performance, practiced throughout South America in the 1970s. He was the first Argentine artist to explore video and light projections, creating highly controversial public installations in the height of the dictatorship. Jorge Orta received the French Ministry of Culture scholarship and moved to Paris in 1982. Parallel to his studio practice, he began experimenting with the technology for large-scale image projection in the early 1980s. In the series *Light Works,* he has illuminated mythical sites and urban locations of cultural and ecological importance across the world from Aso Volcano in Japan, Capadoccia Turkey, the Zocòlo Mexico City, and the Venetien Palaces along the Grand Canal representing Argentina for the Venice Biennale, 1995.

In 1993, the two artists founded their studio in central Paris and began restoration on their research centre, the Dairy, in Marne La Vallée, 2002. In partnership they conduct collaborative research, coordinate master classes and residencies, produce and assemble the multi-media artworks. Parallel and feeding into their studio practice they stage interventions, actions and workshops which explore the crucial themes of contemporary world: the community, social exclusion, dwelling, migration, sustainable development and recycling. Lucy + Jorge Orta have exhibited the results of their collaborations in major contemporary art museums, including the Barbican Art Gallery London, Modern Art Museum Paris, Museum of Contemporary Art Sydney, Boijmans Museum Van Beuningen Rotterdam, as well as the Venice and Johannesburg Biennales.

Paula Orrell

Paula Orrell is Curator of Plymouth Arts Centre, establishing a visual arts programme that has a special interest in artwork that encorporates human interaction and social context, and places emphasis on research, interdisciplinarity and collaboration. Curating a new programme of exhibitions and offsite programme, recent projects with artists and curators include: with (withyou.co.uk), Barbara Holub, Anna Best, Janna Graham, and 16beavergroup. Past curated projects include the first solo exhibition of Lucy Orta in London at the Barbican, a new commission by Tim Brennan at the British Museum and a solo exhibition of acclaimed performance artists Noble and Silver curated in collaboration at Beaconsfield, London. Paula is the founder of an MA programme in fashion curation at the London College of Fashion, University of the Arts London and continues to lecture at academic institutions across the United Kingdom.

Sally Tallant

Sally Tallant is Head of Education and Public Programmes at the Serpentine Gallery where she has developed an ambitious programme of artist's projects, commissions, conferences, talks and events. Projects include *London Interview Marathon* with Hans Ulrich Obrist and Rem Koolhaas; *Disassembly* with Runa Islam, Christian Boltanski, Yona Friedman and Faisal Abdu'Allah; *Lets Twitch Again*, Maria Y'Barra Jnr.; *Hearing Voices, Seeing Things: Art and Mental Health* (seven artists residences with North East London Mental Health Trust); *Park Products* by Kathrin Böhm and Andreas Lang and residencies with Tomoko Takahashi, Toby Paterson and A Constructed World. She has curated and organised exhibitions for the Hayward Gallery, Milch, Chelsea and Westminster Hospital; lectured at the Royal College of Art, Goldsmiths College, The Royal Academy, Central St Martins, Dartington College of Art and is a regular contributor to conferences across the world. She is academic referee for the Litmus Research Centre at Massey University in New Zealand, on the Board of Directors of Exhibition Road Cultural Group and the Advisory Board of the Goldsmiths Media Research Programme *Spaces, Connections, Control* funded by the Leverhume Trust.

Janna Graham

Janna Graham is an organiser, writer, researcher, educator, curator, negotiator, and chronic collaborator. Experimenting with modes of public participation, knowledge formulation and instituent mischief, her current investigations explore the acoustics of administration, participatory organising methods and radical relationship-making. During her eight years at the Art Gallery of Ontario in Toronto she developed exhibitions and programming in collaboration with artists, youth and community organisers. Recent projects include: *Ultra-red, SILENT|LISTEN* at the International AIDS Conference, *Artcirq II*, a residency and exhibition with an Inuit performance/video circus collective at Project Art Centre in Dublin, *The Ambulator:* or *What Happens When we Take Questions for a Walk* (with Susan Kelly and Valeria Graziano), *Academy: Learning from the Museum*, Van Abbemuseum. Other collaborators include: Mercer Union Contemporary Art Centre and *FUSE Magazine*, 16beavergroup, and the debajehmujig theatre. Her musings on art, culture and how to inhabit cultural institutions otherwise have been widely published in Canada and the United Kingdom. She is currently a founding member of the Committee for Radical Diplomacy, a member of the collective Ultra-red and a PhD candidate/tutor at Goldsmiths College in London.

Sophie Hope

Sophie Hope's work inspects the uncertain relationships between art and society. Her current projects include *Reunion*, a programme of meetings, residencies and exhibitions that address the political potential of art practices in Europe (http://www.reunionprojects.org.uk/) and *Art School*, a series of workshops for non-art professionals working with artists. She is currently in residence on the Beyond Action Research Programme in Leidsche Rijn, a new town in Holland, where she is developing a performance set in 3007 with local residents. Sophie co-founded B + B with Sarah Carrington in 2000 and continues to research the function of art through writing, evaluations, exhibitions and the B + B Archive (http://www.welcomebb.org.uk). B + B projects include *Real Estate: Art in a Changing City* (as part of London in Six Easy Steps) at the Institute for Contemporary Art, 2005; *Brand New Letchworth* at The Place Arts Centre, 2003; *Trading Places—Migration, Representation, Collaboration and Activism* at the Pump House Gallery, 2004 and *Talk Show* (as part of Critical Mass) at the Smart Museum, University of Chicago. B + B's recent evaluations of public art projects have included *Art U Need: an Outdoor Revolution* with Commissions East and *Peninsula* with Independent Photography. Sophie also teaches and facilitates workshops and has recently embarked on a PhD on the economics of socially-engaged art.

Chris Wainwright

Chris Wainwright is an artist, curator and former Dean of the School of Art at Central Saint Martins, University of the Arts London. In September 2007, he was nominated as the Head of Colleges at Camberwell, Chelsea and Wimbledon, University of the Arts London. He is also President of ELIA, (The European League of Institutes of the Arts) and Acting Director of ICFAR (The International Centre for Fine Art Research). His recent group exhibitions include shows at Gandhi Group, Chile's Museum of Modern Art and the Donna Beam Gallery. His work is currently being shown as part of the UK touring exhibition *Fleeting Arcadias—Thirty Years of British Landscape Photography* from the Arts Council Collection.

Emma Gibson

Emma Gibson has recently graduated with a BA(Hons) in fashion illustration from the London College of Fashion. Her most recent project *Now I Lay Me* focuses on themes of insanity, identity and the creative mind turned in on itself. Emma has worked as a fashion illustrator for Alexander McQueen, *Tank Magazine*, PPQ Clothing and Son of a Stag London and continues to exhibit her work widely in group exhibitions.

Acknowledgements

Lucy Orta and Paula Orrell would like to extend their special thanks to Deborah Dean of Angel Row Gallery and Mark Day of the NOW Festival for assisting with the funding and development of this publication during the commissioning of *Dwelling X* in Nottingham throughout 2003–2005. Thank you to Sally Tallant, Janna Graham, Sophie Hope and Chris Wainwright for their considered and reflective contributions and to their ceaseless dedication to challenging the artworld. Also to Emma Gibson for her artworking and illustrations. The London College of Fashion and Plymouth Arts Centre have also generously supported this publication. Thank you also to the Galleria Continua San Gimignano-Beijing.

Paula Orrell would like to thank her family for their support and especially to Lucy + Jorge Orta who have continuously challenged her perceptions. Special thanks to James.

Lucy + Jorge Orta would like to thank each and every participant that has joined them on the journey of reflection. Too numerous to mention one by one, each individual has left his or her mark, and opened their eyes and minds to special moments and emotions. To the Orta-studio team who have worked with the artists over the years and to the artisans and fabricators that realise the dreams, thank you Ramiro, Leo, Pablo, Emily.

Sophie Hope would like to thank Jennifer Maddock for contributing to the writing of the resource index profiles, Valentina Gottardi for helping to compile the material, Fran Hope for her work on the design, Sarah Carrington for her editorial input and all those who have provided information and images of the projects.

Picture credits

page 11_photograph by JJ Crance
page 12_photograph by JJ Crance
page 13_photograph by JJ Crance
page 23_photograph by Gino Gabrielli
page 26_photograph by JJ Crance
page 43_photograph by JJ Crance
page 57_photograph by Lothringer 13
page 59_photograph by JJ Crance
page 61_photograph by JJ Crance
page 63_photograph by JJ Crance
page 84_photograph by Gino Gabrielli
page 86_photograph by Gino Gabrielli
page 87_photograph by Gino Gabrielli
page 89_photograph by Gino Gabrielli
page 91_photograph by Gino Gabrielli
page 93_photograph by Gino Gabrielli
page 94_photograph by Marie Clerin
page 95_photograph by Jacqueline Alos
page 97_photograph by JJ Crance
page 99_photograph by JJ Crance
page 101_photograph by Catherine Acin
page 102_photograph by Marie Clerin
page 102_photograph by Philippe Fuzeau
page 103_photograph by Ludwig Forum Aachen
page 104_photograph by Marie Clerin
page 109_photograph by Lothar Schnepf

Edited by Nadine Käthe Monem
Designed by Rachel Pfleger

Black Dog Publishing Limited
Unit 4.4 Tea Building
56 Shoreditch High Street
London E1 6JJ

T. +44 (0)20 7613 1922
F. +44 (0)20 7613 1944
E. info@blackdogonline.com

All opinions expressed within this publication are those of the author and not
necessarily of the publisher.

British Library Cataloguing-in-Publication Data.
A CIP record for this book is available from the British Library.

ISBN10. 1 904772 75 7
ISBN13. 978 1 904772 75 0

BLACK DOG PUBLISHING is an environmentally responsible company. The *Lucy
+ Jorge Orta Pattern Book* is printed on Fedrigoni Symbol Freelife Satin, an
environmentally-friendly ECF (Elemental Chlorine Free) woodfree paper with a
high content of selected preconsumer recycled material. Printed in Slovenia.

architecture art design
fashion history photography
theory and things

www.blackdogonline.com

black dog
publishing